Apple Pro Training Series

Aperture 3,
Second Edition

Dion Scoppettuolo

Apple
Certified

Apple Pro Training Series: Aperture 3, Second Edition
Dion Scoppettuolo
Copyright © 2013 by Dion Scoppettuolo

Published by Peachpit Press. For information on Peachpit Press books, go to:
www.peachpit.com

To report errors, please send a note to errata@peachpit.com
Peachpit Press is a division of Pearson Education

Apple Series Editor: Lisa McClain
Developmental Editor: Bob Lindstrom
Production Coordinator: Kim Wimpsett, Happenstance Type-O-Rama
Contributing Writer: Brendan Boykin, Richard Harrington
Cameos Author: Liz Merfeld
Technical Editor: Ron Brinkmann
Technical Reviewer: Brendan Boykin
Copy Editor: Darren Meiss
Proofreaders: Darren Meiss, Liz Merfeld, Elissa Rabellino
Compositor: Cody Gates, Happenstance Type-O-Rama
Indexer: Jack Lewis
Cover Illustration: Kent Oberheu
Cover Production: Cody Gates, Happenstance Type-O-Rama
Media Reviewer: Eric Geoffroy

ISBN 13: 978-0-321-89864-7
ISBN 0-321-89864-8
9 8 7 6 5 4 3 2 1
Printed and bound in the United States of America

Contents at a Glance

Table of Contents

Getting Started

Welcome to the official Apple Pro Training course for Aperture, the powerful photo editing and management software from Apple. This book includes a variety of real-world photography projects, which are used as clear examples of the way Aperture works, from import and organization to image editing and output.

Whether you're a professional photographer, someone who uses photographs in your work, or someone who is passionate about photography, this book will guide you through the Aperture nondestructive workflow from beginning to end.

The Methodology

This book takes a hands-on approach to learning Aperture. The lessons are designed to show you a real-world workflow of importing, organizing, rating, editing, exporting, printing, publishing, and archiving your images, and performing all the other tasks required after a photo shoot. The projects represent a cross-section of specialty photography genres and types of shoots. Whether or not your type of photography is specifically featured, you'll find that the techniques taught here can be applied.

Aperture has an extensive list of keyboard shortcuts and a variety of ways to navigate through its interface and menus. We focus on the most common keyboard shortcuts you can use to increase your efficiency, and on the interface views and navigation schemes that are most effective for a typical workflow. The Aperture Help menu includes a comprehensive list of keyboard shortcuts if you want to learn more.

Course Structure

This book is designed to teach you to use Aperture using 13 project-based, step-by-step lessons and accompanying media files. It's important to complete each lesson before going onto the next; changes that you make to files in each chapter will affect work you do in subsequent lessons. The book is divided into three sections, as follows:

Creating and Organizing Your Photo Library

Lessons 1–5 focus on creating and organizing your Aperture library. After a quick tour of Aperture, you'll explore how to import from various sources; sort, compare, and rate images quickly and efficiently; apply keywords and metadata; search your library efficiently; utilize GPS location data; index photos based on face detection and recognition; organize images into folders and projects; and archive images in ways that are easy, secure, and intuitive.

Corrective and Creative Image Editing

Lessons 6–10 start out with the basics of image editing and move on to more advanced image-processing features of Aperture. You'll learn to make basic adjustments—such as exposure, white balance, and cropping—and then move on to tonal correction, color correction, and local adjustments such as retouching, cloning, dodge, and burn. Finally, you'll explore the Aperture capabilities specific to using RAW files.

Sharing Your Work

Lessons 11–13 focus on the final stage of any project: creating the final product. You'll learn to share your images for client review in a variety of formats from prints and custom photo books to compelling web journals and dynamic slide shows that mix photos, video, and audio.

Finally, Appendix A tackles some advanced topics, such as automating and scripting workflows, tethered shooting, and multi-monitor configurations. Appendix B explores ways you can integrate third-party plug-ins for image adjustment and sharing.

System Requirements

A minimum hardware and software configuration is required to take advantage of the accelerated performance capabilities of Aperture.

Minimum requirements:

▶ Mac computer with an Intel Core 2 Duo, Core i3, Core i5, Core i7, or Xeon processor and 2 GB of RAM (4 GB for Mac Pro)

▶ OS X 10.8.2 or later

▶ Aperture 3.4 with the latest software updates; please note some screenshots will appear slightly different on other versions.

▶ iPhoto 9.3 or later

Recommended system requirements are constantly evolving as new hardware and software becomes available. To check for the latest requirements, go to www.apple.com/aperture/specs.

Before beginning to use *Apple Pro Training Series: Aperture 3*, you should have a working knowledge of your Mac and its operating system. Make sure that you know how to use the mouse and standard menus and commands, and also how to open, save, and close files. If you need to review these techniques, see the documentation included with your Mac.

Copying the Aperture Lesson Files

To follow along with all the lessons, you'll need to copy the lesson files and libraries onto your hard disk. The lesson files and libraries are located on the DVD accompanying this book. You'll need approximately 4 GB of free space on your hard disk.

> **NOTE** ▶ If you have purchased this title as an eBook, you will find the URL to download the files on the "Where are the Lesson Files" page.

1 Insert the *APTS Aperture3* DVD into your computer's DVD drive.

The Finder window will open, displaying the contents of the DVD. If the window doesn't appear, double-click the *APTS Aperture3* DVD icon to open it.

2 Drag the APTS Aperture book files folder into the Documents folder on your hard disk.

> **NOTE** ▶ The location of this folder is important. The Aperture and iPhoto libraries for this book are located in this folder. You'll also be importing photos and referring to this folder throughout the book.

3 Once the "APTS Aperture book files" folder is copied to your Documents, eject the DVD.

4 Inside your Documents folder, double-click the recently copied "APTS Aperture book files" folder to show its contents.

5 To ensure that you are using the correct iPhoto library, double-click the APTS iPhoto library in the "APTS Aperture book files" folder.

6 If you are prompted to upgrade the Library, choose to upgrade the library.

7 If you are given the option to use iPhoto when you connect your digital camera, click the No button. If asked to Look up Photo Locations, also click No. If you receive a MobileMe has been discontinued dialog, click OK.

8 In Lesson 1, you will perform similar steps to instruct Aperture to use the APTS Aperture Library.

> **NOTE** ▶ When you complete the lessons in this book, you can return to your personal iPhoto and Aperture libraries by double-clicking the libraries located in the OS X Pictures folder, which is your personal libraries' default location.

About the Apple Pro Training Series

Apple Pro Training Series: Aperture 3, Second Edition is both a self-paced learning tool and the official curriculum of the Apple Pro Training and Certification Program.

Developed by experts in the field and certified by Apple, the series is used by Apple Authorized Training Centers worldwide and offers complete training in all Apple Pro products. The lessons are designed to let you learn at your own pace. Each lesson concludes with review questions and answers summarizing what you've learned, which can be used to help you prepare for the Apple Pro Certification Exam.

For a complete list of Apple Pro Training Series books, see the ad at the back of this book, or visit www.peachpit.com/apts.

Apple Pro Certification Program

The Apple Pro Training and Certification Programs are designed to keep you at the forefront of Apple's digital media technology while giving you a competitive edge in today's ever-changing job market. Whether you're an editor, graphic designer, sound designer, special effects artist, or teacher, these training tools are meant to help you expand your skills.

Upon completing the course material in this book, you can become an Apple Certified Pro by taking the certification exam online or at an Apple Authorized Training Center (AATC). Certification is offered in Aperture, Final Cut Pro, Motion, Logic Pro, OS X and OS X Server. Certification gives you official recognition of your knowledge of Apple's technologies and applications while allowing you to market yourself to employers and clients as a skilled user of Apple products. For those who prefer to learn in an instructor-led setting, Apple offers training courses at Apple Authorized Training Centers worldwide. These courses, which use the Apple Pro Training Series books as their curriculum, are taught by Apple Certified Trainers and balance concepts and lectures with hands-on labs and exercises. Apple Authorized Training Centers have been carefully selected and have met Apple's highest standards in all areas, including facilities, instructors, course delivery, and infrastructure. The goal of the program is to offer Apple customers, from beginners to the most seasoned professionals, the highest-quality training experience.

For more information, please see the Apple Certification page at the back of this book, or to find an Authorized Training Center near you, go to training.apple.com.

Companion Web Page

As Aperture 3 is updated, Peachpit may choose to update lessons or post additional exercises on this book's companion webpage, as necessary. Please check www.peachpit.com/apts.aperture3_2E for revised lessons or additional information.

Resources

Apple Pro Training Series: Aperture 3, Second Edition is not intended as a comprehensive reference manual, nor does it replace the documentation that comes with the application. For comprehensive information about program features, refer to these resources:

▶ The Aperture User Manual is available at support.apple.com/manuals/#aperture. You can also launch the documentation by choosing Help > Aperture Help when Aperture is launched.

▶ Apple website: www.apple.com/aperture.

Creating and Organizing
Your Photo Library

1

Lesson Files	APTS Aperture book files > Lessons > Lesson 01 > Memory_Card.dmg
Time	This lesson takes approximately 60 minutes to complete.
Goals	Import images from a memory card
	Navigate the Browser
	Delete images
	Straighten, rotate, and crop images
	Apply ratings to images
	Send images via email

A Quick Tour of Aperture

Digital photography makes it easier than ever to get great shots, and a lot of them. A lot. Just sifting through the photos from a single shoot can take the fun out of photography.

Although iPhoto is a great help, you may need more: more flexibility in where and how you store your files, more metadata to track and organize every image, and more finesse in adjusting color and tone. You want to share and present your photos in many ways: in books, on the web, in a slideshow. And most important, you don't want to buy and learn multiple apps to get your photos under control.

Aperture, photo editing and management software from Apple, provides photographers with all the essential tools they need in one application. Using Aperture, you can easily import, organize, edit, and enhance your photos. Aperture also makes it easy to share and archive your images.

The best way to appreciate the efficiency of Aperture is to get started. This lesson will introduce you to the main window layout and the tools you'll use in Aperture. You'll import and organize images, step through a basic photo edit, and output images to popular online sharing sites.

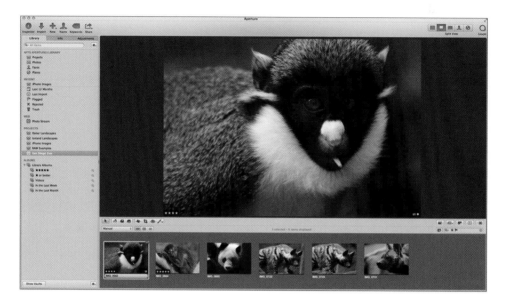

Opening Aperture

You can open Aperture in one of five ways:

▶ Double-click the Aperture application icon in the Applications folder.

▶ Identify Aperture as your default image application, and insert a memory card or attach a camera to your Mac.

▶ Click the Aperture icon in the Dock.

▶ From Launchpad, click the Aperture icon.

▶ Double-click an Aperture library.

Let's start by double-clicking the APTS Aperture3 Library that you copied from the DVD. Doing so will ensure that every time you open Aperture, you'll be using the library that came with this book.

NOTE ▶ Before opening Aperture, be sure to read "Getting Started." Also, verify that your system meets the system requirements and resources for Aperture, and that you've copied the lesson files and the APTS Aperture3 library to your hard disk.

1 In the Finder, open the Documents folder or whichever folder contains the APTS Aperture3 library.

NOTE ▶ After you open your personal library with Aperture 3, you won't be able to open that library with an earlier version of the application. Be sure to back up your personal library if you require compatibility with an earlier version of Aperture.

2 Double-click the APTS Aperture3 Library icon to open the application with this library's content.

When you open Aperture for the first time, you may first see a request to access your contacts followed by a registration form and then a Welcome screen.

3 Click OK to allow access to your Contacts, enter your registration information if requested, and then click Continue.

NOTE ▶ If you've previously opened Aperture, this screen will not appear. Alternately, click upgrade if prompted to upgrade the library.

A preference screen then appears.

In this dialog, you can set Aperture to open automatically whenever you connect a digital camera to your Mac.

4 Click Use Aperture.

NOTE ▶ If you've previously opened Aperture and aren't sure if it is set as your default image capture application, do the following when Aperture opens: Choose Aperture > Preferences. In the Preferences window, click Import, and from the "When a camera is connected, open" pop-up menu, choose Aperture. Close the Preferences window.

Finally, Aperture asks if you want to display your photos on a map. If your photos have embedded GPS location data, Aperture can use that information to display a map that identifies where they were taken. You'll learn more about GPS-tagged images in Lesson 4.

5 Click Yes.

NOTE ▶ If you've previously opened Aperture and clicked No on this screen, Aperture will not look up GPS location information when you perform exercises in future lessons. To set Aperture to look up GPS information, choose Aperture > Preferences. In the Preferences window, click Advanced. From the Look up Places menu, choose Automatically. Close the Preferences window.

Identifying Interface Elements

The Aperture window layout and interface changes to best suit the tasks you are performing. For example, when importing photos, the Import Browser opens to offer you essential importing controls. Likewise, choosing to perform image-editing tasks in a Full Screen view removes the majority of the user interface and gives you a more focused image workspace.

Let's take a quick look at the window layout to become familiar with the Aperture interface.

Toolbar—The toolbar displays commonly used features and main window controls and can be customized for your workflow.

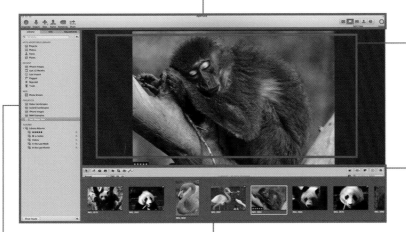

Viewer—When you select one or more images in the Browser, those images appear in the Viewer. The Viewer is a useful area in which to examine images at a larger size or to compare images side by side.

Tool strip—The tool strip includes both tools and display controls for images in the Viewer and Browser. The tool strip is located between the Browser and the Viewer when Aperture is set to Split View.

Browser—The Browser displays thumbnail images of the photos in your library or selected project. Images selected in the library appear in the Browser. You can view images in the Browser in filmstrip view, grid view, and list view.

Inspector pane—The Inspector pane is divided into three tabs: the Library inspector, the Info inspector, and the Adjustments inspector. To switch inspectors, click the desired tab at the top of the Inspector pane.

In the Library inspector, you can organize the projects, albums, and images of your Aperture library.

In the Info inspector, you can view an image's text information, including keywords, captions, descriptions, and the camera settings in use at the time the photo was taken. In addition, you can apply nontext metadata to an image, such as color labels, ratings, and flags.

In the Adjustments inspector, you can apply, edit, and remove the adjustments and effects made to an image.

Let's begin by importing some images into Aperture.

In iPhoto, you import images into Events that are stored in a library. In Aperture, images are imported into projects that are stored in a library.

1 At the top of the Library inspector, select Projects, if necessary.

The Aperture Projects view main window is very similar to the Events view in iPhoto. Each thumbnail represents a project.

2 Position the pointer over the iPhone Images project thumbnail and slowly move it to the right.

Within each project are located your individual photos. You can skim across the project thumbnail to preview the photos it contains.

3 Double-click the iPhone Images project thumbnail.

Double-clicking a project thumbnail in the main window displays the contents of that project and makes it the Recent item in the Library inspector.

4 In the Library inspector, click the Projects icon.

If you use iPhoto, you'll see many familiar items in the Library inspector. You can view an overview of all your projects or just the photos within a single project.

MORE INFO ▶ You'll learn more about the library and projects in Lesson 5.

Importing Images from a Memory Card

The most common sources for the photos you'll import into the Aperture library are memory cards, either by using a dedicated card reader or by connecting your camera directly to your Mac.

TIP▶ Using a card reader is almost always faster than downloading directly from your camera.

For this exercise, you'll use a disk image that will simulate connecting a camera or memory card to your Mac.

1 In the Dock, click the Finder icon to open the Finder.

2 In the Finder window, navigate to APTS Aperture book files > Lessons > Lesson 01.

3 Double-click the disk image Memory_Card.dmg to mount it.

The card may take a moment to appear. Depending on your Finder Preferences, a removable media icon could appear on your desktop called NO_NAME.

Aperture will automatically come to the front, displaying the Import Browser and all the images stored on the memory card.

> ### ▶ Using Other Importing Methods
>
> Aperture offers several methods for importing images that you'll explore later in this book. Here is a quick overview of these methods and where you'll find them described:
>
> - ▶ Importing folders of images from the Finder—Lesson 2
> - ▶ Accessing your iPhoto library—Lesson 4
> - ▶ Importing referenced files—Lesson 5
> - ▶ Transferring projects from another Mac—Lesson 5
> - ▶ Shooting with a tethered camera—Appendix A

Importing into a New Project

On the right side of the Import browser you'll see the Import Settings pop-up menu. Import settings are applied to all the Browser images you choose to import. For example, the first setting displayed is the Aperture library setting, which identifies a project for your images. You can create a new project or select an existing project.

Aperture uses projects to organize images that you import into the library. Projects are similar to Events in iPhoto in that they can be used to group images from the same photo shoot or Event. A project can contain thousands of images, if necessary. When importing images, your first step is to decide if the images should be organized into an existing project or if you want to create a new project for them. In this exercise, you'll create a new project based on the images taken at the San Diego Zoo.

> **TIP** ▶ As your collection of images grows, you'll organize it using a hierarchy of folders, projects, and albums. You can create as many projects as you need and then name them so that they're easy to identify and access. When you want to further refine your organization, you can subdivide a project with albums.

1 In the Import Settings pane, type *San Diego Zoo* in the Project Name field.

When you installed Aperture, it automatically created a library file in your Pictures folder. The Aperture library is a container in which your images are stored and every project, album, image, and adjustment is tracked.

TIP ▶ You can create as many libraries as you want, although you can view only one library at a time inside Aperture. You can switch between Libraries by choosing File > Switch to Library.

By default, the setting Store Files > In the Aperture Library imports the images by copying them from the card reader to the Aperture library. Allowing Aperture to manage the location and organization of your images inside the Aperture library is the easiest way to maintain and back up your library, although other options are available. You'll learn alternative methods of image management in later lessons.

TIP ▶ You can specify a different location for your Aperture library (such as an external hard disk) by choosing Aperture > Preferences > General. Click Change and indicate where you moved the library file or where you want to create a new library.

Now it's time to import the images.

In the Browser, a checkbox is located next to the name of each photo to help identify which images Aperture will import.

2 At the top of the Import Browser window, you'll see two buttons: Check All and Uncheck All. Click Check All to ensure that all the images are imported.

NOTE ▶ By default, all images in the Import browser are selected and ready for import. Step 2 exists as a safety measure to ensure that you didn't accidentally deselect an image in your frenzy to get started.

3 In the lower right of the Import Browser, click Import Checked.

The San Diego Zoo project is created in the Library inspector. Next to the San Diego Zoo project in the Library inspector, a small circular timer provides a visual indication of the import progress. When importing is complete, Aperture displays a dialog that allows you to eject the memory card, as well as delete or keep the items.

4 Select the Eject No Name checkbox and click Keep Items.

TIP ▶ It's better to erase media cards using the format function on your camera rather than using the delete function in Aperture or any other application. Media cards are formatted for specific camera models, and a camera-specific format will more reliably erase a memory card than a generic erase function in an application.

After finishing the importing process, Aperture creates previews of the imported images. You will learn more about previews in Lesson 3.

Working with Images in the Browser

The Browser is a flexible area in which you'll select and view your images in several ways.

1 In the toolbar, cycle through the available main window layouts by clicking the Browser, Split View, and Viewer buttons. When you're done, click the Browser button to return to the Browser view.

 You can also press V to cycle through the main window views until only your Browser is visible.

2 In the lower right of the Browser, browse the available thumbnail sizes by slowly dragging the Thumbnail Resize slider all the way to the right, then all the way to the left. Choose a size that allows all the images to appear in the Browser.

3 Double-click the hyena image titled **IMG_0731**.

The Viewer appears with the selected image.

4 In the Viewer, double-click the image.

You return to the Browser view.

You can click any image or press the arrow keys to quickly navigate between images.

5 Press the Up, Left, and Right Arrow keys to navigate to **IMG_0650** (the image of the lone flamingo).

NOTE ▸ If you are using a MacBook or MacBook Pro that has a Multi-Touch track-pad, or you're using an Apple Magic Mouse, dragging two fingers up or down will scroll the Browser window.

Sorting Images in the Browser

Browser images are sorted by date from left to right, but you can change the order in the Sorting menu.

1 From the Sorting pop-up menu at the top of the Browser, choose Orientation.

The Browser sorts the images so that all landscape images appear first, followed by portrait images.

The secondary sort is in ascending order. The landscape and portrait images are separated, and then images are sorted by date within those two groups.

NOTE ▸ Browser sorting settings are project specific. You can set a sort order in one project and set a different sort order in another project.

2 Click the List View button.

The list view displays a thumbnail along with image information called *metadata*.

TIP ▶ You can customize the list view columns by choosing View > Metadata Display > Customize. See Lesson 2.

3 Click the Date column heading.

The Browser organizes images by date.

4 Click the Grid View button.

NOTE ▶ The Browser automatically switches to a single-row filmstrip view in Split View or Full Screen view to better fit the layout.

Arranging Images Manually

Images can also be organized using custom, free-form arrangements.

1 Make sure that you can see all the images in the Browser, starting with the running flamingo in the upper left and ending with the camel in the lower right. If you can't, drag the Thumbnail Resize slider to the left until all images are visible.

2 In the Browser, drag **IMG_0063**, the image of the guenon monkey (which will later need color correction), to the upper left of the Browser.

As you drag, you'll notice a thin green insertion line in the empty gray background of the Browser. This line indicates where the image will be placed when you release the mouse button.

3 When the green insertion line is displayed on the far left edge of the Browser, release the mouse button.

The image of the guenon monkey is now the first image in the Browser. The Sort pop-up menu is changed to Manual, and even if you switch to another sort order, you'll be able to return to this Manual sort order at any time. This makes it easy to retain a sort order based on personal criteria that may not be one of Aperture's column headings.

Deleting Images

After you import images, you'll probably start selecting the best images. More often than not, you'll find yourself with hundreds or thousands of images to review. One way to quickly cull your photos during this first pass is to delete unwanted photos, such as those that you took with the lens cap on.

1 Select **IMG_0083** (the running flamingo).

The lens cap was off in this case, but it might just as well have been on. Let's delete this image.

2 Press Command-Delete to delete the image.

Just as in iPhoto, the image isn't actually removed from your Mac's hard drive or even placed in the Mac's Trash. Images deleted in Aperture are placed in the Aperture Trash, a separate holding area for bad photos. Think of it as a safety net. Even after deleting this flamingo photo in Aperture, you could still surrender to its hot pink charm and decide to keep it. Just drag it from the Aperture Trash and place it back into a project.

3 In the Library inspector, select Trash.

Selecting Trash in the Library inspector shows you all the images you have deleted from your projects. Now you'll take the next step in removing these photos from the Aperture library and getting them into the Mac's Trash.

4 Choose Aperture > Empty Aperture Trash.

A dialog appears asking you to confirm your decision.

5 Click Delete with a bit of confidence.

Even at this point, that image is not totally gone. The Mac's Trash now contains the image. Last chance to save it before it is removed from your hard disk. Going once. Going twice!

6 In the Dock, click the Trash icon.

7 Choose Empty Trash.

8 If a dialog appears, click Empty Trash.

The scampering flamingo image is now gone forever.

9 Click anywhere on the Aperture interface to return to Aperture.

10 In the Library inspector, select the San Diego Zoo project.

With the bad flamingo image completely deleted from your hard drive, you're now ready to review the remaining pictures.

Selecting and Rotating Images

Most digital cameras have sensors that determine if they are being held horizontally (landscape) or vertically (portrait). This metadata is placed into the image file so that Aperture can correctly orient the image. But if you've scanned images or you use a camera without

an orientation sensor, the Aperture Rotate tool allows you to easily snap the orientation of an image in 90-degree increments.

1 Select the close-up of the panda in the tree (**IMG_0665**).

2 In the tool strip, click the Rotate button.

The image is rotated 90 degrees counterclockwise.

3 Select the image of the mangabey monkey sleeping in the tree (**IMG_0664**).

4 Command-click the image of the saki monkey (**IMG_0690**).

NOTE ▶ Holding down the Command key allows you to select images that are not adjacent to one another in the Browser.

You use a keyboard shortcut to rotate both monkeys at once.

5 Press the] (Right Bracket) key to rotate the selected images 90 degrees clockwise.

TIP ▶ You can press the [(Left Bracket) key to rotate counterclockwise. If you forget these keyboard shortcuts, pause your mouse over the Rotate button in the tool strip to view the keyboard shortcut help tag.

6 Drag a selection rectangle around the two upside-down hyenas (click in the gray area above the hyena on the left and drag into the gray area below the hyena on the right).

7 Press the Left Bracket key twice to rotate the selected images 180 degrees counterclockwise.

The hyenas are rotated to their more menacing upright positions.

Flagging Images in the Browser

Now you have a project containing images that are worthy of at least a passing glance. Some of them are perfect (ahem), and some of them might need some adjustments to framing, color, tone, or whatever. The point is that you need a way to identify which shots are already acceptable and which need additional work. In a large project, you probably aren't going to be able to do this by memory alone.

A flag is a visual indicator attached to an image that marks the image for further scrutiny. You can use flags to mark images you want to email to your Uncle Gino or images that you plan on using in your portfolio, or in this case you'll use flags to keep track of images that need editing.

1 Make sure that you are still displaying only the Browser. If not, press V to cycle through the main window layouts until you reach the Browser view.

2 In the Browser, position your pointer in the upper right of the guenon monkey's thumbnail image.

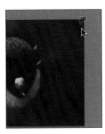

A small, ghosted flag icon appears.

3 Click the flag icon to enable it. You will use this icon to flag images.

Hmmm…let's face it. Most of these images in the Browser need some kind of work. Let's use the keyboard shortcut to flag all of them for future editing.

4 Press Command-A to select all the images in the Browser.

5 Press the / (slash) key to assign a flag to all the images.

On second glance, let's not be so harsh on these pictures. The second and third thumbnail images in the Browser's second row—the mangabey (**IMG_0664**) and the close-up of the panda in the tree (**IMG_0665**)—look pretty good. Let's remove the flags from those images.

6 In the Browser, click the flag icon on the mangabey (**IMG_0664**) and the close-up of the panda in the tree (**IMG_0665**).

You can also drag a selection rectangle around images to apply or remove the flag on selected images.

7 Drag to select the last four images in the Browser: the two images of the hyena ready to pounce (**IMG_0723** and **IMG_0724**), the close-up of the hyena (**IMG_0731**), and the close-up of the camel (**IMG_0738**).

8 Press the / (slash) key to remove the flag from the selected images.

Viewing and Using Metadata

You were able to view some metadata in the Browser's list view, but the Info inspector displays all the image metadata in one location and it's customizable, so you can view what you want when you want. In this exercise, you'll get a brief overview of metadata, which is covered in much greater detail in Lesson 2.

Changing Metadata Views in the Info Inspector

1 Click in the gray area of the Browser to deselect all the images, or press Command-Shift-A.

2 Select the wide shot of the panda in the tree (**IMG_0079**).

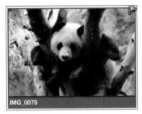

3 Press V so that you can see the Viewer and the Browser in Split View.

4 In the Inspector pane, click the Info tab.

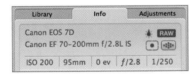

The Info inspector can tell you a lot about the image you are viewing. The top part of the Info inspector looks similar to the LCD on a DSLR camera, so it's conveniently called the Camera Info pane.

5 Position the pointer over the Autofocus Points button.

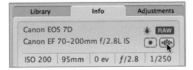

Pausing the pointer over the Autofocus Points button will display an overlay on the image of the AF points from the camera. The bold rectangles are the points used when focusing.

The flag, along with other markings, also can be enabled and disabled in the Info inspector.

Color labels are similar to flags, in that they can be used to identify an image for any reason you choose. Let's color-label a few of the flagged images to indicate how much image editing they will require.

This panda image needs only a bit of work.

6 In the Info inspector, click the Color Label pop-up menu.

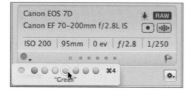

7 Choose green to signify that this image doesn't require a lot of work.

8 In the filmstrip view, drag the scroll bar to the left until you see the meerkat (**IMG_0073**).

9 Click the meerkat image to select it.

10 From the Info inspector's Color Label menu, choose red. We'll use the color red to signify images that are in desperate need of image editing.

11 In the filmstrip view, select the guenon monkey (**IMG_0063**).

12 From the Info inspector's Color Label menu, choose yellow. Only basic image editing is required here. So the color yellow fits that bill.

> **TIP** ▶ Each color label can be accompanied by a text label that details its connotation. For instance, the red color label's text might read "Do ASAP," yellow could have a "Do this week" text label, and green might mean "No Rush." You can enter or edit text labels by choosing Aperture > Preferences and then clicking the Labels tab.

The majority of metadata is displayed in the lower area of the pane. The Metadata View pop-up menu allows you to choose the metadata you want to display.

13 In the Info inspector, click the Metadata View pop-up menu and choose EXIF Info.

> **NOTE** ▶ You'll learn more about EXIF metadata in Lesson 2.

You can search, sift, and sort your images by any of the information shown in the Info inspector and/or by any descriptive information you may enter.

Filtering the Browser

Now that you've flagged some images, you'll filter your Browser to view only those images that need image editing.

1 Press V twice to display only the Browser in the main window layout.

2 In the Browser's search field, click the magnifying glass icon, and from the pop-up menu, choose Flagged.

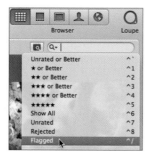

Aperture sifts the Browser to show you only the flagged images.

Entering metadata and filtering your image searches based on that metadata is explored in greater detail in Lesson 2.

Adjusting Images

After you've isolated which images need additional work, you can turn to the Aperture adjustment controls.

The adjustment controls are found primarily in the Adjustments inspector, but a few commonly used adjustments are quickly available in the tool strip.

Understanding Versions and Nondestructive Adjustments

Aperture is designed to protect your master images as soon as they are imported into the library. The original files imported from your camera are never modified or manipulated while you work in Aperture. The moment your images are imported, you begin viewing *versions*, pixel-perfect clones of your master images. Versions are not copies because they are not taking up significant space on your hard drive. Versions are visually indistinguishable clones of your master images, yet they take up a fraction of the disk space. This allows you to make as many versions of a master image as you like without filling your hard drive.

Using versions, you can crop images, modify color, and make tonal adjustments without changing the original image. But more than that, you can add or remove adjustments at any time. The adjustments are never flattened or rendered into your version. They always remain live for your changes.

Keeping all that in mind, you'll make a few image adjustments to an image in this lesson (and a whole lot more in Lessons 6 through 11).

Auto-Correcting White Balance

Different light sources (sunlight, incandescent light bulbs, fluorescent light) have different color temperatures, and images photographed in those temperatures will have a warmer color (more red) or cooler color. Even sunlight has different color temperatures depending on whether it's sunny or cloudy, sunrise or sunset.

Digital cameras have settings for *white balance* to help offset the warmer or cooler colors coming from your lighting situation. But if you are like me, you forget to set it—a single point of failure, human interaction. No worries, you can use the White Balance adjustment in Aperture to correct images that have overly warm or cool color casts.

1 In the Browser, select the guenon monkey image (**IMG_0063**).

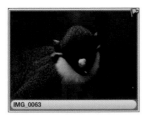

2 Press V to cycle through the main window layouts until you reach Split View.

3 In the Inspector pane, click the Adjustments tab.

The Adjustments tab displays available image adjustments.

4 Click the White Balance eyedropper.

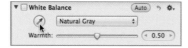

To make it easier to see, a Loupe tool is displayed. The Loupe is designed to magnify a portion of the image. By default, the magnification level is set to 100% (full resolution).

When selecting a white balance reference spot, you are not looking for the brightest white part of the image, as might be your initial inclination. You are not correcting for brightness, you are correcting for color. So, you want to select a spot that should be neutral gray.

TIP ▶ If necessary, you can increase the magnification of the Loupe by choosing a new level in the magnification pop-up menu in its lower-right corner.

5 Position the eyedropper over the white fur under the chin of the guenon.

Notice the RGB numbers displayed inside the Loupe. These numbers represent the level of red, green, and blue color in the area under the eyedropper. In this case, the blue level is higher than the red and green levels, which indicates a preponderance of blue in what should be a neutral gray area. That corresponds to the overall blue color cast in this image. The L value displayed in the Loupe indicates the Luminance value, 98, in this location.

6 Click at this point to sample the off-white pixels.

The white balance of the image is adjusted based on the location you click. In this example, the color temperature is shifted warmer (toward red) to compensate for the heavy blue color cast.

TIP ▶ The ability to adjust white balance within Aperture (or any RAW-capable image-editing application) is one of the benefits of shooting in the RAW format. When working with a JPEG or TIFF image, you can adjust white balance but within a much more limited color range than in a RAW image. Large adjustments on JPEG or TIFF images are likely to produce unpleasant results.

Straightening Images

Although some cameras have orientation sensors, no cameras have level sensors to let you know if your camera is tilted. Actually, some cameras do have a level built into them, but they don't make you stand up straight. So, it's up to you to keep the camera level or correct titled shots in Aperture using the Straighten tool. Unlike the Rotate tool, which is for significant orientation problems, the Straighten tool subtly rotates the image in one-degree or smaller increments.

1 Make sure the guenon monkey image (**IMG_0063**) is still selected.

In this image, the head should be level. There is no obvious horizontal or vertical line in this image that will help guide you, but Aperture can display a grid in the Straighten tool.

2 In the tool strip, click the Straighten tool.

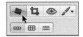

3 Position the tool over the guenon's face.

4 Drag slowly to the left.

The grid appears as the image rotates clockwise. Drag to the right to rotate the image counterclockwise.

You can use the Straighten tool's grid as a guide to align the guenon's pupils to a single horizontal line.

As you straighten the image, Aperture automatically crops the image for you. Although it looks as if it is scaling your image, it's not. It's cropping and filling the rectangular border area to avoid showing the edges of your image as it rotates.

5 Stop dragging and release the Straighten tool when you have aligned the pupils to your satisfaction.

Cropping Images

Aperture has a very flexible Crop tool, and the best thing is that you don't have to crop perfectly the first time. If you choose poorly, just reselect the Crop tool and you once again have access to the entire image for resetting the crop.

1 Select the guenon image (**IMG_0063**) in the Browser, if necessary.

2 Click the Crop tool, or press C.

3 Starting in the upper-left area above the guenon's head, drag to the lower-right corner.

When you select the Crop tool, a small floating window appears, called a *heads-up display*, or HUD. The Crop HUD provides quick access to a few useful tools, including Aspect Ratio.

4 Position the mouse pointer in the center of the crop rectangle.

5 Drag the rectangle to center the guenon's face.

6 Click Apply to crop the image and close the Crop HUD.

You can click the Crop tool again to readjust the crop. The untouched version always sits under your image adjustments so that all adjustments can be enabled and disabled at any time.

7 Click the Crop tool.

The entire image is displayed for your recropping pleasure.

8 In the Crop HUD, select Show Guides to show the rule-of-thirds guides.

The rule of thirds is a theory in the visual arts that suggests you imagine an image divided by a grid of nine equal parts. For a more balanced and interesting composition, important elements in your image should be placed at the four grid intersections or along the grid lines.

9 Position the pointer in the center of the crop rectangle.

10 Drag the rectangle to center the guenon's face so that the eyes are placed along the top horizontal line and the mouth is placed on the bottom horizontal line.

11 Drag the Resize handles on the corners of the crop rectangle to resize the crop if necessary.

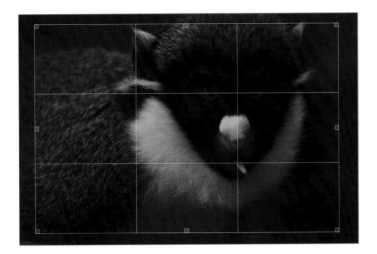

12 Click Apply to close the Crop HUD.

Applying Auto Exposure

The overall image is dark. Because this is the first lesson, you'll address this quickly using the Auto Exposure button; but as a general rule of thumb, using the Auto Exposure button in Aperture is like using the auto-exposure controls on your DSLR. It works well enough on basic images, but you can get better results when you take control. You'll learn more about exposure adjustments in Lesson 6.

1 In the filmstrip view, select the guenon image (**IMG_0063**), if necessary.

2 In the Adjustments pane, in the Exposure area, click Auto.

This is now clearly a better-exposed image and no longer needs to wear the demeaning flag.

3 In the filmstrip view, locate the guenon image and click the flag icon in its upper-right corner.

4 Press the Right Arrow key to select the next image.

You probably noticed that the monkey image disappeared from the filmstrip view. That's because you are still filtering your Browser to show only the flagged images.

5 On the right side of the tool strip, click the Reset button (the X to the right of the search field).

Now all the images are once again displayed in the Browser.

Rating and Rejecting Images

When you work with images in Aperture, you're constantly evaluating the quality of those images. Based on your evaluations, you can rate each image's quality higher or lower. Ratings in Aperture allow you to tag individual images according to the value you place on them, from poor value (one star) to high value (five stars). You can also leave images unrated, or assign a Reject rating for a total of seven ratings.

Because you know that the flagged images still need work, you'll filter the Browser again using the Filter HUD to show only the unflagged images.

1 Press V twice to set the Main Viewer layout to show only the Browser.

2 In the Browser, click the Filter HUD button, or press Command-F.

3 Select the Flagged checkbox.

4 From the pop-up menu, choose No.

5 Close the Filter HUD.

Now you are looking at only those images that do not need obvious image adjustments. Let's use the Aperture rating system to set their relative values. To do that, you'll want to use the Split View layout.

6 Press V to set the Main Viewer layout to Split View.

7 In the Browser's filmstrip view, select the guenon image (**IMG_0063**).

8 Press 4 to apply a four-star rating.

9 Press the Right Arrow key to move to the next image.

10 Press 5 to apply a five-star rating.

11 Press the Right Arrow key to move to the next image.

12 Press 3 to apply a three-star rating.

Go through the next four images, and use your own judgment to apply a rating from 1 to 5 by pressing 1, 2, 3, 4, or 5. Don't rate the last image. We'll do that together.

OK, you must be at the last image in the Browser, the camel. This is a special case. Not good enough to rate even a 1, but not an image that you should be willing to trash just yet. Luckily for just such cases, you have that Reject rating.

13 With the camel image selected, press the 9 key on the keyboard.

The Reject rating is applied as a small X in the lower-left corner of the image. The image will be filtered from view in the Browser as soon as you select another image. The rating doesn't place the image in the Trash, though; it's just a low rank, the lowest possible rank. It's sort of like a demerit in school. You aren't getting kicked out, but you are on your way.

TIP ▶ If you rate an image incorrectly or want to change a rating, select the image and give it the new rating. You can also remove a rating from an image by selecting it and pressing 0.

Sharing Your Photos with Email

Once you've selected and edited photos, you'll probably want to share them with a client, family, or friends. Aperture has a number of ways to share images, but in this introductory lesson you'll cover only a few of the most common ways.

Configuring Email Preferences

Email is still the most common way people share photos. Fortunately, Aperture offers a simple and straightforward way to email images. Although uncompressed images can

be large and difficult to deliver via email, Aperture offers three export presets to create optimized JPEG files that are easy to send. You can also create custom email presets as needed.

When properly set up, Aperture can directly transfer images to your email application. By default, Aperture will use Apple Mail, but you can change this and many other properties in Aperture preferences.

To specify an email export preset for Aperture to use:

1 Choose Aperture > Preferences, or press Command-, (comma).

2 Click Export to view Export preferences.

3 From the "Email Using" pop-up menu, choose an email application. For this exercise, choose Mail.

Aperture allows you to select a preset format for the emailed image, but you can also create your own.

4 From the "Email Photo Export preset" menu, choose Edit.

5 In the Preset Name column, select Email Medium - JPEG.

6 From the Size To pop-up menu, choose Percent of Original.

7 In the Size To field, type *25*.

Aperture allows you to specify a watermark to protect files that you post online or send via email.

NOTE ▶ You can create your own watermark using graphics software. Just be sure to save your watermark as a PSD (Photoshop) or TIFF format file with a transparent background.

8 Select the Show Watermark checkbox, and then click Choose Image.

9 Navigate to the **Watermark.psd** file in the Lesson 01 folder.

10 Select the image and click Choose.

The preset is now complete and can be saved.

11 Click OK to set the Email Export presets.

12 Close the Preferences window.

Sending Images with Email

When your email preferences are configured, sending photos is very easy. In fact, the whole process takes only a few moments.

1 In the Browser filmstrip, select the guenon monkey image (**IMG_0063**).

> **TIP** ▶ You can Command-click to select multiple images at once.

2 Press the Share button and choose Email.

Aperture begins to process the images. The watermarking process takes a little time but is a good idea for security. You can check the progress of the export by choosing Window > Show Activity.

The watermarked image is exported directly to your email application.

> **NOTE** ▶ Before you attempt to email an image, find out the maximum file size your email application supports. You may also want to confirm with the client that he or she wants to receive email attachments. You can always break up a large job into multiple messages by selecting only part of the project.

3 In Mail, address the email and click Send.

TIP ▶ You must have Mail configured on your Mac. If you do, Mail will launch and the image will be embedded at the export preset size. Using the Image Size menu in the lower right of your Mail message, you can customize the size of the image for better email performance.

Sharing Photos with Facebook, Flickr, and Photo Stream

Posting to web-based social networks and photo gallery sites is another common way to share photos. The Share button in the toolbar makes it easy to share your selected photos to popular photo-sharing websites like Facebook and Flickr. You'll learn more about sharing with these sites in Lesson 12.

Aperture also works with Photo Stream, Apple's iCloud service that uploads and stores your last 30 days of photos and automatically pushes them to your iOS devices and computers. Once you enable Photo Stream, you can view your recent photos on all your devices without syncing. You'll learn more about Photo Stream in Lesson 12.

Lesson Review

1. What is the function of the Aperture library?

2. Identify the three main window layouts, along with the keyboard shortcut used to cycle through these layouts.

3. How can you completely remove an image from the Aperture library and the Mac's hard drive?

4. How do you enable and disable a flag attached to an image?

5. What happens when you choose ***** from the pop-up menu in the Aperture Search field?

6. Where will you find the Aperture adjustment controls?

Answers

1. The Aperture library is a container where your images are stored and every project, album, image, and adjustment is tracked. The Library inspector displays your organizational hierarchy. It can contain projects, albums, folders, books, web galleries, and web journals.

2. The Browser, Viewer, and Split View are the three main window layouts. The V key can be used to cycle through the three views.

3. To completely remove an image from the Aperture library and Mac hard drive, you must press Command-Delete in Aperture and then choose Empty Trash from the Aperture menu. You must then empty the Mac's Trash.

4. To enable or disable a flag attached to an image, click in the upper-right corner of the image's thumbnail.

5. Aperture sifts the Browser to show you only the images in your library that you've given five-star ratings.

6. The adjustment controls are found in the Adjustments inspector and the Adjustments pane of the Inspector HUD.

2

Lesson Files	APTS Aperture book files > Lessons > Lesson 02
Time	This lesson takes approximately 75 minutes to complete.
Goals	Import images from the Finder
	Rename both versions and original file names
	Adjust time zone during importing
	Add IPTC metadata
	Define and organize keywords
	Perform batch changes on metadata
	Modify metadata views
	Auto-fill metadata fields using metadata presets
	Create albums and Smart Albums

Lesson **2**

Adding and Managing Metadata

Placing all your photos in a single library isn't much of a benefit if you can't find the photos you want when you want them. Many digital SLR cameras record technical information when taking a picture—such as the current date, ISO setting, and shutter speed—and embed that data in the photo. Aperture can use that information, called *EXIF* (Exchangeable Image File), to sift, sort, and search your library.

You can also add custom information at any time that can help locate one or more images based on descriptive criteria. Both the EXIF and the custom descriptive information (IPTC CORE) are known as *metadata*.

In this lesson, you'll add metadata to your photos using a variety of methods. You'll begin by selectively importing images and using the import settings to add and change metadata. You'll explore multiple ways to view and add metadata to images in your library. Finally, you'll better organize your images by using metadata to filter project images into Smart Albums.

Importing files from the Finder

Although most of the time you will import from a memory card, you can import images from a variety of sources. In this exercise, you will import a folder of images from your hard disk.

1 In the toolbar, click the Import button.

The Import browser appears.

NOTE ▶ In Lesson 1 you had no need to click the Import button because when the card reader mounted, Aperture opened automatically along with the Import browser.

2 At the bottom of the window, navigate to APTS Aperture book files > Lessons > Lesson 02 > **Day 01**.

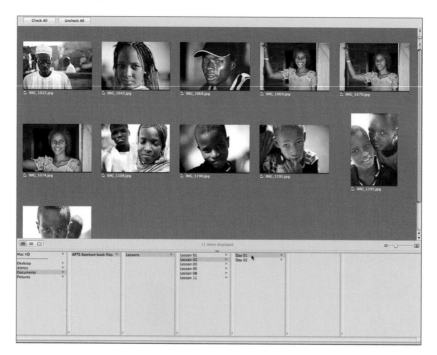

3 Drag the Thumbnail Resize slider until the images are visible in the window.

> **TIP** ▶ You can drag down the border between the navigation area and thumbnails to create more space for the thumbnails.

4 In the Import Settings, leave Destination set to New Project.

5 In the Project Name field, type *People of NW Africa*.

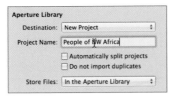

As in Lesson 1, Aperture will manage your files in the Aperture library. Now you're ready to add some metadata and customize the image names during importing.

Customizing Import Settings

You can add and modify metadata at any time, but you can save time by performing some operations during the import process. Applying metadata and renaming files while importing images saves you from the monumental task of later reorganizing your entire library.

In Lesson 1, you imported images from a simulated card reader. In this lesson, you'll import a folder of images from the Finder and apply import settings to add metadata and change the name and timestamps of your images.

Showing File Info on Import

Before you begin changing any metadata, you should examine some of the information you have on the files.

1 From the Import Settings pop-up menu, choose File Info.

2 Select the first image in the Browser.

The file info shows the fundamental file metadata for a selected image. When import settings modify this file information, file info will appear in red.

Renaming Images

Aperture offers a lot of flexibility when naming and renaming your images. In Lesson 1, Aperture simply used the original file names as the version names. But the names that original images are given by the camera are usually meaningless, so Aperture helps you apply a more useful name to the versions. You can also use Aperture to change a photo's original file name on your hard disk to match the new version name of your choice.

In this exercise, you'll create new version names and modify the original file names to match. You could do this the easy way by choosing one of the many renaming templates in Aperture, but that's not much of a lesson, is it? So, let's create a new preset that defines exactly how the images are renamed.

1 From the Import Settings pop-up menu, choose Rename Files.

Clicking the Version Name menu will display all the presets for renaming your files, but in this lesson we'll create our own preset.

2 From the Version Name pop-up menu, choose Edit.

3 In the Naming Presets dialog, click the Add (+) button to create a new preset based on the "Custom Name with Index" preset.

4 To name the preset, type *Custom Name Date and Time*, and then press Return.

5 In the Format field, click to the right of the Index Number element, and press Delete to clear it from the Format field.

6 Drag the Image Date element into the Format field and place it to the right of the Custom Name element. Press the Right Arrow key, then press the Spacebar to add a space.

7 Type *at*, and then press the Spacebar again.

8 Drag the Image Time element to the right of the word *at* to match the following figure:

In the Example field, you'll see a preview of the formatting results.

Leave the Custom Name field empty. Doing so will allow you to enter a name whenever you utilize this preset.

9 Click OK to save the custom preset.

The newly created preset is automatically active and displayed next to Version Name in the Import Settings pane.

10 In the Name Text field, type *Senegal*.

11 Click the Rename Original File checkbox.

This preset will create a version name that includes the custom name you entered followed by the image date and time. It will also change the name of the original file in the Finder. Next, you'll enter additional metadata to complete the import process.

Adjusting Time Zones

Most photographers set the time zone on their cameras to their home time zones. But what happens when you travel outside your time zone? Should you change your camera's time? That's probably not a good idea because you could later forget to change it back. And what do you when moving through multiple different time zones? Changing camera time on location can get too confusing. Instead, using Aperture, you can shift the time zone to accurately reflect when an image was shot.

1 From the Import Settings pop-up menu, choose Time Zone.

Aperture sets the Camera Time to your local time zone by default; but this photographer lived in Los Angeles, so you'll set the Camera Time to America/Los Angeles.

Because the images you are importing were shot in Senegal, you can use the capital of Senegal as the time zone.

2 From the Camera Time pop-up menu, choose America > Los Angeles. From the Actual Time Zone pop-up menu, choose Africa > Dakar.

Adding Descriptive Metadata

So far, you've dealt only with the relatively technical EXIF metadata. Now it's time to add your own descriptive metadata, called *IPTC metadata*. IPTC stands for International Press Telecommunications Council. Did that help explain it? No, I didn't think so.

IPTC is group of major news agencies that defined a standard set of descriptive metadata that can be applied to images. The IPTC Core specification includes many metadata entries, and, more than likely, you won't need or want to use them all. Although Aperture supports the complete set of IPTC Core fields, it also provides metadata presets that help you get to your most-used fields without scrolling through a long field list. Let's create our own metadata preset that will greatly reduce the number of fields we have to look through when entering information.

1 Choose Import Settings > Metadata Presets.

2 From the Metadata pop-up menu, choose Edit.

3 In the Metadata pane, from the Metadata Action pop-up menu (gear icon), choose New Preset.

This new preset will include only copyright information and keywords that you add to your images, so let's name it accordingly.

4 In the Preset Name field, type *Keywords and Copyright*, and press Return.

5 In the IPTC Content controls, select the Keywords checkbox to add this field to our preset.

6 In the IPTC Status controls, select the Copyright checkbox to add this field to our preset.

7 Click OK.

TIP ▶ IPTC Core is a standard set of data fields, which can be exported from Aperture as a sidecar XML file or embedded in images. Any application that reads IPTC metadata can read the information applied to your images. By default, IPTC is only embedded when you export. To embed IPTC metadata into originals, you must choose Metadata > Write IPTC Metadata to Original.

8 In the Metadata Presets Keywords field, type *Africa*.

Keywords are descriptive words that you add to make it easier to find similar images. The keywords entered in the import settings are applied to all the images you import. You'll add more keywords later, but a keyword of *Africa* seems to be an appropriate starting point for all of the images in this lesson.

9 In the Copyright Notice field, press Option-G to insert the Copyright symbol. Then type the photographer's name, *Don Holtz.*

10 To begin importing images using these import settings, click Import Checked.

11 When the import process is complete, click OK in the dialog that appears.

Importing Images into Projects

In this exercise, you want to add images from a Day 02 shoot to your People of NW Africa project. Those Day 02 images need similar but not identical import settings, and you want to be a bit more selective about which images are imported.

1 In the toolbar, click Import to display the Import browser.

Aperture retains the Import Settings fields from the previous import session. In our case, it's a great thing; all we have to do is add some information. In the future, when you are working on another project, look at the Import Settings to make sure they are correct for your new import.

2 Navigate to APTS Aperture book files > Lessons > Lesson 02 > **Day 02**.

3 In the Import Settings dialog, choose Destination > People of NW Africa.

4 Because the Day 02 images were shot in Mauritania, in the Rename Files controls, change the Name Text field to *Mauritania*.

5 In the Time Zone controls, verify that the Actual Time pop-up menu is still set to Africa/Dakar, which is in the same time zone as Mauritania.

6 In the Metadata Presets controls, in the Keywords field, type *A* (for Africa). Aperture fills in the rest of the word. Then press Tab to move to the next field.

7 In the Copyright field, press Option-G to insert a copyright symbol. The photographer's name, *Don Holtz*, fills in automatically. Press Tab.

Until now, you've imported all of the displayed images into the Import browser. Now you are going to deselect a few browser images that you do not want to import.

8 Drag down the scroll bar until you can see the last four images of the young boys holding instant photos.

9 Deselect the checkboxes next to these last four images (**IMG_060258.jpg, IMG_060260. jpg, IMG_060278.jpg,** and **IMG_060280.jpg**).

10 Click Import Checked to start importing only the selected images.

11 When the import process is complete, click OK in the dialog that appears.

Displaying Metadata in the Browser and Viewer

You can use many methods for viewing metadata in Aperture. By default, Aperture will display some metadata with images in the Viewer and Browser. You can change the metadata that is displayed to only that information you choose. You can quickly turn on and off the metadata views that are displayed in the Viewer and the Browser. When the metadata views are turned on, you can also toggle between a basic and an expanded option.

1 In the Library tab in the Inspector pane, verify that the People of NW Africa project is selected.

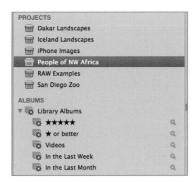

2　You should see both the Browser and Viewer in the Split View layout. If necessary, cycle through your views by pressing V until you see the Split View.

3　In the Browser, select the first image, **Senegal 2006-11-03 at 06-53-44**.

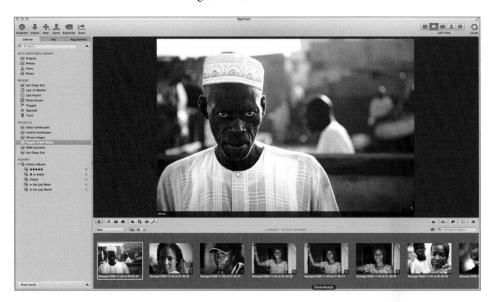

When a keyword has been applied to an image, a badge icon is displayed in the lower-right corner of the image and its thumbnail.

4　Press Y to turn off metadata in the Viewer.

The keyword and badge disappear from the Viewer image.

TIP▸ You can also turn on and off metadata for the Viewer by choosing View > Metadata Display > (Viewer) Show Metadata.

5　Press U to turn off metadata in the Browser.

9 Deselect the checkboxes next to these last four images (**IMG_060258.jpg, IMG_060260. jpg, IMG_060278.jpg,** and **IMG_060280.jpg**).

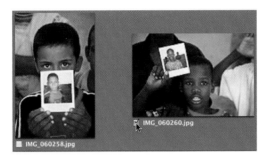

10 Click Import Checked to start importing only the selected images.

11 When the import process is complete, click OK in the dialog that appears.

Displaying Metadata in the Browser and Viewer

You can use many methods for viewing metadata in Aperture. By default, Aperture will display some metadata with images in the Viewer and Browser. You can change the metadata that is displayed to only that information you choose. You can quickly turn on and off the metadata views that are displayed in the Viewer and the Browser. When the metadata views are turned on, you can also toggle between a basic and an expanded option.

1 In the Library tab in the Inspector pane, verify that the People of NW Africa project is selected.

2 You should see both the Browser and Viewer in the Split View layout. If necessary, cycle through your views by pressing V until you see the Split View.

3 In the Browser, select the first image, **Senegal 2006-11-03 at 06-53-44**.

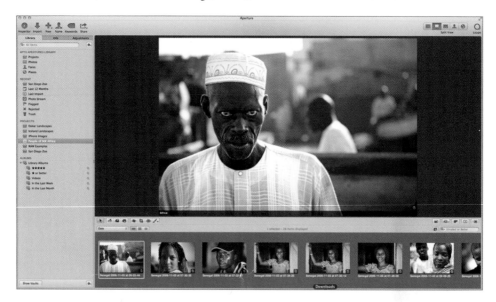

When a keyword has been applied to an image, a badge icon is displayed in the lower-right corner of the image and its thumbnail.

4 Press Y to turn off metadata in the Viewer.

The keyword and badge disappear from the Viewer image.

TIP You can also turn on and off metadata for the Viewer by choosing View > Metadata Display > (Viewer) Show Metadata.

5 Press U to turn off metadata in the Browser.

Metadata views are handled separately for the Browser and the Viewer.

TIP You can also choose to turn on and off metadata for the Browser by choosing View > Metadata Display > (Browser) Show Metadata. The metadata view will also apply when working in the Browser's Full Screen or filmstrip view.

6 Press Y and then press U to turn on the metadata view in both the Browser and the Viewer.

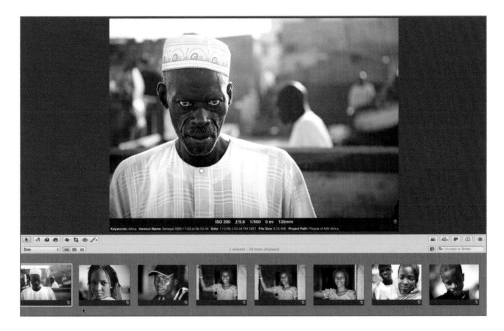

7 Press Shift-Y to display an expanded set of metadata information in the Viewer.

8 Press Shift-U to display an expanded set of metadata in the Browser.

This view isn't as impressive because you haven't added any ratings or other metadata, which would be displayed in this Browser's expanded metadata view. Let's create a customized metadata view.

9 Choose View > Metadata Display > Customize, or press Command-J.

The Browser & Viewer Metadata dialog appears. It displays two sets of views for the Viewer, the Browser's grid view, and the Browser's list view, as well as a view for the metadata help tags. Let's work with the Viewer options.

10 Choose View > Basic View.

11 In the Metadata Fields column, click the Aperture disclosure triangle and select the Version Name checkbox.

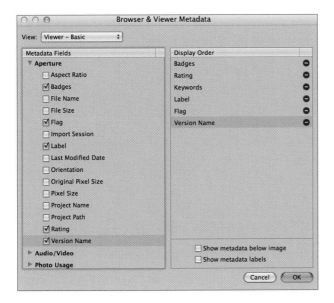

12 Click OK.

The version name now appears in the Viewer metadata.

13 Press Shift-U and then press Shift-Y to return to the original default views.

The metadata display options are a quick, heads-up way to see detailed information on a version. There's one additional method of displaying metadata for images in the Browser and Viewer: the image help tag.

14 Position your pointer over the image in the Main Viewer and press Control-T.

Metadata Tooltips appear. The Metadata Tooltips disappear after 30 seconds if the pointer is not moved.

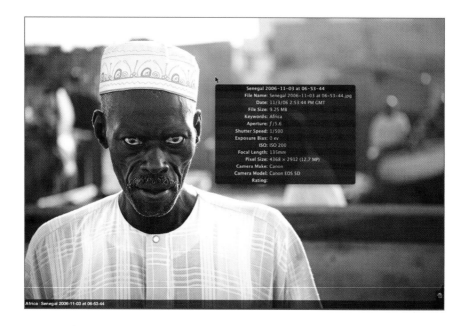

15 In the Browser, position the pointer over the second thumbnail.

The Metadata Tooltips update to display information specific to this image.

16 Press T to hide the Metadata Tooltips.

> **NOTE** ▶ Metadata Tooltips can be used to view image information in any area of Aperture. The tooltip information can be modified in the Browser & Viewer Metadata dialog, just as you modified the Viewer metadata.

Using Keywords

During import, you added a keyword to all of the images at once. That was an easy way to assign some keyword metadata to the images without typing the data for each image. But not all of your images will need the same metadata. So, different images will require specific keywords to have more refined search information.

Assigning Keywords Using the Info Inspector

The easiest way to add one keyword to one image is to type it into the Keyword field of the Info inspector.

1 If necessary, press V until you see the Split View layout showing both the Browser and Viewer.

2 Press W to cycle through the Inspector Tabs until the Info tab is active.

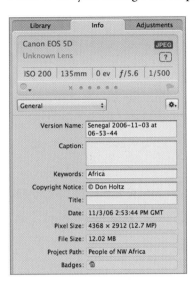

3 In the filmstrip view, select the fourth image: **Senegal 2006-11-03 at 07-34-25**.

4 In the Info tab, make sure that the pop-up menu is set to General. Then in the Keywords field, click to place the pointer after *Africa*. Type a comma, and then press the Spacebar.

 NOTE ▶ Keywords are always separated by a comma.

5 Type *smile*, and then press Tab.

Version Name:	Senegal 2006-11-03 at 07-34-25
Caption:	
Keywords:	Africa, smile
Copyright Notice:	©Don Holtz

NOTE ▶ The Info tab is specific to a single image. Additions made to the metadata in the tab affect only the selected image. Later in this lesson, you'll learn how to apply keywords to multiple images..

Defining Keywords in the Keywords HUD

When applying keywords to a project, your first step is to determine which words to use. The goal is to add keyword tags that will let you perform useful searches, both inside the project and within your entire Aperture library. So you need to think about how you might want to search.

Let's assume the library will grow with the addition of many other projects and images from other shoots. You might want to search your entire library for specific People of NW Africa images.

In this project, you have images of men, women, and children. You also have close-ups and group shots. You can apply these keywords to help differentiate between shots.

Luckily, you don't have to type every keyword that you want to add to an image. Aperture comes with a Keywords HUD (heads-up display) that contains well over 100 keywords to describe photographs. The keywords are organized into hierarchies, which makes it easier to find groups of words that go together. You can also add keywords that are specific to your images and apply as many keywords to an image as you like.

Dragging Keywords

One way to assign keywords is to drag them directly from the Keywords HUD to one or more images.

1 To open the Keywords HUD, choose Window > Show Keywords HUD.

The Keywords HUD contains a number of predefined keywords organized by category, such as *Wedding*. You should also see the *Africa* and *smile* keywords that you added earlier.

TIP ▶ If you don't want to use all the predefined keywords provided by Aperture, you can delete them. For example, if you never shoot weddings, you can delete the Wedding category by selecting it and then clicking the Remove Keyword button at the bottom of the HUD.

2 Select the first image in the Browser, **Senegal 2006-11-03 at 06-53-44**.

You already added the keyword *Africa* to all of the images using the Import Settings dialog. You'll now add another keyword to all the images using the Keywords HUD.

3 In the Keywords HUD search field, type *Portrait*.

You could also navigate through the disclosure triangles to find the keyword you are looking for, but using the search field is much faster when you want a specific word.

4 From the Image Type category in the HUD, drag the keyword *Portrait* onto the image in the Viewer.

The selected image now has the keyword *Portrait*.

NOTE ▶ The same keyword can exist in multiple groups as an organizational convenience.

5 Click the Browser button, or press V repeatedly to cycle through the layouts and display the Browser.

6 Select the second image in the library to make the Browser active.

7 Press Command-A to select all the images.

NOTE ▶ If you skip step 6, you will be selecting everything in the Keywords HUD, not all the images in the Browser.

Let's add the keyword *Portrait* to all the remaining images.

8 Drag the *Portrait* keyword from the Keywords HUD onto any image in the Browser.

In the Info inspector, you can see that the keyword was added to the selected image.

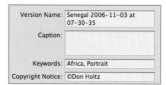

NOTE ▶ Dragging the same keyword onto an image twice, as you just did with the first image in the Browser, will not apply that keyword twice.

9 In the Keywords HUD, click the Reset button at the right side of the search field to clear the search.

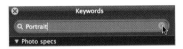

The Keywords HUD makes it easy to view all the keywords you have added, along with all the keywords that Aperture provides. After a few projects, the HUD can become a long list of words without any organization. So it's a good idea to figure out how to organize the HUD before you add more keywords.

Working with Groups in the Keywords HUD

You can group keywords into a customized hierarchy using the Keywords HUD. Notice that the *Africa* keyword doesn't have a disclosure triangle. This is because it doesn't have any subordinate keywords attached. In this exercise, you'll add a subordinate keyword to *Africa* and then organize both *Africa* and its subordinate keyword as subordinates to an existing keyword.

1 With the *Africa* keyword selected, click the Add Subordinate Keyword button at the bottom of the Keywords HUD.

Africa becomes a keyword group, with one subordinate keyword, *Untitled*.

NOTE ▶ Clicking the Add Keyword button adds a keyword at the same level as the currently selected keyword; clicking the Add Subordinate Keyword button adds a new keyword as a child of the currently selected keyword.

2 Rename the *Untitled* keyword by typing *West Africa,* to specify a region of the continent.

3 Press Tab, and then click the disclosure triangle next to Africa to collapse the group into a nice, neat line item.

4 Scroll down and click the disclosure triangle next to "Stock categories."

5 Drag the Africa category down over the Travel sub-category of Stock categories until it highlights the word *Travel*. Be warned: It scrolls quickly as you drag near the bottom of the HUD.

6 Release the keyword to place the Africa category into Travel.

7 In the warning dialog that appears, click Merge Keywords.

Africa and West Africa are now included as a group under Travel.

NOTE ▶ The warning indicates that some versions have this keyword applied. After you move the keyword, it is still applied to the same number of versions.

8 Close the HUD.

NOTE ▶ It's important to understand that the hierarchical structure shown in the Keywords HUD is for organizational purposes only. Keywords don't actually have a hierarchical relationship. If you add a subordinate keyword, its parents are not added automatically.

You'll now add the new *West Africa* keyword to all the images by using the Batch Change command.

Batch Changing Metadata

The *West Africa* keyword belongs on all the images because all the people in these photos are from the western region of Africa. If you miss an opportunity to add a keyword during import and dragging the keywords seems like too much work, you can use another method to add keywords to all the images in a project. Batch Change is a useful command because it allows you to add *or replace* metadata on selected images.

1 In the Browser, press Command-A to select all the images.

2 Choose Metadata > Batch Change, or press Command-Shift-B.

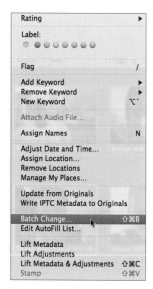

3 In the Keywords field, type *West Africa* and select the checkbox.

4 Make sure that Append is selected so that the keywords currently applied to your images are retained and the keywords typed in the Batch Change pane are added.

TIP ▶ If you wanted to replace all the keywords that are currently applied to your images, you would select Replace. But be aware that selecting the Copyright Notice checkbox would cause the empty Copyright Notice field to replace your existing Copyright field.

5 Click OK.

In the Keywords field in the Info inspector, you'll see that after the keyword portrait, Aperture places a comma and a space, and then appends the new keyword.

Using Keyword Buttons

If you want to add a keyword to a few images, dragging from the Keywords HUD is easy enough. But if you're working with a large number of images and they all require different combinations of keywords, you'll probably find it easier to use the Aperture keyword controls.

1 Press Command-Shift-A to deselect all the images in the Browser.

2 Press V to cycle to the Split View layout.

3 Select the first image in the filmstrip view.

4 Choose Window > Show Keyword Controls, or press Shift-D.

Minimize	⌘M
Zoom	
Show Inspector HUD	H
Show Keywords HUD	⇧H
Show Lift & Stamp HUD	
Show Project Info	⇧I
Hide Inspector	I
Show Vaults	⇧R
Hide Control Bar	D
Show Keyword Controls	⇧D
Show Activity	⇧⌘0
✓ Aperture	

The control bar will display special keyword buttons and controls.

You can use the keyword buttons to assign keywords with a single click or keyboard shortcut. However, the Aperture keyword buttons are initially configured with a set of default keywords, and not necessarily the ones you need. So let's create a custom keyword set.

NOTE ▶ You can edit the Keyword buttons regardless of which images are open in the Browser or the layout you're using.

5 In the control bar, from the Select Preset Group pop-up menu, choose Edit Buttons.

The Edit Button Sets dialog allows you to create groups, or sets, of keyword buttons. You can define as many keyword groups as you want and freely switch among them to perform various keyword functions.

The Photo Descriptors button set in the left column comes up selected. The contents of this set—the keyword buttons it contains—appear in the middle column. The right column shows all of your currently defined keywords (your keywords library).

6 Click the Add (+) button to create a new keyword button preset group.

7 Name the new keyword preset group *Portraits*, and press Return. The Contents column will be empty because the new preset group doesn't yet have any keywords in it.

> **TIP** Keeping group names short will make them easier to view in the control bar's Select Preset Group pop-up menu.

To add keywords to the preset group, drag them from the Keywords Library column to the Contents column.

8 In the Keywords Library column, click the disclosure triangle next to Stock categories.

9 Scroll down and click the disclosure triangle next to People.

10 Command-click Children, Man, and Woman to select them.

NOTE ▶ You can edit your keywords library using the buttons at the bottom of the right column in the Edit Button Sets dialog. All four buttons—Lock/Unlock Keyword, Add Keyword, Add Subordinate Keyword, and Remove Keyword—work just like the equivalent buttons in the Keywords HUD.

11 Drag all three keywords to the Contents column.

TIP ▶ You can rearrange the order of keywords in the Contents pane by dragging them up and down. You can delete a keyword by selecting it and then clicking the Remove Selected Keywords button.

12 Scroll the Keywords Library column to locate Photo Specs, then click the disclosure triangle next to it to reveal its contents.

13 Under Image Type, Command-click Close-up and Group to select them.

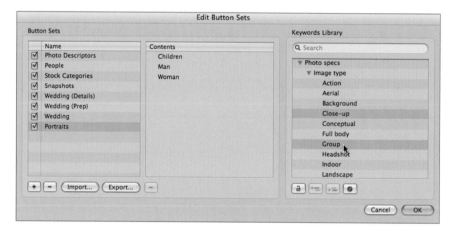

14 Drag both keywords to the Contents column.

15 Click OK.

NOTE ▶ You can use the same keyword in as many groups as you'd like. It can be convenient to have specific keywords in multiple sets.

Now that you've created the keyword buttons, let's use them to apply more keywords.

Applying Keywords Using Buttons

The keyword buttons in the control bar are unchanged—the control bar still shows the Photo Descriptors keywords. You must select your new button set in order to use it.

1 From the Select Preset Group pop-up menu, choose Portraits. The Portraits keyword buttons now appear in the control bar.

2 Select the first image in the Browser, **Senegal 2006-11-03 at 06-53-44**.

> **TIP** ▶ If you can't see the version name in the Browser, it is listed at the top of the Info inspector when the default General View is selected.

3 In the control bar, click the Man button to apply the keyword to the selected image.

Man should appear in the Keyword field and in the Viewer metadata area.

4 Click the Close-up button to assign the keyword *Close-up* to the image.

5 Press the Right Arrow key to move to the next image in the Browser.

6 In the control bar, click the Woman button to apply the keyword to the selected image.

7 Click the Close-up button to assign the keyword to the image.

8 Press the Right Arrow key to move to the next image in the Browser.

9 In the control bar, click the Man and Close-up buttons.

10 Press the Right Arrow key to move to the next image in the Browser.

11 Press Shift–Right Arrow twice to select all three shots of the woman.

12 In the control bar, click the Woman and Close-up buttons.

All three images of the woman in the doorway receive those keywords.

TIP If you would like to add keywords in other preset groups, press period (.) to switch to the next preset group.

Applying Keywords Using Keyboard Shortcuts

Now let's try another method of assigning keywords: using keyboard shortcuts. Not using the mouse should greatly speed the keyword addition process.

1 With three images still selected from the previous exercise, press Right Arrow to move to the next image: **Senegal 2006-11-03 at 09-59-29**, the woman with the light blue head scarf.

2 Position the pointer over the Woman button on the control bar.

A dialog appears that displays the keyboard shortcuts for the button. Pressing Option-3 will add the *Woman* keyword, and pressing Shift-Option-3 will remove the *Woman* keyword.

3 Press Option-3 to assign the keyword *Woman*.

The keyboard shortcuts are assigned in order from the top button to the bottom button and then left to right:

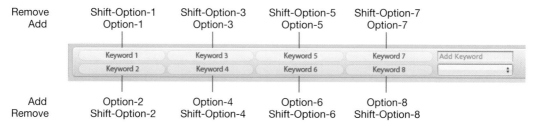

Up to eight keyboard shortcuts can be assigned.

4 Press Option-4 to assign the keyword *Close-up*.

> **NOTE** ▶ If you're using a keyboard with an extended numeric keypad, the keypad won't work for the keyword control shortcuts. Instead, use the number keys on your main keyboard.

5 Press the Right Arrow to select **Senegal 2006-11-03 at 15-40-52**, and then press Shift–Right Arrow to select the adjacent three images of the boys.

6 Assign the *Children* keyword by pressing Option-1.

7 Assign the *Close-up* keyword by pressing Option-4.

8 Press period (.) twice to switch the preset group to People, and then press Option-5 to apply the keyword *Boy*.

9 Press comma (,) twice to switch to your Portraits group.

NOTE ▶ Although the control bar is open in this exercise, keyword keyboard short-cuts will work even if the control bar is closed.

10 Practice using the keyboard shortcuts to move through the remaining images, apply-ing the following keywords:

Mauritania 2006-11-06 at 07-42-27: *Woman, Close-up.*

Next three Mauritania Images: *Woman, Group.*

Mauritania 2006-11-06 at 07-49-03: *Woman, Close-up.*

Mauritania 2006-11-06 at 07-50-31: *Woman, Close-up.*

Next five Mauritania Images: *Children, Group.*

Next three Mauritania Images: *Woman, Close-up.*

Next two Mauritania Images: *Woman, Group.*

Mauritania 2006-11-06 at 15-48-14: *Woman, Close-up.*

Keywords are fundamental to organizing and finding images quickly, and using keyword shortcuts is probably the quickest way to assign a number of keywords to multiple images.

Applying Keywords Using the Lift & Stamp Tools

You've probably noticed that many of your images need the same keywords. After you've gone to the trouble of assigning keywords to one image, you can easily copy those keywords to other images using the Lift & Stamp tools. The Lift tool copies metadata and adjustments from one image, and applies, or stamps, them to other images.

1 Press V to cycle to the Browser view. If necessary, drag the Browser Thumbnail Resize slider to display all the images.

2 Select the fourth image, **Senegal 2006-11-03 at 07-34-25**.

This is the first image of the woman smiling in the doorway. Earlier in this lesson, you applied the keyword *Smile* to this image using the Info inspector. Now you'll apply the *Smile* keyword from this image to other images using the Lift & Stamp tools.

3 In the lower left of the Browser, click the Lift button, or press Command-Shift-C.

The Lift & Stamp HUD appears with metadata lifted from the selected image. A checkbox appears next to each item. You can deselect a checkbox if you don't want to stamp that information onto another image.

4 Deselect the IPTC checkbox. This contains your copyright metadata, which you do not want to stamp onto the other images.

5 In the Lift & Stamp HUD, click the disclosure triangle next to Keywords to display the lifted keywords.

In this case, you want to stamp only the *Smile* keyword onto the other images.

6 Select the line item Close-up, and press Delete to omit it from the listing.

7 Similarly, delete Portrait and Woman, leaving only the keywords *Africa*, *Smile*, and-
West Africa.

> **NOTE** ▶ The keywords Africa and West Africa are already applied to all the images in
> this project. Stamping those keywords will not add them again. Stamp adds only new
> keywords; it does not replace keywords or duplicate existing ones.

8 Select the next image of the woman in the doorway, **Senegal 2006-11-03 at 07-35-14**.

9 In the Lift & Stamp HUD, click the Stamp Selected Images button, or in the tool strip,
click the Stamp button.

The *Smile* keyword is stamped into the keyword field in the Info inspector.

10 Select **Senegal 2006-11-03 at 07-36-09**, the third image of the woman in the doorway.

11 Press the Command key and click any remaining images in the Browser in which someone is smiling.

If you don't count images with smiling children that are too far away to see, you'll probably select four images. However, it's not critical that you find *all* the images, as long as you find a few.

12 Click Stamp Selected Images, or press Command-Shift-V, to stamp the images with the lifted keywords.

13 Close the Lift & Stamp HUD.

The keywords are stamped across the selected images. The Lift & Stamp tool is a great time-saver when you want to copy keywords onto a number of other images, but, as you'll learn in Lesson 6, you can also use it for image adjustments.

Editing Metadata Views and Presets

The fields that appear in the Info tab of the Inspector pane depend on which of the many metadata views is selected. Aperture comes with more than a dozen customizable views, or you can create your own from scratch. Let's begin by editing an existing view.

1 If necessary, press W to cycle through the Inspector pane tabs until the Info tab is selected.

2 In the Browser, select **Senegal 2006-11-03 at 06-53-44**.

3 From the Metadata View pop-up menu at the top of the Info tab, choose Edit.

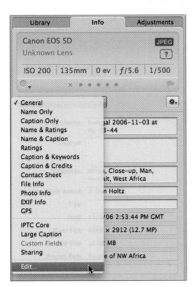

The Metadata Views dialog is divided into two columns. The Metadata Views column lists the current views. The Metadata Fields column lists all the fields that are available in the selected view. A checkbox allows you to select the fields that are included in the currently selected view.

4 Click the disclosure triangle next to EXIF, and deselect the Date checkbox.

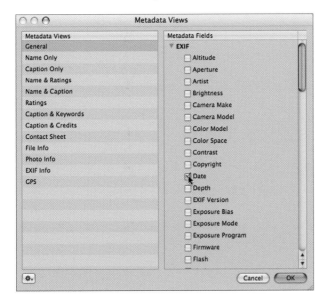

5 Click the EXIF disclosure triangle to hide the EXIF fields.

6 Click the disclosure triangles next to IPTC and Status.

7 Deselect the Title checkbox.

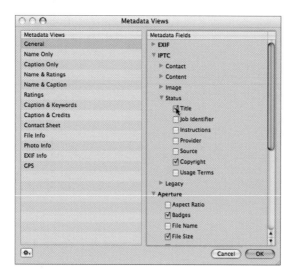

Now let's add some metadata.

8 Click the EXIF disclosure triangle.

9 Scroll down and select the checkboxes for Aperture, ISO, and Shutter Speed.

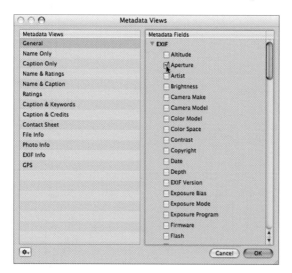

10 Scroll to the top of the column, and click the EXIF disclosure triangle to hide the EXIF fields.

11 Click OK.

The new items are added to the general view. You can also rearrange the order of the fields in the Info tab.

12 In the Info inspector, position the pointer over the Project Path title.

The background behind Project Path is highlighted.

13 Drag Project Path below Version Name.

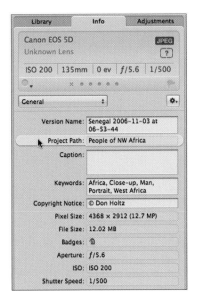

In many cases, the Metadata views that Aperture provides will suit your needs, especially with a bit more editing as you did previously. In some cases, however, you may need to create a completely new view.

Creating a Metadata View

Sometimes it can be difficult to find the few specific pieces of information you want when many fields are displayed. Fortunately, you can create your own metadata views that display as many or as few fields as you like. Creating a view with reduced fields allows you to scan a shorter list and more quickly find the fields that you want.

1 In the Info inspector, from the Metadata View pop-up menu, choose Edit.

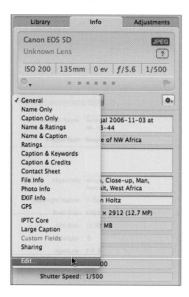

2 In the Metadata Views dialog, from the Action pop-up menu, choose New View.

3 Type *Photographer's Info* as the name for the View, and then press Tab.

4 In the IPTC Contact section, select the checkboxes next to Creator, City, State/Province, and Website.

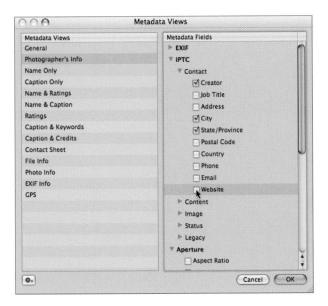

5 In the IPTC Status section, select the Copyright checkbox.

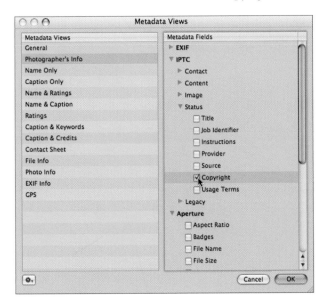

6 Click OK.

The Info inspector now displays the Photographer's Info Metadata view.

The order in which these metadata views are displayed can also be customized.

7 Click the Metadata View pop-up menu and choose Edit.

8 In the Metadata Views dialog, drag down Photographer's Info until it's the last item below GPS.

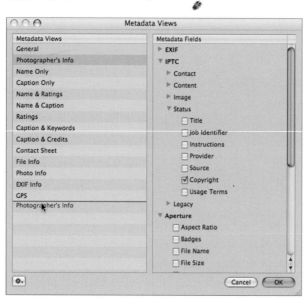

9 Click OK.

Now you have a view that displays information about the photographer. Well, it almost displays that information. You haven't entered all of it yet.

Creating and Applying Metadata Presets

The information that you need to enter in the Photographer's Info metadata view is the type of information that probably doesn't change from project to project, particularly if this is your library. It would be useful to quickly enter this fairly consistent data. Using metadata presets in Aperture, you can fill in fields automatically during import, or in the Batch Change dialog, or directly in the Info inspector.

To this point, you manually entered metadata information and applied it your images. In this next exercise, you'll create a preset that will instruct Aperture to fill in fields automatically when that preset is selected in the import settings or in the Info inspector.

If you examine the Info inspector, you'll see that the Copyright field already was filled in during import. So, you're going to enter the rest of the information and then save that information in a preset.

1 In the Browser, select **Senegal 2006-11-03 at 06-53-44**.

2 In the Info inspector, in the Creator field, enter *Don Holtz*.

3 In the Contact City field, enter *Topanga*, and in the Contact State/Province field, enter *Ca*.

4 In the Contact Website(s) field, enter *www.donholtz.com*. Verify that © Don Holtz is in the Copyright Notice field.

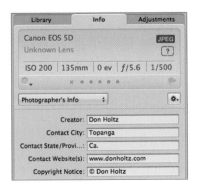

5 Press Tab.

 NOTE ▶ Do not press Return, or you will create a new line inside the field.

6 From the Action pop-up menu, choose New Preset from Version.

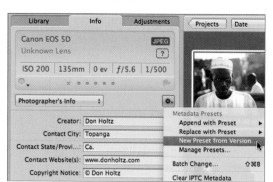

Because you have chosen this, the information in the metadata view will become the basis for your preset.

TIP If you want to create a preset that does not correspond to the currently displayed metadata view, from the Action pop-up menu, choose Manage Presets, and then create a new preset.

7 Name the new preset *Basic Credit Info*, and click OK.

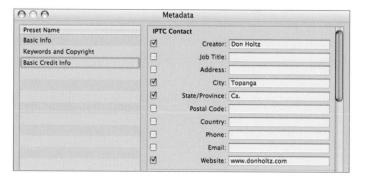

8 Press Command-A to select all the images.

9 From the Metadata menu, choose Batch Change, or press Command-Shift-B.

The Batch Change dialog appears.

10 From the Add Metadata From pop-up menu, choose Basic Credit Info to apply your new preset.

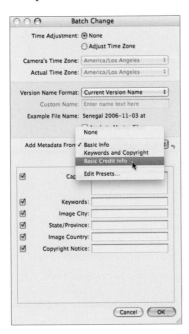

The filled-in Credit field appears.

11 Click Replace.

If you select Append, the copyright notice will display twice, because it already exists in the Copyright field.

12 Click OK to apply the preset.

You didn't get trumpets or confetti, but your new preset really did work. Still, a small amount of skepticism is healthy, so let's double-check the results.

13 Press Command-Shift-A to deselect all the images in the Browser.

14 Click a few images in the Browser, and verify that the additional information is displayed in the Info inspector.

Modifying One Field of Metadata

In some situations, you may need to enter custom metadata for each image. This process can be tedious. Fortunately, Aperture provides a way to keep your current metadata field active while you select a different image. Let's quickly add captions for a few images.

1 In the Browser, select **Senegal 2006-11-03 at 06-53-44**. Click the Info inspector, and from the Metadata View pop-up menu, choose Caption & Keywords.

2 In the Caption field, type *A revered elder on the beach of St Louis, Senegal.*

3 Press Command–Right Arrow.

A new image is selected, but the Caption field remains ready for you to type text.

TIP ▶ Holding down Command while pressing any of the arrow keys will allow you to keep a field live while changing images.

4 In the Caption field, type *In a small village, she watches over children.*

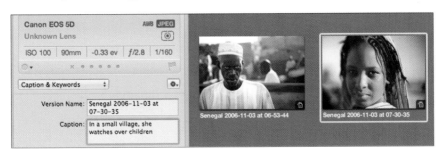

5 Press Command–Right Arrow to select the next image.

6 In the Caption field, type *A friendly man in a tiny soda shack.*

7 Press Tab twice to remove the insertion point from the text fields.

Sorting and Filtering Your Project

Although metadata can be informative on its own, the ability to sort and organize images based on that metadata makes the time you spend applying it worthwhile.

Filtering Data in the Browser

The Browser search field provides a quick way to control which images you're viewing. Let's use Browser search to display only Senegal-related images.

1 Press Command-Shift-A to deselect any images.

2 Press I to close the Inspector pane.

3 Click in the Browser search field.

4 In the Browser search field, type *Senegal*, and press Return.

NOTE ▶ The Browser search field searches for symbols as well as characters.

Only the images with *Senegal* in the version name are displayed.

5 In the Browser search field, click the Reset button to clear the field.

The Browser search field doesn't automatically clear even if you quit Aperture. It is easy to accidentally enter a character in the search field and panic when images disappear. Be sure to clear the search field when you are done with a search.

TIP ▶ You can always tell that a character is entered in the Browser search field when the Reset button is displayed to the right of the field.

Using the Filter HUD
In the Browser Filter HUD, you can enter much more detailed image-filtering information.

1 To the left of the Browser search field, click the Filter HUD button.

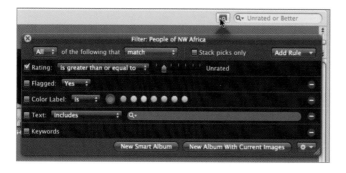

TIP ▶ Although the Filter HUD appears below the Filter HUD button, as do all Aperture HUDs, it's free floating, so you can drag it anywhere on your display.

2 Select the Keywords checkbox.

A listing of keywords used in this project appears.

3 Select the Children checkbox.

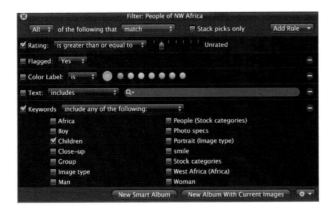

Only the images of children are shown. Now let's narrow down our selection.

4 Choose Add Rule > EXIF.

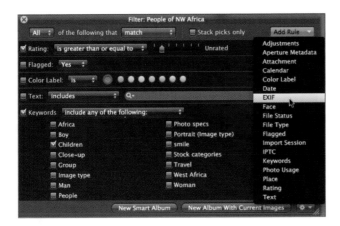

The Browser can now be filtered using any EXIF data.

5 From the EXIF pop-up menu, choose Date.

6 Verify the EXIF value is set to "is."

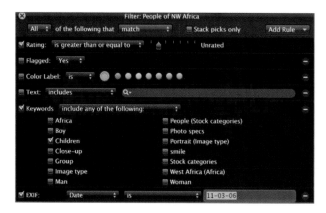

7 In the entry field, type *11-03-06,* and then press Tab.

The Browser is filtered to include only images of children shot on the third day of the month. Now you'll reset the filter.

8 Close the Filter HUD.

9 Clear the filter criteria by clicking the Reset button.

Because of the amount of EXIF data and additional metadata each image carries with it, a project with a thousand images becomes more manageable when you can filter it based on precise criteria. Instantly you can find images shot with specific lenses on exact dates, or images shot with a fast shutter speed of children playing outdoors. Once you've found those images, you can then place them into albums so that you never have to perform the search again.

Working with Albums

Albums allow you to manually sort images in Aperture. They don't move or alter your images; they simply reference them. It's easiest to start creating an album by first selecting the images you'll want to include in it, although images can be added to albums at any time.

1 Press I to return to the Inspector pane.

2 Press W to cycle through the tabs and arrive at the Library tab.

3 Press Command-Shift-A to deselect any images.

4 Select the People of NW Africa project.

5 Select the first image in the Browser, **Senegal 2006-11-03 at 06-53-44**.

6 Command-click the third image in the Browser, **Senegal 2006-11-03 at 07-32-27**.

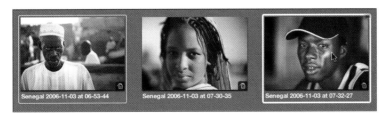

7 From the New button pop-up menu in the toolbar, choose Album, or press Command-L.

8 Enter the Album name *NW African Men* in the dialog. Make sure the "Add selected items to new album" checkbox is selected, and then click OK.

The new album appears under the People of NW Africa project and contains the two selected images.

9 In the Inspector pane, click the People of NW Africa project.

The images were not moved out of the project. They are just referenced into an album. The same version of the image is displayed in two places.

Working with Smart Albums

In the previous exercise, you added images to an album. All changes, whether they add to or remove images from an album, are performed manually.

Smart Albums, like filtered browsers, are updated dynamically according to metadata criteria that you define. When you change the criteria associated with a particular Smart Album, the contents of the Smart Album change automatically.

> **TIP** ▶ Aperture comes with a selection of Smart Albums already set up in the library. For example, you could choose Smart Albums that gather all the images taken in the previous week, or all the images taken in the previous month. The Smart Albums included in Aperture are located in the Albums section in the Library inspector. Although these Smart Albums work in all your projects by default, you can add your own criteria at any time to refine their filtering.

Creating Smart Albums

To become familiar with Smart Albums, let's create a Smart Album that contains only children images.

1 Select the People of NW Africa project.

2 From the toolbar, choose New > Smart Album, or press Command-Shift-L.

> **NOTE** ▶ By first selecting the People of NW Africa project, you are limiting the Smart Album to search only within that project.

A new, untitled Smart Album appears along with a Filter HUD for setting its criteria.

3 Rename the untitled Smart Album *NW African Children*, and then press Return.

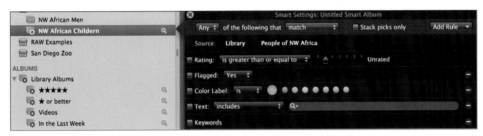

The Filter HUD, as mentioned earlier, lets you specify your search criteria. Smart Albums can search projects, folders, or entire libraries. The search location of the Filter HUD is displayed in the Source area. The "bread crumb" display shows that this Filter HUD is searching in Library > People of NW Africa Project. You can click the Library element to expand the search across the entire library.

4 In the Filter HUD Source area, make sure that the People of NW Africa source element is selected (identified by a dark background).

5 Select the Keywords checkbox.

6 Select the Children checkbox.

7 Close the Smart Settings HUD.

The images matching the search criteria appear in the Browser. You can work with these images in the same way as you would work with the images in any project or standard album. If you change the search criteria or import new photos that match existing criteria, Aperture will update the Smart Album so that it includes all the images in the project that meet its criteria.

Creating Smart Albums Using the Browser Filter

The Browser filter also can be used to create albums and Smart Albums. The advantage to this is that you're viewing the results first in the Browser and then choosing to create a new album or Smart Album based on the filtered Browser. You can also quickly create several albums or Smart Albums by changing criteria in the Browser's Filter HUD before creating a new album or Smart Album.

1 In the library, select the People of NW Africa project.

2 In the upper right of the Browser, click the Filter HUD button.

The Filter HUD appears.

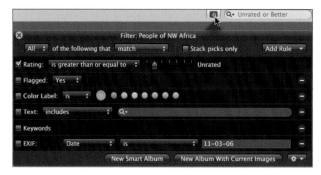

3 On the far right end of the EXIF field, click the Remove (minus sign) button to remove the EXIF search criteria you applied earlier in this lesson.

4 In the Filter HUD, select the Keywords checkbox.

5 Deselect the Children checkbox.

6 Select the Woman checkbox.

7 At the bottom of the Filter HUD, click New Smart Album.

A new Smart Album appears beneath the People of NW Africa project in the Library inspector.

8 Name the new Smart Album *NW African Women*, and press Return.

9 Select the People of NW Africa project again.

10 Click the Filter HUD button.

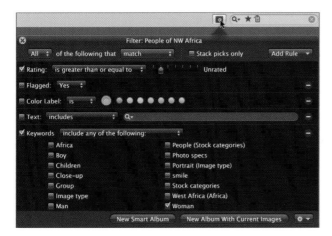

Keywords and Woman should still be selected.

11 From the pop-up menu, choose "do not match."

The image sort inverts the selection to include images that do not match the keyword *Woman*. It's an interesting option, but we don't need an album with this criterion.

12 Reset the pop-up menu to "match."

13 Deselect the Keywords checkbox.

14 Drag the Ratings slider all the way to the right to show five stars.

No images appear because you haven't yet rated any of the People of NW Africa images. You'll do that in the next lesson.

15 Click the New Smart Album button and name the Smart Album *NW Africa Five Star Images*, and press Return.

16 In the library, select the People of NW Africa project.

Yikes! No images. Take a deep breath. It can be alarming when this happens, but before you panic, check the search field.

17 In the Browser, clear the search field by clicking the Reset button.

Ahhh, the images are back. We all feel better now. In the next lesson, you'll get into evaluating, comparing, and rating these amazing images.

> **TIP** You can base a search on a vast amount of data. In addition to content descriptions, a search can include camera-specific information such as a camera's model or a specific lens, an f-stop, or any setting that is saved as part of the EXIF information. Additionally, you can search based on any image adjustments. As you work your way through the lessons in the book, try searching for images based on the image adjustments you're applying. Try also searching for images that have not been adjusted—a search technique that is a great way to keep track of the images that need additional work.

Lesson Review

1. How does time adjustment work?

2. How can keywording help you?

3. How do you let Aperture know that you do not want to import specific images in the Import browser?

4. How would you show only those images in the Browser that were taken on a specific day, month, and year?

5. What is the difference between albums and Smart Albums?

Answers

1. Time adjustment uses the camera time zone as a starting point and creates an adjusted time zone based on where a photo was shot.

2. Keywording can be used in addition to the information that's embedded in an image to differentiate between images. This will allow you to create useful searches that can quickly find images inside a project or an entire library.

3. In the Image browser, checkboxes are selected to identify images that will be imported. You can deselect a checkbox on images that you do not want Aperture to import.

4. Use the Filter HUD in the Browser to filter images based on any IPTC Core or EXIF metadata, including when the image was taken.

5. Albums are static groupings of images into which you manually add images. Smart Albums are dynamically updated with images based on filter criteria.

3

Lesson Files APTS Aperture3 Library

Time This lesson takes approximately 90 minutes to complete.

Goals Evaluate images in Full Screen view

Examine detail using the Loupe

Compare and rate images

Organize a series of images into stacks

Arrange photo collections on the Light Table

Lesson **3**

Comparing and Evaluating Images

Everyone seems to have a capable camera with them these days, whether it's a DSLR, a spiffy point and shoot, or a mobile phone's camera.

With all these devices on hand, it means most of us have more photos than ever. However, culling down those photos is now more time consuming and laborious. Aperture can assist your critical eye in finding the best collection of images and make the process a lot more fun.

In this lesson, still working with the People of NW Africa albums, you'll apply Quick Preview mode to speed up image loading. Then you'll inspect, compare, and rate images in Full Screen view. Using stacks, you can accelerate the process of sorting and choosing your favorite shots. Finally, you will use the flexible Light Table to create a layout of images that works great as a collection.

Generating Aperture Previews

Images in Aperture are shown on your display at the highest possible quality, by default. Opening full-resolution images from disk can be especially processor intensive and time consuming, particularly when decoding large RAW images.

At times, you may not need the highest-quality image, when sharing photos with applications such as iMovie or Keynote, for instance, or when playing slideshows. Even when reviewing project images you may prefer responsiveness to pixel-perfect resolution. Generating previews is your solution.

Smaller (and more efficient) JPEG-format preview files are created automatically during the import process, or you can create them at any time. You can set the size and quality of previews in the Aperture preferences, or you can use embedded JPEG images if you are shooting RAW + JPEG pairs in your camera.

> **TIP** ▶ After import, you'll notice the status "Processing" displayed in the tool strip area above the Browser. Part of that processing is the creation of JPEG previews.

Let's configure Aperture to create some previews.

1 Select the People of NW Africa project.

2 Choose Aperture > Preferences.

3 Click the Previews button.

4 From the Photo Preview pop-up menu, choose the resolution with an asterisk next to it.

 This resolution is the closest match to your display resolution.

 NOTE ▶ Setting the preview resolution to match your display's resolution will limit the preview's file size while maintaining a high-quality preview of your image. Depending upon your display resolution, larger previews may be a good option when using the Aperture library with iMovie or Keynote because these applications, and others, use the image previews rather than the original images.

5 Verify that the Preview Quality slider is set to 6 Medium.

Adjusting the Preview Quality to 6 Medium results in an image with a reasonable file size, yet with sufficiently high quality to fully review content.

6 Close Aperture preferences.

All future importing sessions will automatically create previews using these settings. Because the People of NW Africa project is already imported, it has previews that were generated using the older settings.

Next, you'll delete those old previews and generate new previews using the new settings. Let's save one old preview to later compare with the new previews.

7 Select the second image in the Browser.

8 Choose Edit > Select to End, or press Shift-End.

9 Choose Photos > Delete Previews.

A warning dialog appears to confirm that you want to delete the previews.

10 Click Delete.

11 Choose Photos > Update Previews to create new preview images.

When Aperture finishes processing in the background, all the images except the first image, which we didn't update, will have previews generated at the current settings.

> **TIP** If Aperture alerts you that all previews are up to date and no updating is required, you can force previews to rebuild by Option-clicking the Photos menu. The Update Previews option will change to Generate Previews. Choose Generate Previews to create the new files.

Using Quick Previews

One way previews are used is to accelerate performance as you quickly scan through images. Quick Preview mode is a feature that prevents Aperture from opening the highest-quality version of an image and, instead, accesses the preview.

> **NOTE ▶** It's important to note that Quick Preview mode cannot be used when you are adjusting images. Image-processing functions require access to the original pixel data, which you aren't using in Quick Preview mode.

Let's begin by looking at the first image in the browser, which is the one that we did not update using the new Preview settings.

1 Select the first image in the Browser.

2 In the toolbar, click Split View, or press V, to cycle through the main window layouts until you are in Split View.

3 Position your pointer over the tip of the man's nose in the image.

4 Press Z to zoom in to the image.

Pressing Z zooms in to the image to produce a full-resolution view, showing every pixel image even though it may not fully fit in the Viewer.

5 In the lower-right corner of the Viewer, click the Quick Preview button. The button turns yellow to indicate that it's active.

You're now looking at the image using the old preview settings. This is a half-resolution JPEG image with a quality setting of 6.

Let's update this image to apply the new preview settings.

6 Choose Photos > Delete Preview, confirm the deletion, and then choose Photos > Update Preview. Click OK.

It may take a few seconds to update the preview. When it is done, you won't notice any significant difference in the Viewer, but your previews will occupy less space on your hard disk.

7 Press the Right Arrow key to move to the next image.

8 Hold down the Right Arrow key to move quickly through the images.

9 Click the Quick Preview button to turn off Quick Preview mode.

10 Press Z to see the entire image in the Viewer.

> **TIP** ▶ You could perform these same steps without activating Quick Preview mode, but turning it on accelerates navigating, regardless of the computer you're using.

Previews are useful for quickly reviewing and shuffling through a lot of images. But when you need to slow down and study each image without distractions, that's when you can switch to Full Screen view.

Evaluating Images in Full-Screen Mode

The Full Screen view in Aperture reduces the interface to a bare minimum so you can focus on the images. Each image is displayed in its entirety so you can better evaluate

detail and clarity. In this exercise, you'll use Full Screen view to assess and rate some of the images in your project.

1 In the Library inspector, select the NW African Men album.

2 Select the first image, **Senegal 2006-11-03 at 06-53-44**.

The image appears in the Main Viewer.

With Quick Preview turned off, you'll use the Full Screen view to evaluate the images at full resolution, rather than just the lower-resolution preview.

3 Choose View > Full Screen, or press F.

4 Position your pointer over the man's nose and press Z.

Aperture zooms in to the image at the location of your pointer.

NOTE ▶ You may notice the text Loading at the top center of the image. This indicates that the highest-quality image, not a preview, is displayed on the screen.

Pressing the Z key displays the image at full resolution in 1:1 pixel ratio. Viewing the full-resolution image allows you to evaluate the image based on actual pixels instead of on a scaled-down preview. When an image doesn't fit within the Viewer, you can pan the image.

5 Drag the image to pan it.

At 100 percent resolution, you can see the full impact of the intensity in the man's face. It is a powerful image and we definitely want to include it in any showing of

these images. To ensure that, let's rate it highly using the star-rating system you explored in Lesson 1.

6 Press 5 to add a five-star rating to this image.

The five-star rating appears in the bottom left of the image.

7 Press Z to display the entire image again.

8 Press the Right Arrow key to select the next image, **Senegal 2006-11-03 at 07-32-27**.

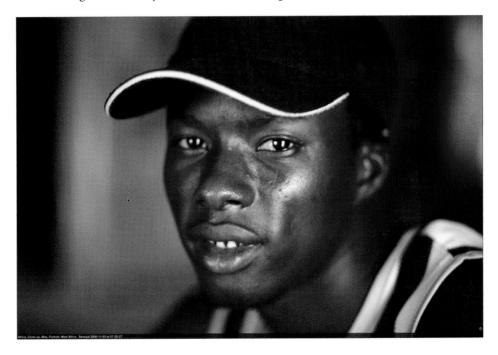

9 Position the pointer over the subject's nose, and press Z.

10 Drag on the image to pan it in the Viewer.

TIP ▶ If you have a scrolling mouse, you can move the scroll wheel to pan images in the Viewer. You can also pan by dragging two fingers on a Multi-Touch trackpad or a single finger on an Apple Magic Mouse.

Panning is helpful, but it would be more useful if you could see which portion of the image you were viewing in the context of the entire image.

The navigation box is located near the right edge of the image. The white rectangle shows the portion of the image that is currently visible in the Viewer. The 100% indicates the current scale of the image.

11 Position the mouse pointer over the navigation box.

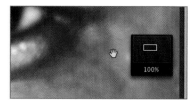

The navigation box expands to show a thumbnail of the full image.

12 Drag the white rectangle in the pane to pan the image in the Viewer. Using this tool makes it much easier to pan precisely.

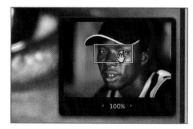

This is another stunning image but, due to the extremely shallow depth of field, only the tip of the subject's nose and his upper lip are in focus. Let's rate this with four stars.

13 Press 4 to assign a four-star rating.

14 Press Z to zoom out and view the entire image.

Switching Projects in Full Screen View

Full Screen view is not limited to displaying only a single image in the Viewer. You can also use Full Screen view for the Browser and switch between multiple projects or albums.

1 Press V to switch to the Browser.

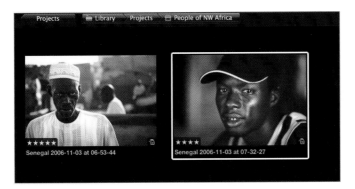

The Full Screen view in the Browser looks much like the standard Browser view with the scale slider in the lower right and the Filter HUD in the upper right. However, you now have the ability to switch to any project or album in your library.

2 At the top left of the screen, click the People of NW Africa project.

3 From the pop-up menu, choose NW African Children.

4 Press V to display the first image in Full Screen view.

5 Move your pointer to the bottom of the screen.

The Browser appears in the filmstrip view. If you move your pointer up above the filmstrip, it disappears.

6 To lock the filmstrip in place, click the Always Show Filmstrip control at the far right end of the filmstrip.

The image scales down to fit within the screen space above the filmstrip.

You can also gain access to Full Screen view's toolbar.

7 Move your pointer to the top of the screen.

The toolbar appears. If you move your pointer below the toolbar, it disappears.

8 To lock the toolbar in place, click the Always Show Toolbar control at the far right end of the toolbar.

The image scales down further to fit within the screen space between the toolbar and the filmstrip.

Using the Loupe Tool

The Loupe is a convenient and effective tool for magnifying portions of an image to see them with more detail. Instead of zooming in to the entire image and panning, you hover the Loupe tool over any portion of an image anywhere in Aperture. While the Loupe tool can be configured in a few ways, the default setting is the Centered Loupe.

Using the Centered Loupe

The Centered Loupe works by positioning the Loupe over an area of the image that you want to magnify, just as you would use a traditional Loupe tool on a light table.

1 In the toolbar, click the Loupe button, or press the Grave Accent (`) key.

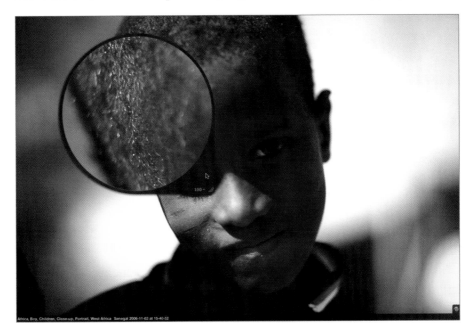

2 Drag the center of the Loupe over the eye to the left of the image and release the mouse button.

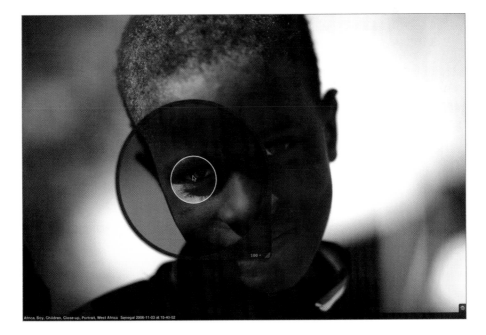

A small white circle appears in the center of the Loupe as you begin to drag. This circle represents the area of the image that will be magnified after you release the Loupe.

To see more detail, you can increase the Loupe's magnification.

3 From the pop-up menu at the lower-right corner of the Centered Loupe, choose 200%. In addition, you can reposition the Loupe by dragging the handle above the scale indication.

NOTE ▶ When you zoom beyond 100%, the image is not smoothed. You're viewing the scaled pixel information without blending applied. This allows you to accurately assess the pixel information.

4 Press Command-Shift-Hyphen two times to change the zoom to 50%.

TIP ▶ Zooming to 50% is a quick way of subtly zooming in to part of an image while still viewing compositional elements.

5 Press Command-Shift-Plus Sign (+) to return the Loupe zoom value to 100%.

Using the Cursor-Focused Loupe
The cursor-focused Loupe differs from the Centered Loupe in that it uses your mouse pointer position as the location on which to center a zoom.

1 Drag the Centered Loupe to the right until it no longer overlaps with the face in the Viewer.

2 From the pop-up menu at the lower-right corner of the Centered Loupe, choose Focus on Cursor.

3 Position the pointer (cursor) over the image in the Viewer.

If the Loupe is too large for the screen, you can change its diameter.

4 Press Shift-Option-Hyphen (-) to reduce the Loupe's diameter.

TIP ▶ If you want to see a larger area inside the Loupe, press Shift-Option-Plus Sign (+) to increase the diameter of the Loupe.

The Loupe can also display the precise red, green, blue, and luminance values of the pixel under the pointer.

5 From the Loupe's pop-up menu, choose Color Value.

6 Position the pointer over the image in the Viewer.

When the zoom level of the Loupe is at 400% or above, you can enable a pixel grid, which helps to define each individual pixel.

7 Press Command-Shift-Plus Sign (+) to increase the Loupe zoom value to 400%.

8 In the Loupe's pop-up menu, choose Pixel Grid.

9 Move the pointer over the image to view the more clearly delineated pixels within the grid.

10 In the Loupe's pop-up menu, choose Color Value to disable the RGBL display.

11 In the Loupe's pop-up menu, choose Pixel Grid to disable the grid display.

12 Press the Grave Accent (`) key to hide the Loupe tool.

It ultimately does not matter which style of the Loupe tool you use, the ability to examine areas of an image at greater than 100 percent magnification is fundamental to evaluating image quality.

Using the Loupe in the Browser

The Loupe tool can be used outside of the Full Screen view with the same functionality. It can even magnify image thumbnails in the Browser.

1 Press F or Esc to exit Full Screen view.

2 Press the Grave Accent (`) key to open the Loupe tool.

3 From the Loupe's pop-up menu, choose Focus on Loupe and choose 200%.

4 Drag the center of the Loupe to the Browser and release the Loupe when you are over the third image in the Browser, **Senegal 2006-11-03 at 15-41-51**.

5 In the Browser, drag the Loupe's handle to view different parts of **Senegal 2006-11-03 at 15-41-51**.

If you are viewing an image in the Browser through the Loupe, you can easily load that image into the Viewer to see the full image more clearly.

6 From the Loupe's pop-up menu, choose Select Targeted Image to load the magnified thumbnail into the Viewer.

7 Press the Grave Accent (`` ` ``) key to hide the Loupe tool.

NOTE ▶ There is an alternate Loupe you can access by disabling Use Centered Loup in the Loupe pop-up menu. This Loupe is left over from the first version of Aperture and is a bit less feature rich than the two Loupes previously described. The alternate Loupe does not have a pop-up menu, so Loupe options are accessed via a Control-click (or right-click) menu.

Assigning Image Ratings

In Lesson 1, you learned a bit about rating images using keyboard shortcuts. But there are other ways to assign ratings, and if you are more inclined to sit back with the mouse or trackpad, you may find it more convenient to use one of these other rating methods. In this exercise, you'll rate your images with the same star rating system but using the control bar instead of keyboard shortcuts.

1 Choose Window > Show Control Bar, or press D, to display the control bar under the Browser, if necessary.

2 Press Shift-D to remove the keywords and display only the control bar.

The control bar includes rating buttons, as well as navigation buttons with which to select images in the Browser.

3 On the control bar, click the Move Selection Right button until you reach the image of the two boys in the Browser, **Senegal 2006-11-03 at 15-42-20.**

This is a nice picture of two young friends. Let's be a bit conservative here and rate it with three stars.

4 Click the Increase Rating button three times to assign a three-star rating to the image.

NOTE ▸ You should see three stars (***) displayed in the lower left of both the Browser thumbnail and the main Viewer image. If not, press Y to turn on the metadata overlay in the main Viewer, and press U to turn on the metadata overlay in the Browser, just as you did in Lesson 2.

5 Click the first image in the Browser, **Senegal 2006-11-03 at 15-40-52**.

Great image. Let's give this a full five-star rating.

6 Click the Increase Rating button five times to assign a five-star rating to the image.

7 On the control bar, use the Move Selection buttons to select **Senegal 2006-11-03 at 15-41-30**.

This image isn't among the best.

8 Click the Reject button (X) to reject the image.

The Reject button does not delete the image. It just filters it from the Browser, based on the Filter HUD. It's another level in the rating scale, the lowest possible rating.

9 On the control bar, click the Move Selection Right button to view the next image in the Browser, **Senegal 2006-11-03 at 15-41-51**.

This one has the look of a truly great image. If only we had a six-star rating. Well, we don't; but we can apply five stars and then return to the previous five-star image and downgrade it to four stars.

10 Click the Select button (the checkmark icon) to instantly apply a five-star rating.

Clicking the Select button once is much quicker than clicking the Increase Rating button five times.

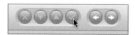

11 On the control bar, click the Move Selection Left button to return to the first image in the Browser, **Senegal 2006-11-03 at 15-40-52**.

12 Use the Ratings buttons to assign this image four stars.

Comparing and Rating a Group of Images

Selecting and rating an entire group of images at once can accelerate the rating process. Aperture has some clever ways of rating images within a group.

1 Drag a selection rectangle that starts in the gray area above the last image in the Browser (**Mauritania 2006-11-06 at 14-36-18**) and continues left to include two additional images: **Mauritania 2006-11-06 at 14-35-21** and **Mauritania 2006-11-06 at 14-35-38**.

NOTE ▶ You should see three images displayed in the Viewer. If you look carefully, the three images in the Viewer should be in reverse order compared to the Browser, that is, the leftmost image in the Viewer is the rightmost image in the Browser, due to the direction you selected in the Browser.

These are all good shots. To fully evaluate them, you should compare them side by side with a bit more detail and a bit more room.

2 Choose Window > Hide Inspector, or press I.

3 Press Z to zoom in to all three images.

The images are now displayed at full resolution. To make your evaluation, you ought to view a more salient part of each image.

4 On the leftmost image (**Mauritania 2006-11-06 at 14-36-18**), drag in the navigation box to view the face of the girl holding the baby.

5 Do the same for the other two images; all the images should include the face of the girl holding the baby.

Viewing a similar area of the image makes it much easier to notice that the center image is not as clear as the other two. This three-up display becomes even more useful when you can pan the images simultaneously.

6 In the leftmost image (**Mauritania 2006-11-06 at 14-36-18**), Shift-drag in the navigation box so that all images pan to the boy standing in front of the girl.

The boy's expression is best in the center and leftmost images.

7 Drag farther to the left in the navigation box so that all images pan to the older boy standing to the left of the girl.

> **TIP** If you find it easier to pan using one of the other image's navigation boxes, just Shift-drag in the navigation box of another image.

The leftmost image turns out to have great expressions all around. Plus, it's the only image in which the baby is looking into the camera. For the moment, let's try making that the five-star Select image.

8 Press 5.

Five stars appear in the lower-left corner of each of the three images in the Viewer (as well as on the image thumbnails in the Browser). However, you wanted to apply the five-star Select rating only to the leftmost image in the Viewer.

9 Press 0 to remove the Select rating you just applied to the three images.

The next section will use the primary selection option to help you rate these images correctly while still having all three selected.

Using Primary Selection Options to Rate Images

Aperture features an innovative tool, the Primary Only button, to modify metadata in one primary image of a group, without altering your overall selection.

1 On the tool strip, click the Primary Only button.

When you do so, a white outline appears around the primary selection, and the outlines for the non-primary selections disappear.

2 In the Viewer, select the leftmost image and press 5 to assign a five-star rating to the primary selection.

Only the primary image is rated.

3 In the Viewer, click the middle image to select it.

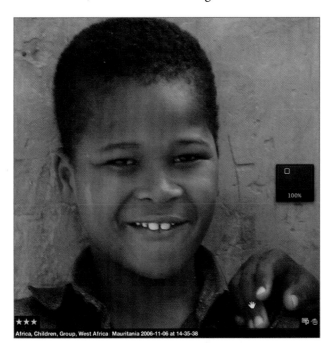

4 This is a good image. Press 3 to assign it a three-star rating.

5 Click the rightmost image in the Viewer to select it. Because this image is a bit out of focus, press 1 to give this image a one-star rating.

6 Press Z and then click the Primary Only button to disable the mode.

NOTE ▶ The Primary Only feature can be used with several metadata functions, including rotation and keyword applications, and simply as a tool for switching between an overall selection and a single primary image for image evaluation.

Working with Stacks

Digital SLR cameras, as well as some consumer point-and-shoot cameras, have a feature called continuous-shooting mode (or burst mode), which lets you capture several photos in the time span of one second. Continuous shooting mode is great for taking shots of moving objects because it allows you to capture the perfect form of the movement. Even portrait photographers use continuous shooting mode because, when subjects relax, it permits them to capture the natural subtlety in a fleeting expression.

To help you organize, compare, and contrast a burst of similar images, Aperture allows you to group, or *stack,* images. Stacks can be created automatically based on a time range, or you can manually group images into stacks. Either way, stacking groups' images is for viewing purposes only; it doesn't affect where they're stored within your Aperture library.

Using Auto-Stack

When you auto-stack images, Aperture uses the images' timestamp metadata to group images shot within up to one minute of each other. Stacking is not permanent and can be undone or edited at any time.

1 Press I to open the Inspector.

2 Select the NW African Women Smart Album.

3 Press V to cycle the Viewer until you see the Browser.

4 Press Command-A to select all the images in the Browser.

5 Choose Stacks > Auto-Stack, or press Command-Option-A, to open the Auto-Stack Images HUD.

The slider in the HUD represents time in seconds. As you move the slider to the right, to 10 seconds for instance, images shot within ten seconds of each other are grouped together into a stack, indicated by a darker gray background behind each group.

Stack grouping is dynamic, so as you move the time slider, you'll see the changes.

6 Drag the Auto-Stack Images slider all the way to the right.

Four stacks are created. A Stack button is displayed in the upper-left corner of the first thumbnail of each stack. The Stack button represents the number of images in the stack.

7 Close the Auto-Stack Images HUD.

8 Choose Stacks > Close All Stacks. Closing stacks can save you a significant amount of space in the Browser.

9 Click the Browser background to deselect all of the images.

Extracting and Adding Images to Stacks

At times, you'll want to move images in and out of stacks to correct for images that may fall outside of the time range but visually still belong in the stack and vice versa.

1 Drag the Thumbnail Resize slider to the right until the thumbnails fill the Browser.

2 Select the woman in the black head scarf, **Mauritania 2006-11-06 at 07-42-27**.

3 Click the Stack button (3), or choose Stacks > Open Stack and view its contents.

There are two things wrong with this stack. First, the close-up of the woman, although captured at the same time, does not seem to belong in the same stack as the group photos. Second, a similar group photo after the stack is not currently included in the stack.

4 Drag the close-up image of the woman in the black head scarf to the left (**Mauritania 2006-11-06 at 07-42-27**).

5 When a green vertical line appears against the left edge of the stack, release the mouse button.

The close-up image is extracted from the stack.

6 Click **Mauritania 2006-11-06 at 07-48-55**, the third photo of the group of women.

7 Click the Stack button (2), or choose Stacks > Open Stack.

This stack needs to be split. One image is a group shot and the other is a close-up of a woman. Once split, you can then add the group shot to the stack before it that contains similar group shots.

8 Choose Stacks > Unstack, or press Command-Shift-K.

 TIP ▶ You can customize the toolbar to add buttons that will perform stack adjustment, such as the Unstack button.

9 Drag **Mauritania 2006-11-06 at 07-48-55** to the left, onto the right edge of the stack.

 A vertical green line will appear just inside the right edge of the stack.

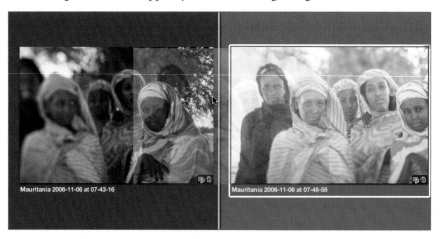

10 Release the image.

 All three group photos are now included in one stack.

 TIP ▶ Any manual stacking adjustments will be altered if you auto-stack the same images after those adjustments.

11 Click the Stack button (3) for the group of women you just created, or choose Stacks > Close Stack to collapse the stack and make more room in the Browser.

Creating Stacks Manually

You can create your own stacks to group similar images that may not fall within a similar time range. The current album includes three close-up shots of women (**Mauritania 2006-11-06 at 07-49-03**, **Mauritania 2006-11-06 at 07-50-31**, and **Mauritania 2006-11-06 at 15-38-09**) that could go together. Let's manually place these three close-up shots into a stack.

1 Select the three images by drawing a selection rectangle around them.

2 Choose Stacks > Stack or press Command-K.

3 Click the Stack button (3) for the women close-ups you just created, or choose Stacks > Close Stack.

 You've created a new stack that includes the three selected images.

Splitting Stacks

Sometimes auto-stacking includes too many images. Although the images may have been shot within the designated time range, they are different enough that you want to organize them into separate stacks.

1　Select **Mauritania 2006-11-06 at 15-46-49**.

2　Click the Stack button (5), or choose Stacks > Open Stack.

The first two images are close-ups, and the last three images are group photos. Although they were all shot within a brief time range, it seems odd to include the close-ups with the group photos. Let's split these into two stacks.

3　Select the first group shot in the stack, **Mauritania 2006-11-06 at 15-48-05**.

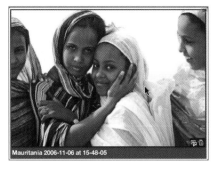

This image will be the first placed in the second stack. Any image before this selected image will remain in the original stack.

4　Choose Stacks > Split Stack.

You have successfully split a large stack into two smaller stacks.

5　Choose Stacks > Close All Stacks to collapse the stack and make more room in the Browser.

Merging Stacks

When two stacks have similar images, you can combine them into a single stack. If you think of these images as a group, stacking them can make it easier to find the best single image to represent them all.

1 Select the close-up group represented by the image, **Mauritania 2006-11-06 at 07-49-03**.

2 Shift-click the next close-up group represented by the image, **Mauritania 2006-11-06 at 15-46-49**.

3 Choose Stacks > Stack to merge the two stacks.

4 Click the Stack button (5) on the newly merged stack, or choose Stacks > Close Stack to make more room in the Browser.

Using Stack Mode

The pick image is designated as the best image of a stack. It's the image that is viewed when you close the stack and only one representative image is visible. By default, the pick is the

first image in the stack. Using Stack mode, you can view the current pick next to the alternatives in the stack. You can reorder the images and select your favorite as the stack's pick.

1 Select **Senegal 2006-11-03 at 07-34-25**, the first stack with the woman in the doorway.

2 Press the V key to show the Viewer and browser in Split View. Then press F to enter Full Screen view. This will provide the maximum screen space for comparing images.

3 From the toolbar, from the Viewer Mode pop-up menu, choose Stack.

The Viewer displays two images. The current pick of the stack is outlined in green. The second shot of the stack is outlined in white. The green and white outlines also appear on the corresponding thumbnails in the Browser. A small label is displayed above each image in the Viewer to indicate the current pick and the alternate.

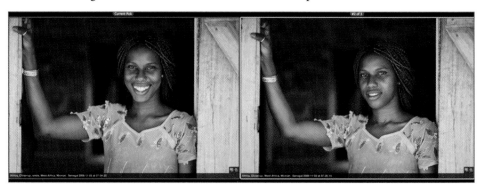

Because of her beaming smile, I would still say the current pick is the better image.

4 Press the Right Arrow key to compare the current pick with the next image in the stack.

The pick is nice, but the alternative image has a tighter crop and seems more relaxed and natural. Let's make that the new pick.

5 Press Command-Backslash (\) to select **Senegal 2006-11-03 at 07-36-09** as the pick.

When you select a new image as the pick of the stack, you'll see an image-swapping animation in the Browser. The new pick is now the first image in the stack, and the old pick is bumped into second place.

6 Press the Down Arrow key.

Pressing the Up and Down Arrow keys will move you to the next or the previous stack. You'll notice that as you leave a stack it closes in the Browser.

For a variety of reasons, the current pick is still the better image. Let's move on to the third image in the stack.

7 Press the Right Arrow key to compare the current pick with the next image in the stack. Everyone has a much better expression in the alternative image. Make that the new pick.

8 Press Command-Backslash (\) to select **Senegal 2006-11-03 at 07-48-55** as the pick.

9 Press F to exit Full Screen view.

Now that you have mastered making new picks in a stack, let's take a look at further refining the stack order.

Promoting and Demoting Picks

The images that are not the picks of stacks can be arranged from left to right within a stack in an order of your preference. If for some reason you need an alternative to the

stack's pick, reordering your stack alternatives will ensure that your second in line is truly the second-best image in the stack.

In this exercise, you'll add buttons to the toolbar that will assist you in reordering the images within a stack.

1 Control-click (or right-click) the toolbar, and choose Customize Toolbar from the shortcut menu to open the Customize Toolbar dialog.

TIP In addition to customizing the toolbar, you can change the keyboard shortcuts for Aperture. Choose Aperture > Commands > Customize to display the Command Editor. You can browse existing keyboard shortcuts or create your own.

2 Drag the Promote, Demote, and Pick buttons from the dialog to the right of the Share button in the toolbar.

3 Drag the Flexible Space item from the dialog to in between the Share and Promote buttons.

The Space block should center the Promote, Demote, and Pick buttons in the center of the toolbar.

4 In the Customize Toolbar dialog, click Done.

> **TIP** ▶ If you'd like to restore the default toolbar arrangement, drag the framed cluster of buttons from the bottom of the Customize Toolbar dialog to the toolbar.

5 Press the Down Arrow key to change to the next stack, beginning with the pick image **Mauritania 2006-11-06 at 07-49-03**.

By scanning the stack in the Browser you can see that the third image, **Mauritania 2006-11-06 at 15-38-09**, should be the pick, at least initially.

6 Press the Right Arrow key to view the third image as the alternate.

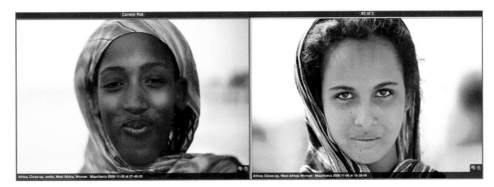

7 In the toolbar, click the Pick button.

Mauritania 2006-11-06 at 15-38-09 is now the new pick, and you can compare it with the new alternate, **Mauritania 2006-11-06 at 15-46-49**.

The alternate is good but not as good as the pick. Let's make the alternate the second in line.

8 Click the Promote button.

The alternate image animates in the Browser and moves up one spot in the stack.

9 Click the Promote button again, or press Command-Left Bracket ([).

The alternate image is now second in line, behind the pick.

10 Press the Right Arrow key.

Although you didn't look at all the images, let's jump to the conclusion that the alternate is the weakest image in the stack and relocate the alternate image as the last image in the stack.

11 In the toolbar, click the Demote button twice, or press Command-Right Bracket (]) twice, to demote the alternate to the last position in the stack.

Got the hang of it? Let's go through one last stack to reinforce the keyboard commands. Using the keyboard commands in Stack mode can speed up the process of reviewing several stacks.

12 Press the Down Arrow key to change to the next stack. This will be the last stack in the Browser.

13 Press Command-Right Bracket (]) to demote the alternate to the last position in the stack.

14 Use the Arrow keys to select the new alternate, **Mauritania 2006-11-06 at 15-48-14**.

This alternate is a wonderfully touching image. Make it the pick of the stack.

15 Press Command-Backslash (\).

You've selected your favorite images as the pick for each stack. But you're still in Stack mode. If you recall, you entered Stack mode using the Viewer Mode menu from the Full Screen view toolbar. That menu doesn't exist in the toolbar when you are not in Full Screen view, so let's find the Viewer Mode options in the View menu.

16 Choose View > Main Viewer > Show Multiple.

NOTE ▶ Show Multiple is the default view when Aperture is opened, regardless of the view you were in when you last quit the application.

17 Choose Stacks > Close All Stacks. Only single images and the picks of the stacks are now visible in the Browser.

NOTE ▶ Adjusting the hierarchy of a stack by promoting and demoting images will save time when you're looking for an alternative to your pick. You won't have to search the stack because your second image in the stack has already been designated as your second choice. Closing stacks when you're not working within a stack will free up Browser real estate to display more images.

Speed Rating Images Using Keystrokes

The rating system in Aperture can use multi-function keystrokes to speed the process of rating your images. The faster you finish rating your images, the quicker you can get back to shooting.

1 Select the first image in the Browser, **Senegal 2006-11-03 at 07-30-35**.

2 Press Control-Backslash (\). **Senegal 2006-11-03 at 07-30-35** is now a five-star image.

You're automatically moved to the next image, the woman in the doorway. The five-star rating you applied to the previous image can be seen in the Browser.

3 Press Control-Backslash (\) to assign a five-star rating and automatically move to the next image. Press Control-Backslash (\) again to rate **Senegal 2006-11-03 at 07-36-09**.

This next image seems nice, but let's take a closer look using the Loupe tool.

4 Press the Grave Accent (`) key to open the Loupe tool.

5 Drag the Loupe over the woman's forehead.

The detail in her forehead could detract from her serene expression. This is potentially a five-star image, but let's rate it with four stars and add a flag to identify it as an image that needs some work.

6 Press the Forward Slash (/) key to apply a flag to this image.

7 Press 4 to assign a four-star rating.

8 Press the Right Arrow key to select the next image.

9 Press Shift-Right Arrow to add the next image to your selection.

Both **Mauritania 2006-11-06 at 07-42-27** and **Mauritania 2006-11-06 at 07-48-55** should be selected, and both images are worth five-star ratings.

10 Press 5 to assign a five-star rating to both images.

You can also jump across sets of images by using the Command key.

11 Press Command-Down Arrow to select the next set of images.

The two-image selection moves over two images and retains a two-image selection.

TIP ▶ Press Command with the Left and Right Arrow keys to move a group selection over one image at a time. Press Command with the Up and Down Arrow keys to move over multiple images at a time, depending on the size of the selection.

It's tough working with beautiful five-star images.

12 Press 5 to add these two images to our five-star winners.

TIP ▶ Many more keyboard shortcut combinations are available in Aperture. Position your mouse pointer over each of the control bar buttons to display a help tag showing available keyboard shortcut combinations.

Reviewing Collections on the Light Table

The Light Table can be compared to the worktable in your studio where you lay out printed photos side by side. In the Aperture Light Table, you can grab images from any project, quickly align them on a grid, and scale them. The Light Table is a never-ending canvas that grows as you add more and more images. It's extremely useful for reviewing how images work together as a collection or for experimenting with editorial layouts.

Creating a Light Table

A Light Table is another item that is created and stored in the Library inspector. You can create empty Light Tables and use images from multiple projects, or you can select the images in a project or album and base the Light Table contents on the selection.

1 In the Library inspector, select the five-star Smart Album you created earlier.

The Smart Album is now filled with all the five-star images you have rated.

2 Click in the Browser to activate the window, then press Command-A to select all the images in the Browser.

3 Click and hold the New button in the toolbar and scroll down to choose Light Table.

4 Name the Light Table *NW Africa Light Table*, and press Return.

5 Press I to close the Library inspector and then press Option-semicolon (;) to close the stacks.

6 Select and drag the first two images onto the lower-left corner of the Light Table grid.

7 Click the grid background to deselect the images.

In the Browser, the two thumbnails that are on the Light Table now have small red badges to identify that they have been placed on the Light Table. You can also filter the Browser to show only images that are not on the Light Table.

8 In the tool strip, click the Show Unplaced Images button.

The Browser displays only images that are not currently placed on the Light Table.

9 Select and drag the stack and the next image in the Browser to the upper-right corner of the Light Table grid.

You can continue to add images from other albums by dragging them to the Light Table item in the Library inspector. Once you have all the images you need, you can begin to group and arrange them into a collection to see which groups work best together in a layout.

Navigating and Arranging Images in the Light Table

The Light Table is an infinite canvas that grows as necessary. You can resize, reposition, and arrange multiple image groups on one Light Table. As the canvas grows and groups spread out, how you navigate between them becomes more important.

1 Position the pointer over the smiling woman in the doorway image on the Light Table.

Resize handles appear around the image.

NOTE ▶ The resize handles show up only when your mouse pointer is positioned over an image on the Light Table.

2 Drag the bottom-center resize handle to roughly double the image's size.

3 In the Canvas, Shift-click the boy image.

4 Drag the Zoom slider to fill the screen with the boy and woman images.

5 Control-click the image of the boy and choose Arrange from the shortcut menu.

6 Control-click the image of the boy again and choose Align > Top Edges from the shortcut menu.

7 Click the Light Table Navigator button, or press Shift-N.

The Light Table zooms out, and the navigator frame appears surrounding the smiling woman in doorway image.

8 Drag the navigator frame over the man and woman images, and then release the frame.

9 Drag the image of the old man and place it under the woman image.

Yellow dynamic alignment guides will appear to help you align the images. Also, use the Light Table grid to keep the images separated by roughly half a grid space.

10 When three yellow lines appear over the old man and the woman images, this indicates that the two sides and the centers of the images are aligned. Release the image.

11 Click the "Scale to Fit" button, or press Shift-A.

The Light Table view zooms out enough to fit the two groups of images.

12 Shift-click the young woman and old man images you just aligned.

13 Drag the two images directly under the boy image, and use the yellow dynamic alignment guides to position them.

14 On the smiling woman in the doorway image, drag out the lower-left resize handle until a yellow alignment guide indicates that the bottom edge of her frame and the bottom edge of the old man's frame are aligned.

15 Click the "Scale to Fit" button, or press Shift-A.

At this point, you could work with the remaining images, experimenting with different layouts, or you could decide to print your Light Table arrangement. You'll explore printing in detail in Lesson 13.

> **NOTE ▶** Images in the Light Table cannot be directly cropped, straightened, or corrected for red eye. To perform these actions, return to the Smart Album or the original project that contains the images.

This lesson took you through what are probably the most critical post-shoot tasks you do as a photographer: evaluating detail, focus, and clarity; comparing and contrasting like-images; identifying your best shots; and laying out collections to see how it all works together. The tools in Aperture aid you in these tasks and make them flow smoothly from one to another, so in the end, you have a library that places your best work at your fingertips.

Lesson Review

1. How does Quick Preview work?

2. What is stacking?

3. What information does auto-stacking use?

4. What is the pick of a stack?

5. True or false: Rejecting an image adds it to the Aperture Trash.

Answers

1. Quick Preview uses smaller image previews rather than decoding the original image files. If the generated preview isn't available, Aperture will use the embedded JPEG, if available.

2. Stacking is a way to organize a series of similar images. You can auto-stack images or stack them manually. Stacking groups your images for viewing purposes; it doesn't change where they're stored within your Aperture library.

3. Auto-stacking uses the timestamp metadata.

4. The first image in a stack is the pick of the stack.

5. False. Rejecting an image is just part of the rating system and does not move images into the Trash.

4

Lesson Files

APTS Aperture book files > APTS iPhoto Library

APTS Aperture book files > Lessons > Lesson04

Time

This lesson takes approximately 60 minutes to complete.

Goals

Access an iPhoto library within Aperture

Merge two libraries into one Aperture library

View a photo's location on a map

Assign a location to a photo and project

Import a GPS track log

Name detected faces in a project

Assign missing faces

Create Smart Albums of specific people

Lesson **4**

Indexing Photos Using Faces and Places

In Lesson 3, you learned that metadata can come from a camera, or can be entered manually in the form of keywords, captions, ratings, and so on. Those types of metadata are great for identifying when and how the photo was taken. But how can you precisely determine where a photo was taken or who is in the photo? You could take scrupulous notes while shooting…yeah, me neither. Thankfully, there are easy and engaging ways in which Aperture can help you.

In this lesson, you'll examine two features that provide very natural ways to index photos—Faces and Places. Faces is a feature that not only detects faces of people in your photos, but with some minor assistance from you can also recognize those people. The second feature, Places, uses GPS data to identify where photos were taken.

Beginning with version 3.3, Aperture and iPhoto can share a photo library. When you adjust images using Aperture's tools, the changes appear in iPhoto, and vice versa. You don't need to import, export, or reprocess photos from one app to the other—it happens automatically. Faces and Places work across both apps, too.

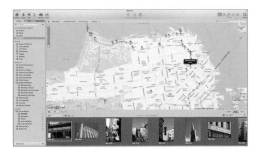

Moving from iPhoto to Aperture

For many iPhoto users, switching to Aperture is a natural progression. Aperture includes almost all the fun and elegant features of iPhoto while adding more comprehensive image management, editing, and output capabilities. The unified library makes it easy to step up from iPhoto to the advanced tools in Aperture. Or return to iPhoto to create a calendar or cards after making professional edits to images in Aperture. Whether your photos are intended for professional use, or purely for fun, you get the best of both apps.

Switching Libraries

Aperture allows you to switch between different libraries without quitting the application. These could be multiple Aperture libraries that you have for different clients or separate libraries that, due to their size, need to be stored on additional storage devices. Aperture also allows you to open iPhoto libraries, beginning with iPhoto version 9.3. This is handy for keeping your personal photos separate from your client libraries, while letting you take advantage of powerful Aperture features. And even after opening an iPhoto library in Aperture, that library is still available to iPhoto. Additionally, you can open Aperture libraries in iPhoto if you want to take advantage of some iPhoto-only features. Just make sure that only Aperture or only iPhoto is open while using the other's library.

To open a different library:

1 In Aperture, select Projects in the Library inspector.

Take note that you are currently looking at the projects contained in the APTS Aperture3 Library. These projects are the ones you have been working with thus far such as the San Diego Zoo and People of NW Africa. That is about to change.

2 Choose File > Switch to Library > Other/New.

Aperture presents the Library Selector window that lists all of the libraries available to Aperture. Here you see the current library APTS Aperture3 Library and the APTS iPhoto Library that you copied from the book's DVD during the Getting Started instructions. Below the list, you are given the opportunity to search for additional libraries or to create a new library.

3 Select the APTS iPhoto Library in the list, and then click Choose.

NOTE ▶ Click Upgrade if prompted to upgrade the library.

Aperture switches to the APTS iPhoto Library and displays its contents. iPhoto Events are displayed in the top Projects section of the Library inspector. These new projects are skimmable to allow you to preview the projects' images. You could now begin working with the iPhoto images with the advanced tools of Aperture. Let's switch back to the previous Aperture library before proceeding.

4 From the File menu again, choose Switch to Library > APTS Aperture3 Library.

The Projects displayed in the Browser and the Library inspector return to the familiar elements you had been working with previously.

Switching between libraries is painless; however, you may want to gather images from multiple libraries into one. In the next exercise, you'll create one library out of the Aperture and iPhoto libraries you used in this exercise.

Merging Libraries

Although switching between libraries is incredibly easy in Aperture, you may want to carry the images, metadata, and searches of one Aperture library into another. This scenario occurs when images you need for one project are split between two libraries. Here you will import an iPhoto library into the current Aperture library. However, you could have a situation where you want to merge two Aperture libraries as well. To import an iPhoto library into an Aperture library:

1 Begin in the Library inspector, selecting the Projects icon listed under the APTS Aperture3 Library.

2 Choose File > Import > Library.

Aperture automatically navigates to the expected location for the iPhoto library, which is the Pictures folder inside your user folder. For this book, you are utilizing an iPhoto library installed elsewhere.

3 In the Import dialog, select Documents in the left sidebar. Inside the Documents folder, select the APTS Aperture book files folder, and then select the APTS iPhoto Library. Click Import.

Aperture begins the merging process. A progress bar appears at the top of the interface.

When Aperture has finished the merger, the APTS Aperture3 Library updates to display its new contents. All of the Events of the iPhoto library now appear as projects in Aperture.

NOTE ▸ By default, importing images from your iPhoto library into your Aperture library copies the files. You end up with two original images: one in your Aperture library and one in your iPhoto library. This can double the amount of disk space used, so after importing your iPhoto images, you can delete your images from iPhoto, if desired.

Using Places to Put Pictures on a Map

You can now buy cameras with built-in or optional GPS capabilities. GPS-equipped cameras will record where you shot each picture, just as transparently as they capture EXIF metadata. If you own an iPhone 3G or newer, you already have a GPS-equipped camera. The built-in iPhone GPS hardware tags each photograph with location data.

The Aperture Places feature uses that GPS data to help you organize, filter, and find your images.

NOTE ▸ To use Places, you must be connected to the Internet. The Places maps and parts of the location database are not stored on your hard disk because they are updated regularly.

Viewing GPS-Tagged Images in Places

With Places, you can view all your GPS-tagged images on a map, or only those from a selected project. Let's start by viewing all the GPS-tagged images for all your projects.

1 In the Library inspector, select Places.

The viewer is replaced by a map view with a filmstrip view. You see only the images in the library that are currently tagged with location data. The red pins on the map indicate where photos were taken. You can change the style of your map to show a satellite, road, or default terrain view.

2 Click the Road button to change the Places map to a different style.

> **TIP** ▶ When using a Magic Mouse or a Multi-Touch trackpad, you can zoom in to the map by swiping two fingers up or down. You can pan the map by dragging your finger.

3 Place the pointer over the red pin on the West Coast of the US.

> **NOTE** ▶ Multiple photos taken in one general area may appear as a single pin until you zoom in to the map.

4 Click the arrow to the right of the pin's location label.

The map scales to view only those images associated with the selected pin.

The filmstrip view applies the Filter HUD to filter out images that are not located in the San Francisco Bay area. You'll need to clear that filter before you can view other images.

5 Clear the filmstrip view's search field by clicking the Reset button (the X to the right).

You can use the Path Navigator pop-up menus at the top of the Places view to quickly jump between locations. Let's view the pictures that were taken in Tasmania.

6 From the Path Navigator pop-up menus, choose States/Provinces > Tasmania.

TIP If Tasmania does not appear, click the "home" icon to the left of Countries first, then try step 6 again.

Another way to zoom in to the map is to draw a selection rectangle around an area.

TIP You can also zoom and pan using the map's Overview Map pane.

7 Hold down the Command key and draw a selection rectangle around the pin to the southeast of Hobart, Tasmania. The map zooms in to the area defined by the selection rectangle.

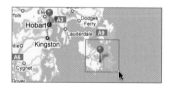

8 In the lower right of the map, click the bottom Tasmania pin. The pin turns yellow. The two photos taken in that area are highlighted in the filmstrip view.

9 Click the arrow on the right of the Tasmania pin's location label to zoom in.

10 Click the first image in the filmstrip view, **SJH180120108**.

The pin's location label appears, showing which pin represents the selected image. If you are interested only in location metadata in a selected project, you can use the Places button in the toolbar.

11 In the Library inspector, select the iPhone Images project.

12 In the toolbar, click the Places button to view the Places map for this project.

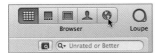

Clicking the Places button in the Library inspector shows all the locations for every project. Clicking the Places button in the toolbar shows only the locations in the selected project. The functionality is the same regardless of which view you are using.

> **TIP** If no pins or images appear, click the California button in the Path Navigator above the map.

Assigning Locations
Even without a GPS-equipped camera or iPhone, you can use Places to assign a location to a photo by dragging photos to the map.

1 In the Library inspector, select the Around San Francisco project.

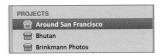

2 Select the first rhino image, **IMG_2277**.

3 Shift-click the chimpanzee image to the right, **IMG_2623**, to select six images.

4 In the Places search field, type *San Francisco Zoo*. The San Francisco Zoo appears in the list.

5 In the list, choose San Francisco Zoo.

6 Click Assign Location. The selected images are now assigned to the San Francisco Zoo. Each image that you selected in the filmstrip view now has a red pin attached to it.

You can also drop images onto the map and Aperture will attempt to find a local place of interest.

7 In the filmstrip view, select the first four images, starting with the skulls and ending with the butterfly. These images were taken at the California Academy of Sciences in Golden Gate Park.

8 On the Zoom slider, click the Zoom Out button (minus sign) four times, or until you can see Golden Gate Park at the top of the map.

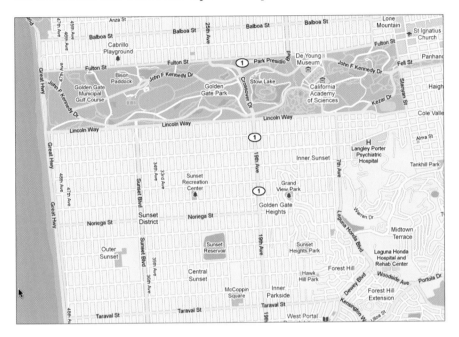

9 Hold down the Command key and draw a selection rectangle around the right half of the park to zoom in to that area on the map.

10 In the map, locate the California Academy of Sciences, and then drag the four selected images onto the gray rectangle or text that marks the academy.

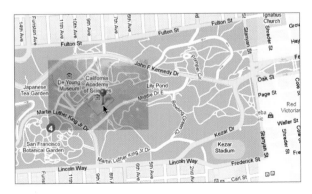

11 In the dialog that appears, click Done.

Aperture assigns those images to that map location, and also identifies the location as the California Academy of Sciences.

> **TIP** ▶ If the pin displays another location, select the pin, click the Move Pins button at the bottom left of the map, and then drag the pin to a new location. Click Done after dropping the pin.

Assigning a Location to a Project

Although it's handy to assign individual photos to specific locations, when you have a large library of images without GPS metadata, you probably don't have the time to assign a location to each photo. A quick way to benefit from Places is to assign an entire project to a location.

1 In the Library inspector, select Projects.

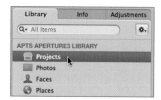

2 Place your pointer over the San Diego Zoo project and click the Info button to view the Info dialog.

3 Click Assign Location to open the Location dialog.

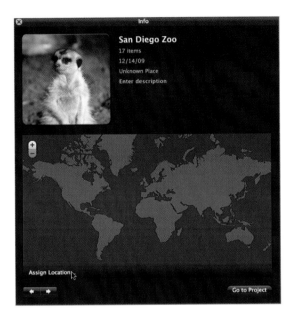

4 In the search field, type *San Diego Zoo*.

5 In the list that appears, choose San Diego Zoo.

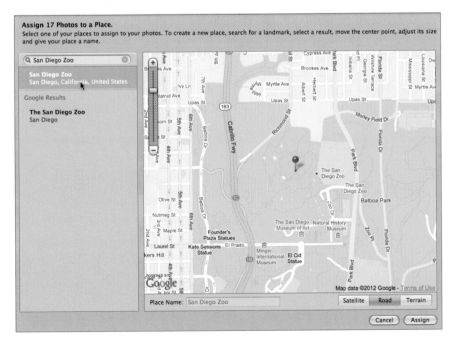

6 Click Assign to link all the images in the project to the San Diego Zoo location.

7 Close the Info dialog.

Adding an Unknown Location to the Places Database

When Aperture can identify your photo location, using Places is very easy; but what happens when the Aperture location database doesn't know your location? Let's find out.

1 In the Library inspector, select the Bhutan project, and then in the Browser, select the first image.

2 Press Command-A to select all the images.

3 In the toolbar, click the Places button.

4 Triple-click in the Places search field to select all the current text, and type *Bhutan*.

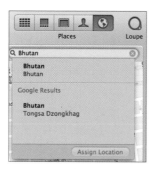

Not surprisingly, the list of places isn't long, so you'll need to add your own. When Aperture doesn't have location information in its database, it does what we all do: it uses a search engine. You can find obscure locations and even addresses by using Assign Location.

5 Choose Metadata > Assign Location. This should look a little familiar. It's the same Location window you saw when you clicked the Assign Location button on the project Info dialog.

6 In the search field, type *Punakha,* which is the town in Bhutan where these photos were taken.

7 Select Punakha in the Google Results.

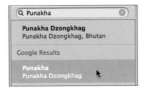

By selecting any location under the Google results, you can edit the location pin placement and the broader area associated with the location. A blue circle appears on the map that roughly identifies the area of the Punakha Dzongkhag (Fortress). Although this location is roughly where these photos were taken, the images were actually shot over a much wider area than just the fortress. Rather than be too specific, let's modify this pin to associate it with a more general area.

8 Click the Zoom slider's Zoom Out button three times and then drag the map up until the town of Wangdue Phodrang appears at the bottom of the map.

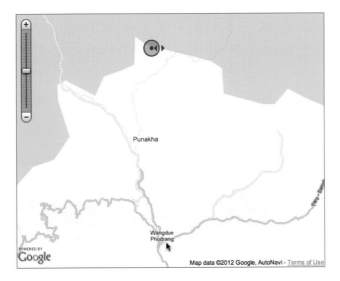

9 Use the center circle and the blue arrows at the right side of the circle to highlight the map as shown.

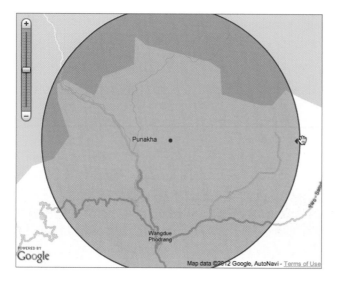

The blue circle represents the area that you will mark as the district of Punakha. Because locations can't always be represented as a single dot, Aperture allows you to assign a wider area to a given location.

The last thing you'll do is name this area more generally, as the town of Punakha is not only the Punakha Fortress.

10 At the bottom of the Assign Location dialog, in the Place Name field, type *Punakha District* and then press Tab.

TIP You can remove any location you added to the database by choosing Metadata > Manage My Places.

11 Click Assign.

Your nine photos are now assigned to a wider area in the town of Punakha, Bhutan.

Removing a Photo from a Location

You've been doing well, but you just hit a small bump. You discover that The Tiger's Nest Monastery is in Paro Bhutan, not Punakha. How did you miss that one? You'll want to move those three photos from Punakha to the correct location of Paro.

1 Press Command-Shift-A to deselect all the images in the Browser.

2 In the Browser, select the three Tiger's Nest images.

3 From the Action pop-up menu, choose Remove Locations to remove the red location badges from the Tiger's Nest thumbnails in the Browser.

4 On the Zoom slider, click the Zoom Out button, and drag the map to the right until you see the town of Paro on the left side of the map.

5 Drag the three Tiger's Nest images to the area above Paro. Click Done.

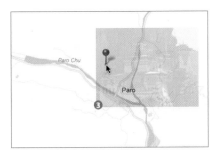

The pin and photos are assigned to *Paro District*. Aperture knows that this location is within the district of Paro, but that's as much as it knows. Fortunately, it's easy to get more specific.

6 Control-click (or right-click) the pin, and from the shortcut menu, choose New Place for Photos.

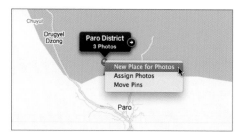

7 In the Place Name field, type *Tiger's Nest*, press Tab, and click Add Place.

You've successfully moved the 300-year-old monastery 90 miles to its correct location. Well, at least you've moved the three photos of the 300-year-old monastery to their correct location and added the location's name.

Assigning a Location in the Info Inspector

You don't always need to view such a large map when assigning an image location. You can do it within the Info inspector. It's not as swanky in appearance, but it gets the job done efficiently.

1 Click the Split View button, so you can see the Viewer and the filmstrip view.

2 Select the Around San Francisco project.

3 In the filmstrip view, select the last image, **IMG_3332**. This photo of the famous painted ladies of San Francisco should be assigned to Alamo Square.

4 In the Inspector pane, click the Info tab.

5 In the Info inspector, click the Show Map button at the bottom of the inspector. There's no location metadata assigned to this photo, so let's add it.

6 In the Location field, type *Alamo Square*.

7 In the list that appears, select Alamo Square.

8 Click the Assign Location button (checkmark) to confirm the location.

The photo now has the location marked as Alamo Square in San Francisco, but it's not as precise as you might like it. In the next exercise, you'll move it.

Moving a Pin

When Aperture assigns a location for images without GPS data, it places the pin in the center of that location. Having taken the picture, you probably have a more exact knowledge of where you were. You can move a pin to match exactly where a photo was taken with just a few simple steps.

1 In the toolbar, click the Places button.

Aperture places this photo in the center of Alamo Square. The picture was actually taken at the southeast corner of the park near Steiner and Hayes Streets, so you'll move the pin.

TIP If no pins appear, click the Places button in the Path Navigator to update the map.

🏠 United States ▾ California ▾ San Francisco ▾ 4 Places ▾

2 On the map, click the Alamo Square pin.

3 On the Zoom slider, click the Zoom button (plus sign) three or four times.

4 In the lower left of the Maps dialog, click the Move Pins button.

The pin turns purple, and a dialog appears.

5 Drag the pin to the lower-right corner of Alamo Square.

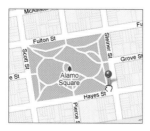

6 In the dialog, click Done to confirm its new location.

Being able to move a pin to the precise location where the photo was taken makes Places just as valuable for the photos in your library that lack GPS data, which is probably most of them.

Importing GPS Track Files

You aren't limited to assigning locations manually or taking pictures only with your iPhone. You can get location data for your images in other ways, such as using a small handheld GPS receiver that can continuously capture location data and save it as a track log in GPX format. If you don't want to carry a separate GPS device, certain iPhone apps do the same thing. Path Tracker is one such app that can record and save your iPhone location data as a GPS track log that you can add to Aperture.

> **NOTE** ▶ Track log files include GPS receiver data. Aperture imports two track log formats: NMEA and GPX.

1 In the Library inspector, select the Around San Francisco project, if necessary.

2 In the toolbar, click the Places button, if necessary.

3 From the GPS pop-up menu below the map, choose Import GPS Track.

> **TIP** ▶ You could also apply location information from iPhone photos to photos in your Aperture library by choosing GPS > Import GPS from iPhone Photos.

4 Navigate to APTS Aperture book files > Lessons > Lesson04.

5 Select San Francisco GPS Track.gpx, and click the Choose Track File button to import the track log.

With the track log imported, you can see the path that was taken during the time the photographs were shot. The track log includes timestamps that are recorded every few seconds. Because your photos have times associated with them, Aperture can match times and locations for perfect placement of each photo.

> **TIP** ▶ Make sure your camera's date/time is correctly set. The GPS device will always get the proper time from the GPS signal but your camera requires your assistance.

Since many of your photos in the Browser already have locations assigned, it would be easier if you could just view the images without location data.

6 Clear the Browser's search field first, then click the Show Unplaced Images button.

7 In the Browser, select the first image of the cable car, **IMG_2660**.

8 Zoom in and reposition the map if necessary to focus on the lower right of the GPS track. Drag the image onto the starting point of the track log. You can find the start-

ing point by dragging the image over the track path and dropping when the label says 14 hrs 0 minutes.

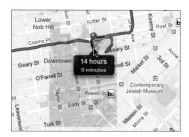

9 From the dialog that appears, choose Assign Location. Each photo is placed along the track according to the time it was taken.

TIP ▸ Typically, GPS logs are created using UTC (Coordinated Universal Time, or to those of us less technical, GMT, Greenwich Mean Time). Aperture automatically assumes that track logs are UTC based and shifts the track log times based on your Mac clock settings. If your GPS device is not based on UTC time, this can cause an offset. If the track log's timestamp is offset, you can change the time zone in the GPS menu just as you modified the time zone of the Africa images in Lesson 2.

Creating a Smart Album from a Map

Now that you have tagged all your photos with location information, you can create geography-based Smart Albums.

1 From the Library inspector, select the Places view.

2 From the Path Navigator pop-up menus, click the Home button to see the entire world map.

3 Command-drag a selection rectangle around the pins located in the western United States. This scales the map to show only that area.

4 From the Action pop-up menu at the bottom of the map, choose New Smart Album from View.

5 In the Library inspector, type *Western US* as the name of the new Smart Album.

6 In the toolbar, click the Places button to see a map of all the locations for images taken in the Western US if necessary.

 TIP If no pins appear, click the United States button in the Path Navigator above the map.

 In the future, if you add any images to your library that fall within the region defined for that Smart Album, they automatically will be added to that Smart Album. If you want to narrow your Smart Album to a specific state or city, you can use the Smart Album's Smart Settings HUD.

7 Click the Smart Album's Smart Settings HUD.

 The Area checkbox sets your criteria to include images that fall within the area viewed in the map.

8 Deselect the Area checkbox.

9 From the Add Rule pop-up menu, choose Place, and select the Place checkbox.

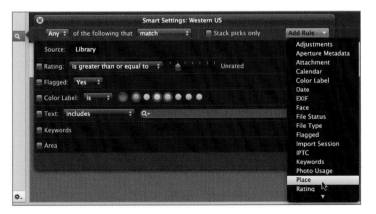

10 In the Place field, type *California* to narrow the geographical area for this Smart Album.

11 Close the Smart Album's Smart Settings HUD.

Organizing a Library Using Faces

Now that you know where your images were taken, you'd also like to know who is in them. Faces is an Aperture feature that not only detects human faces in images (not dogs or cats) but can also recognize the same face throughout your library.

Using Faces View

Like Places, Faces can be applied to an entire library or only a single project. You can choose which by using the Faces view in the Library inspector, or as in this exercise, clicking the Faces button in the toolbar.

1 In the Library inspector, select the Catherine Hall Studios project.

2 In the toolbar, click the Faces button.

Aperture opens the Faces view, which is initially displayed as an empty corkboard with a special filmstrip view at the bottom of the window. The thumbnails are zoomed in to each face that Aperture detects in the project images. The next step is to assign names to those faces, which will add them to the corkboard area. Let's focus on finding all the photos of the bride and groom in this wedding.

3 On the first image in the filmstrip view, click the label to ready it for text entry.

4 Type *Cathy* and press Return.

5 The next image in the Browser is selected and ready for naming; verify the image is of the first man, and then type *Ron* and press Return.

> **TIP** ▶ If you are a fan of cork, you can leave the design alone. If you desire a less photorealistic design, you can turn off the corkboard look from the Appearance section of Aperture preferences.

Confirming and Rejecting Matches

The corkboard is the place where any face that is detected and given a name is displayed. Each image on the corkboard represents one or more photos that depict that person.

1 Double-click the Cathy image located on the corkboard.

Double-clicking an image on the corkboard displays the confirmed images of that person. Images are displayed in the lower part of the window that Aperture believes may also contain that person.

You'll need to confirm or reject the images on the lower part of the window. Let's zoom in to make it easier to identify which faces Aperture thinks are similar to Cathy's.

2 At the bottom of the window, click Faces to zoom in to the face in the photo that Aperture thinks could be Cathy.

Not all of these images may be of Cathy, so you'll only confirm those that are.

3 Click Confirm Faces.

4 In the bottom half of the window, click the image similar to the one shown here.

A green highlight indicates that this image will be confirmed as Cathy when you click Done. Let's find a faster way to confirm the remaining images.

5 Drag a selection rectangle around a few images of Cathy. Continue to click or drag to select the Cathy images.

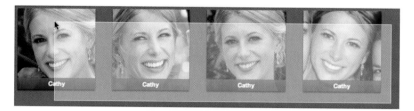

6 Click Done. Now you can confirm the photos with the groom in them.

7 Click the All Faces button.

8 Double-click Ron.

9 Click the Faces button to zoom in, if necessary.

10 Click Confirm Faces.

11 Drag a selection rectangle around the confirmed images of Ron, leaving those images of other people out of the selection.

12 Click Done.

By confirming more images, Aperture has more angles, lighting, and facial expressions to evaluate, giving a better idea of what Ron looks like in multiple situations. After reanalyzing the remaining photos, Aperture identifies more photos that may contain Ron.

13 Click Confirm Faces.

14 Click once on the images of Ron.

15 Click twice on the images of other people to mark them as Not Ron.

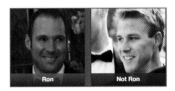

16 After verifying your "Ron" and "Not Ron" selections, click Done.

17 Click the All Faces button to return to the Faces view.

You could continue confirming and rejecting faces as Ron, but you get the idea. The recognition isn't infallible, so prepare to find some misidentifications. However, Aperture can be incredibly helpful overall at quickly finding images of important people in your library.

Adding a Name to a Face

You can also use the Name button to add names to faces. In some cases, faces may be detected but—because of lighting, aging, or the way a head is tilted—the face may not be recognized as one of the people you've already identified. You can click the Name button to link the face with the appropriate name.

1 In the Library Inspector, select the Catherine Hall Studios project, and select the Browser view button from the toolbar.

2 Double-click the first image in the Browser, **02_0058_HJ_036-2**.

3 In the toolbar, click the Name button.

4 A face label is displayed as *unnamed*. Type *Cathy* in the face label. Before you complete the name, Cathy's ID will appear in the list.

5 From the list, choose Cathy to assign the name, then click Done.

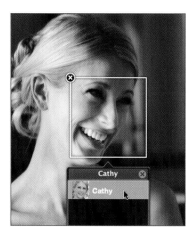

TIP ▸ You can remove a face label by selecting the photo, clicking the Name button in the toolbar, and clicking the Remove button in the top-left corner of the positioning box.

Adding Missed Faces

On occasion, your subjects won't be looking into the camera, so Aperture may not find their faces. Yet, you still may want to identify them in the shot. Aperture has a way for you to manually identify a face and assign a name.

1 In the toolbar, click the Browser button, or press V until the Browser is displayed.

2 Scroll the Browser until you see the image **23_0484_HJ_256**.

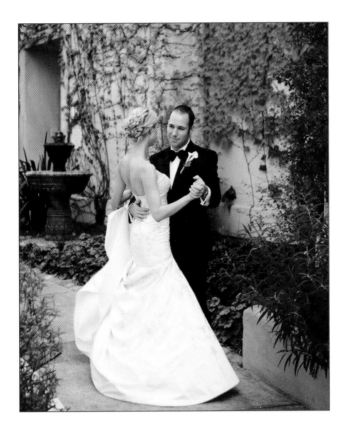

3 Double-click the image to display it in the Viewer.

4 In the toolbar, click the Name button.

As you can see, Aperture found Ron's face but not Cathy's because she is facing away from the camera. You can add Cathy so this photo shows up when you search for her.

5 In the dialog, click the Add Missing Face button.

6 Drag the rectangle to position it over Cathy's head.

7 In the face label, begin typing *Cathy*.

Cathy's name and picture are displayed.

8 From the list, choose Cathy to assign her name to the image. Click Done. This image is added to the collection of Cathy photos.

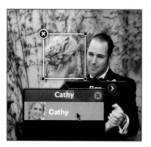

Adding Facebook IDs to Faces

If you use Facebook to share photos, you can can automatically convert Faces information into Facebook tags and share with the people identified in the photos. All you need are their Facebook IDs.

1 In the Library inspector, select the Faces view.

2 On Cathy's picture, click the Info button.

Here is where you would enter the email address associated with the recipient's Facebook ID. You will also need to confirm that the default preference is still in place to share the Faces info. Aperture does not publish the email address on the web. The address is only used on Facebook to announce that the person has been tagged in a photo.

3 Close the Info window.

4 Choose Aperture > Preferences, and click the Export button.

5 Make sure that "Include face info in exported photos" is selected. When this option is selected, the name of the subject is added to the exported image's metadata as a keyword.

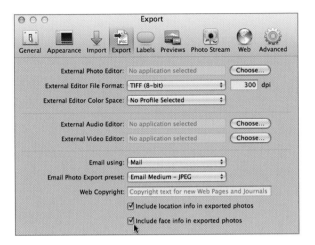

6 Close preferences.

Creating a Faces Smart Album

After you have applied names to Faces, you can create Smart Albums based on the people in your photos.

1 In the library, select the Faces view, if necessary.

2 Shift-click Cathy and Ron's images.

3 Drag the two images to the Albums section in the Library inspector, and then press the V key to view the Browser only.

A Smart Album is automatically created with the name Cathy or Ron. But what if we wanted this Smart Album to only include photos with Cathy *and* Ron?

4 Click the Smart Album Smart Settings HUD.

5 In the pop-up menu at the top left of the HUD, change Any to All.

6 Close the Smart Settings HUD.

7 Click the Smart Album's name to highlight it.

8 Double-click the word *or*, which is in the title of the Smart Album.

9 Change the word *or* to *and*, and then press Return.

Faces and Places information is based on emerging and constantly evolving technologies. It eventually will become essential search criteria just as keywords and EXIF metadata are today. Although Faces may make a wrong suggestion at times, and not everyone has a GPS for their camera, the flexibility of these features means any library can benefit from this technology today and reap even greater rewards as the technology matures.

Lesson Review

1. How do you switch between libraries within Aperture?

2. What command allows you to merge two Aperture libraries?

3. What is GPX?

4. How do you view a map only for photos of a certain project?

5. Where do you find the menu to create a new Smart Album based on the Places view?

6. How do you add a name to a face that has not been located by Aperture?

Answers

1. Choose File > Switch to Library. In the submenu, select Other/New to select another Aperture Library or to open an iPhoto Library. If you have previously opened the library, you will find it listed in the submenu.

2. With the destination library active within Aperture, choose File > Import > Library. You may also use this feature to merge an iPhoto library into an Aperture library.

3. GPX is one of the GPS track log file types that Aperture can import. The other supported format is NMEA.

4. Select the project, and then click the Places button in the toolbar. Selecting the Places view in the Library inspector will show you the locations for all projects.

5. The "New Smart Album from View" is found in the Places Action pop-up menu in the tool strip.

6. Select an image to display in the Viewer. In the toolbar, click the Name button, and in the dialog click the Add Missing Face button. Finally, type a name in the label.

5

Lesson Files APTS Aperture book files > Lessons > Lesson 05 > Memory_Card02

Time This lesson takes approximately 90 minutes to complete.

Goals Import referenced files

Create a backup during import

Manage images and referenced files

Create folders and move images between projects

Work with multiple libraries

Move projects between Macs

Back up and restore images using vaults

Managing Projects and the Library

You organize your projects in the library for the same reasons you place documents in Mac folders. It not only organizes your content and makes image collection easier to find, it also puts your images in context. Because the criteria you use to organize your shots should be based on your personal workflow, Aperture offers a range of organizational options that start with choosing where you want to keep original images.

In this lesson, you'll import images as referenced files that are stored outside the Aperture library, and use folders to manage a growing number of projects. Then, you'll create simple backups and more sophisticated backups called *vaults*.

Importing Referenced Images

In Aperture, you have considerable flexibility when deciding how your original images are organized on your hard disk. Many users prefer the convenience of a *managed* library, which has been your approach in the previous lessons. A managed library keeps your images organized in one container, the Aperture library. The benefit of having Aperture manage your originals is the simplicity and reliability of knowing exactly where every image lives. It also ensures that your originals are always accessible to Aperture. Additionally, a managed library provides benefits such as one-click backup of original images into a vault.

> **NOTE ▶** Managed libraries are just folders placed in a container that OS X calls a package. The package hides the folder structure, by default; it also stores the original files in their native formats so that you can easily remove or extract original images, as needed.

If you want to maintain an image folder structure you've already created in Finder, you can choose to import images using a referenced library approach. That is, you can link or reference those images in Aperture from their existing locations, rather than copying them into an Aperture library.

The referenced library approach allows you to add images from multiple locations, including multiple hard disks, without duplicating files. This gives you more flexibility over where you store your original images. Less frequently used images can be stored offline (such as on an external hard disk), yet you can still see previews of those images in Aperture.

Using an Aperture-managed library is not inherently better than using a referenced library, or vice versa. It's really a matter of personal choice and workflow. Using a referenced library offers storage flexibility, but places the onus on you to manually manage your folder structure and backup strategy. Using a managed library reduces the time you spend managing assets, but requires that your "current" library be stored in one location.

> **NOTE ▶** You can have as many Aperture libraries as you choose, but you can view only one library at a time.

Choose a Location for Referenced Files

Now that you understand your library options, let's import referenced files. The settings you need are located to the right of the Import browser.

1 In the Dock, click the Finder icon.

2 In the Finder, navigate to APTS Aperture book files > Lessons > Lesson 05.

3 Double-click **Memory_Card 02.dmg** to mount the disk image, which is simulating a memory card. The disk image may take a moment to mount. When it's mounted, you'll see a removable media icon called **NO_NAME** on your desktop.

The Aperture Import browser will automatically come to the front, displaying all the images stored on your simulated memory card.

4 In the Import Settings pane, in the Project Name field, type *Uganda The Pearl of Africa*.

Yes, you've done this before. But here is the new part. You can choose to store images in the Aperture library or anywhere else on any hard disk. In this case, the images are stored on a memory card. You'll copy these files from the memory card and place them within a folder in the Pictures folder of your Mac hard disk.

5 From the Store Files pop-up menu, choose Pictures.

6 From the Subfolder pop-up menu, choose Project Name.

7 From the Import Settings pop-up menu, choose Rename Files to remove it from the Settings window. Then, from the same pop-up menu, also choose Time Zone and Metadata Presets.

If you don't choose a subfolder, all the images will be stored in the Pictures folder, which might be an organizational mess. By choosing Project Name as the subfolder, the images will be saved to a "Uganda The Pearl of Africa" folder within the Pictures folder.

> **NOTE ▶** Although Aperture uses the terms managed library and referenced library, libraries and projects can include both managed files and referenced files. Even so, it's a good idea to set up your library in a consistent manner and choose one organizational approach or the other.

Excluding File Types on Import

Some DSLRs capture more than just photos. In the same way that you can choose which photos to import, you can also choose which file types to import from a memory card. The simulated memory card you work with in this lesson includes two video files, identified by the small video icon in the lower-right corners of the thumbnails. You can preview video clips in the Browser and then decide whether to import them.

1 Double-click the last image in the Browser, **MVI_9861.MOV.** This is a video clip shot on a DSLR with video recording capabilities.

2 Move your pointer to the lower part of the Viewer and click the Play button that appears. These video files were not that interesting. Let's not import them to your library.

3 Double-click the Viewer to return to the Import browser.

4 From the Import Settings pop-up menu, choose File Types.

5 Select "Exclude videos" to tell Aperture not to import video files.

Excluding videos hides video files in the Import browser and keeps them from being imported.

Creating a Backup During Import

If you have an external hard disk, you can easily initiate a simple backup of your original images in the import settings.

1 From the Import Settings pop-up menu, choose Backup Location.

2 From the Backup To pop-up menu, choose Documents.

3 From the Subfolder pop-up menu, choose Project Name.

Whether you are using a managed or referenced library, creating a backup of your originals is always a good idea. You want to back up to an external hard disk to keep your backup separate from your library.

NOTE ▸ Configuring a backup in the import settings backs up only your original images. Later in this lesson, you'll create a vault, which is a backup that saves the images along with any metadata and adjustments you applied.

4 Near the bottom of the Import pane, click Import Checked. When the images finish importing, leave Eject No_Name selected and click Keep Items.

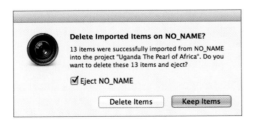

Although you are importing images as referenced files, Aperture creates previews and adds metadata in the library that it tracks along with the referenced files. This way you can see previews of the referenced files and associated metadata even when they are located offline on a disconnected hard disk.

Exploring Additional Import Settings

You've already used a number of the import settings in Aperture, but there are still others that can be of benefit with more specific workflows:

▶ Actions—Using AppleScript, you can trigger actions to take place just after an import is completed. Learn more about AppleScript from the Apple.com website and discover more about AppleScript actions at www.apple.com/aperture/resources.

▶ Effects—In some cases you may import multiple images that require similar adjustments, such as a white-balance correction or black-and-white conversion. Effects can be added to adjust all your images during importing, which saves you from doing it later.

▶ RAW + JPEG pairs—Many photographers shoot RAW + JPEG pairs in their cameras to have both formats available if they need them. This Aperture import setting allows you to import both formats or only the format of your choice. If you import both, the two matching files appear as one image in the library. You can select which format is viewed, and you can swap selections with a simple Control-click (or right-click.) If you choose to import just one format, you can apply this setting to import the other format at a later date and pair the two files as if you previously had imported both formats.

Working with Referenced Images

Referenced files appear in Aperture the same way managed files appear, with one exception. Referenced files have a badge in their lower-right corners that designates them as referenced files.

Because these files can be located anywhere on any hard disk, file management issues can arise that are unique to working with referenced images. Let's look at some of those problems and how Aperture minimizes their consequences.

Finding Your Original Files

Among the reasons to use referenced files is the possibility that your images will exist in the OS X Finder like any other file. You have instant access to your original images anytime you want—if you can find them. Because referenced files can live anywhere on any hard disk, locating one in the Finder is not as intuitive as seeing that image in an Aperture library browser. So, you may want to have Aperture help you locate a referenced file in the Finder.

1 In the library, select the Uganda The Pearl of Africa project.

2 Click the Browser button, or press V until the Browser is displayed.

3 Select the cattle image, **IMG_9359**.

4 Choose File > Show in Finder. You return to the Finder. The folder where the image is stored is displayed with your image selected.

Repairing Broken Links

When using a referenced library organization, your images are "free range" images. That is, they are located in folders on your hard disk, and like any other file on your Mac, they can move around. Because Aperture isn't managing those referenced files, it knows only where they were when you imported them. If you use the Finder to move them to a new hard disk, you'll break the link between the versions in the Aperture library and the actual original files on the hard disk.

Aperture is pretty smart about files that have moved to new locations on the same hard disk. It can usually find those on its own. Broken links occur most often when you use the Finder to move images to a different hard disk. However, when necessary, you can repair broken links between the Aperture versions and relocated original files.

1 Quit Aperture.

2 In the Finder, select the cattle image, **IMG_9359**, if it's not still selected from the previous exercise.

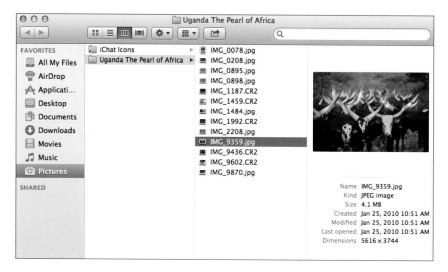

You are going to break a link by dragging all the images from the "Uganda The Pearl of Africa" folder into the Trash. You will not empty the Trash—you will just move the files there for this exercise.

3 Press Command-A to select all the files in the "Uganda The Pearl of Africa" folder.

4 Choose File > Move to Trash, or press Command-Delete. The Trash is one location in which Aperture will not automatically locate your images, even though the image is technically on the same hard disk.

5 In Aperture, double-click the cattle image in the Browser. You can see that the image has a small yellow warning badge in its lower-right corner.

The yellow warning badge covers the referenced file badge to indicate that the original file is not located where Aperture thinks it should be. You can still view images in the Viewer, but you are viewing only the Aperture previews.

NOTE ▶ If missing referenced files are linked to an external hard disk that is offline, Aperture will automatically relink the files when the hard disk is reconnected.

6 Click the Adjustments tab. When original files cannot be found, adjustments cannot be performed, so the Adjustments inspector parameters are dimmed and files will not export.

OK, let's use our imaginations for a moment to explore relinking in Aperture. You are going to use the disk image you used earlier to simulate a new hard disk where you moved your images. You'll first mount the disk image. Aperture will think you'll want to import, so you'll cancel that. Then, you can use the disk image to simulate an external hard disk.

7 In the Dock, click the Finder icon.

8 In the Finder, navigate to APTS Aperture book files > Lessons > Lesson 05.

9 Double-click **Memory_Card 02.dmg** to mount the disk image.

The Aperture Import browser will automatically come to the front, displaying all the images stored in the disk image. Let's cancel the Import dialog and use the disk image to simulate an external hard disk on which to store your original images.

10 In the upper-left of the Import dialog, click the Cancel button.

11 In the toolbar, click the Browser button, or press V until you see the Browser.

12 Press Command-A to select all the images in the Browser. Notice that all the images have a yellow warning badge because they all have missing original files.

13 Choose File > Locate Referenced Files.

The top half of the dialog shows the missing files and their last known paths in red. In the bottom half of the dialog, you can navigate to the current image locations.

14 Select the first item in the list.

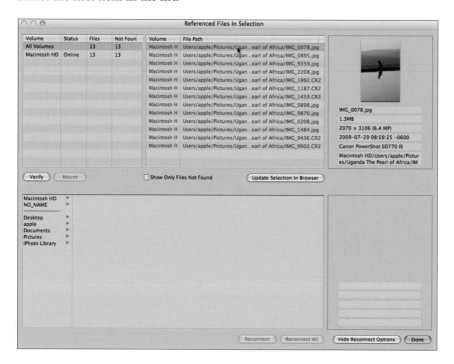

15 In the bottom half of the dialog, find the same file from the path NO_NAME > DCIM.

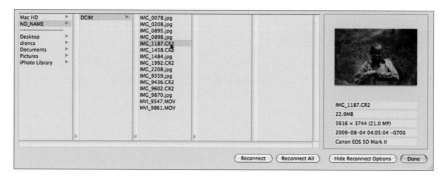

16 Click Reconnect All. Click Done.

The yellow badges no longer appear on the images, and the versions in Aperture link
to the original files on your new hard disk. Remember, you are using this disk image
to simulate a new hard disk. It's generally not a good practice to store images on a
memory card because they are too easy to erase.

Now let's use Aperture to return the files from the Finder to the "Uganda The Pearl of
Africa" folder.

Moving Referenced Images

If you want to move referenced files from one location or hard disk to another, use
Aperture to move them, not the Finder.

1 Press Command-A to select all the images in the Browser, if they're not still selected
from the last exercise.

2 Choose File > Relocate Originals.

3 In the dialog, select the destination for your images—in this case, Pictures > Uganda
The Pearl of Africa.

4 From the Subfolder Format pop-up menu, choose None because you already have the
"Uganda The Pearl of Africa" folder.

5 Make sure Name Format is set to Original File Name. This will ensure that the original file is not renamed.

6 Click Relocate Originals. The original files are moved (not copied) from the NO_NAME disk image to the "Uganda The Pearl of Africa" folder.

NOTE ▶ Because you just removed the files from the NO_NAME disk, if you want to repeat the exercises in this lesson, you will need to reinstall the Lesson 5 files from the DVD provided with this book.

Converting Referenced Images to Managed Images

If you choose to start organizing your images using a referenced library setup and later find that it's not the way you want to work, you can change your mind and convert to a managed library organization at any time.

1 In the library, select the Uganda The Pearl of Africa project.

2 Choose File > Consolidate Originals for Project. A dialog appears that provides the option to move or copy the images into the Aperture library.

3 Select Move Files.

4 Click OK. The referenced file badge will be removed as each image is consolidated into the Aperture library.

> **NOTE ▸** Although the Consolidate Originals dialog warns that you cannot undo this operation, you can turn managed files into referenced files using the Relocate Originals menu item, as you did in the previous exercise.

Organizing a Growing Library

As a library grows over time you can do many things to make it more manageable. In this exercise, you'll add more hierarchy to your library projects and create a working strategy for moving between your portable and your desktop. Then, you will utilize the vault system in Aperture to back up all your images, projects, metadata, and adjustments.

Using Folders

When you have too many projects, Light Tables, albums and so on in your library, you can use folders to create an additional hierarchy layer to make your content more orderly and improve organization.

> **TIP ▸** If you have a structure of folders, albums, Light Tables, and other items you want to use in other projects, you can choose File > Duplicate Project Structure to create an empty duplicate structure for a new project.

1 In the Library inspector, select the People of NW Africa project. From the toolbar, choose New > Folder, or press Command-Shift-N.

> **TIP ▸** A new folder is created under the project you select, or on the same level if you select an album, Light Table, book page, or webpage item. If you want a folder to contain multiple projects, make sure that nothing is selected in the library, and then from the toolbar, choose New > Folder.

2 Name the new folder *Albums*, and press Return.

3 Click the NW African Men album, and then Shift-click the NW African Women album. All the NW African albums are selected.

4 Drag the albums into the Albums folder. All four albums are now organized into a folder.

> **TIP** If you place multiple projects into a folder, you can view all the images together by selecting the folder.

> **NOTE** ▸ Folders can be used to group any items in the library with the exception of the top-level projects, photos, faces, places, flagged, or trash items.

Moving Images Between Projects

At times, you may want to move or copy images to other projects. For example, you have just a single, lonely photo in the Iceland Landscapes project. Let's rename that project to Landscapes and move other landscape images into it to make a more satisfying image group.

1 Set the main window layout to display the Browser, if necessary.

2 Select the Iceland Landscapes project.

3 Click the Iceland Landscapes name to enable text editing and type *Landscapes*.

4 Select the Dakar Landscapes project.

5 Select the first image in the Browser. Press Command-A to select all three images in the Browser and then drag them onto the Landscapes project.

6 Select the Landscapes project. You can see that you've just moved the images into a new project.

7 Control-click the Dakar Landscapes project, and from the shortcut menu, choose Delete Project.

NOTE ▶ If you drag an image into a different project, the image will be moved, not copied, to that project, and will no longer appear in Smart Albums created in the original project. If, however, you drag an image to an album underneath a project, the file is referenced in the album and in the original project.

Creating Favorite Projects

The library can become loaded with items very quickly. Adding folders to your hierarchy can improve the organizational structure, but they also add to the time it takes you to find projects and albums. Fortunately, you can search your library and create favorite projects, albums, Light Tables, and other items that help you find files more easily.

1 In the Library inspector, click in the search field and type *women*. The People of NW Africa project is displayed with the NW African Women album under it.

2 Select the NW African Women album.

While you have it here, let's ensure the image of the woman in the blue head scarf is flagged. With the photo flagged, you can quickly find it when you want to perform some image adjustments.

3 In the Browser, click in the upper-right corner of the image to flag this photo, or
select the thumbnail and press / (slash), if necessary.

Now, after that small detour, let's create a favorite.

4 In the library, from the Action pop-up menu, choose Add to Favorites.

NOTE ▸ You can remove a favorite by selecting the item in the library, and from the
Action pop-up menu, choosing Remove From Favorites.

5 Clear the search field.

6 Click the search field pop-up menu icon to the left of the search field, and choose
Favorite Items. You can see that you now have favorites!

7 When you finish staring in amazement at your favorites, click the search field pop-up menu again, and from the pop-up menu, choose All Items.

Using Multiple Libraries

When importing images, the Aperture default behavior is to create a managed library with all your photos stored in the Aperture library. Depending on the size of your hard disk, how many photos you have, and your reckless need to shoot maximum megapixel RAW files, your library could quickly fill all your available storage space.

You can work around this problem and still use a managed library by creating multiple libraries. Aperture allows you to specify where your Aperture library is stored, so there's no reason you can't save multiple libraries to different hard disks.

1 To create a new Aperture library in a new location, start by choosing File > Switch to Library > Other/New from the menu bar.

2 Click Create New, in the dialog that appears.

In the sheet that appears, you can customize the name of the Aperture library and specify the library's location. If you need to see a full Finder window, click the expand arrow (the down pointing arrow) to the right of the Save As field.

3 Rename the library as "Aperture Library 2" and set the destination as the Documents folder. Click Create.

Aperture will create and then switch to the new, empty library, but it has not deleted the images from your old library, which is still intact in its original location. Instead, Aperture has created a new library container at the location you just specified.

NOTE ▶ Creating a new library in your Documents folder when you are running out of storage space on your hard disk probably isn't the smartest thing to do. In the "real world," outside of this book, you would select a large external hard disk as the destination for your new Aperture library.

4 To return to your old library, choose File > Switch to Library > APTS Aperture3 Library.

Your old library returns with the Projects view selected, and ready for you to begin working.

Syncing Two Libraries

If you are working on location using your portable Mac, you can create projects just as you do on your desktop Mac. Depending on the amount of storage space you have avail-

able, you can import the images into the Aperture library, or store them on an external disk and import them as referenced files.

When you get back home, you'll need to copy any changes you've made on the road back to your desktop Mac—including any new imported images, new projects, and metadata changes. The easiest way to do this is to export the new project as a library.

1 In the Library inspector, select the Tasmania project.

2 Choose File > Export > Project as New Library.

3 Leave the Export name as is, select your Desktop, and click Export Library.

> **NOTE ▸** Projects that are exported remain in the originating library. Copies of all the images are created in a new library when you export.

If the project contains only managed images, those will be included in the exported package. That's the easiest path.

If the project contains referenced images located on your portable hard disk, you have two options: First, you could export the project and retain the link to the files' current location. Then, from the Finder, copy the images to a location on your desktop Mac. Second, you could select the "Copy Originals into exported library" checkbox when you export from your portable to create a managed library that contains your entire project, including all the original images. After you merge the portable's library into your desktop Mac library, you can relocate those originals as referenced files, if you choose.

Let's pretend the library you created earlier is your desktop Mac library.

4 Choose File > Switch to Library > Aperture Library 2.

5 To import the Tasmania project file into Aperture, choose File > Import > Library. Then navigate to the Tasmania Library on your Desktop, and click Import.

TIP ▶ You can drag projects from the Aperture library onto your Mac desktop or to another Finder location as an alternative way to export it. You can also drag a library from the Finder into your open Aperture library to import and merge it.

Aperture will merge the project into your existing Aperture library. If the imported project contains original images, they will be copied into the library as managed images. If it contains referenced images, and you manually moved the images to a disk on your Mac computer, you will need to use the Locate Referenced Files dialog to reconnect the images.

6 Choose File > Switch to Library >APTS Aperture3 Library to return to your main working library.

7 When importing is complete (and only when it is complete!) and you decide to quit Aperture for the day, remember to delete the exported project file on your Desktop. That's just good housekeeping.

NOTE ▶ Before you import, make sure the project does not already exist in your library. If it does exist and you are importing a newer version, a dialog will appear prompting you to choose between adding the newer project or merging the changes into the existing project.

Between referenced images, import/export of projects, and Aperture controls for managing referenced files, you should find that you can easily move select portions of your library from system to system, making it easy to spread your work across multiple Macs.

Backing Up Using a Vault

Earlier you created a backup during import. That's a quick and easy way to back up original images, but what about backing up all the projects, keywords, and ratings you applied, as well as the Smart Albums you created and image adjustments you made? How do you back up all that work? Aperture has a vault system that makes it very easy to incrementally back up not only your images, but also all the work you've done in Aperture.

1 From the Vault Action pop-up menu, choose Add Vault.

A dialog appears that shows the number of managed files that will be included and the number of referenced files that will not be included. All your adjustments, ratings, and other metadata will be saved in the vault no matter where the original images are located.

2 Click Continue.

It's important to select a qualified location for your vault. Vaults that include managed files need just as much space as your library occupies. So you need to select a hard disk that has sufficient available storage space. In the real world, you would select an external hard disk. For the purpose of this exercise, we'll simulate it.

3 In the Save As field, type *Apple Training Vault*. Click Add, and then click Show Vaults at the bottom of the Inspector.

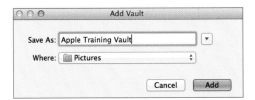

A red circular icon appears near the bottom of the library. This is the Update All Vaults button. It's red because none of the images have been updated into the vault. The Update All Vaults button changes color to indicate the current vault state.

Button Color	Meaning
Red	Images have been added to the library but are not backed up.
Yellow	Changes to images (such as adjustments or keywords) have been added but are not backed up.
Black	The vault is fully up to date.

4 If you haven't already, click the Show Vaults button.

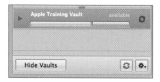

5 Click the disclosure triangle next to Apple Training Vault. A vault status button is also shown here for each vault. The same red, yellow, and black labels are displayed for each vault you create.

Clicking the disclosure triangle shows where the vault is stored, and the color-coded bar indicates the amount of storage space available and how much is used by the vault.

In the Vault Action pop-up menu, you can choose to update a vault, restore a library from a vault, or delete a vault.

TIP Updating vaults cannot be canceled and it prevents you from working in Aperture. It's a good idea to update your vault when you are ready to take a break or at the end of the day when you will no longer be working in Aperture.

6 From the Vault Action pop-up menu, choose Remove Vault.

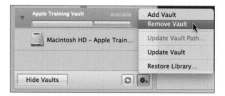

7 In the dialog that appears, click Remove and Delete.

You should now understand how to create a flexible Aperture Library that is well orga-
nized and securely backed up. There is no single right way to organize and manage your
library. Whatever works best for you is the correct way, and if you change your mind
down the road, the tools are there to help.

Lesson Review

1. Describe the difference between a managed library and a referenced library.

2. Which backup method backs up your managed, original images and all the projects,
 metadata, and adjustments you've applied in the Aperture library, and which backs up
 only your original images?

3. How do you select a new location for your Aperture library?

4. What is the difference between using the Consolidate Originals and Relocate
 Originals options?

5. What happens to referenced files when you back up using a vault?

Answers

1. A managed library stores all your original images in the Aperture library. A refer-
 enced library can store original files anywhere.

2. The vault backs up your entire Aperture library and all its managed items. A backup
 created in the import settings backs up only original images.

3. Choose File > Switch to Library > Other/New and use the Create New button to indi-
 cate where you'd like to store the new library.

4. Consolidate Originals is used to move referenced files into the Aperture library,
 thereby making them managed originals. Relocate Originals is used to move refer-
 enced files to a new location on your hard disk. If you use Relocate Originals on a file
 that is stored within the Aperture library, that file becomes a referenced file.

5. Nothing. Referenced files are not included in vaults. Only managed files, projects, and
 other library items, metadata, and adjustments are included in the vault.

Cameo: Catherine Hall

Something Old and Something New

WHILE HER CLIENT ROSTER boasts companies such as John Deere, Goldman Sachs, and Reuters, San Francisco-based photographer Catherine Hall's passion is delivering top-notch wedding photos to couples worldwide—as well as teaching and judging at top international workshops and tradeshows.

A photographer since the age of 16, Hall began her career as a protégé of venerable photojournalist Steve McCurry and shot photos for Getty Images before her first wedding assignment in 2006. Today, couples make up three-quarters of Hall's clientele, and she was recently voted "Best Weddings, Photographer" by prominent wedding website The Knot. Evolving to please a younger, social media-savvy demographic, Hall has embraced new ways to share their images, while still offering traditional photo-sharing formats.

Typically, how many deliverables do you create for a single project?

Couples always get a DVD of unretouched digital negatives in JPEG format. I never give them retouched images on DVD. There's a huge artistry that goes into

retouching, and I believe it's important to maintain control over the final product so that my clients receive the best.

Ninety percent get an album and a slideshow on the web that includes all their retouched images with music from music licensing service Triple Scoop Music.

My image narration offerings are pretty rare. By the time my clients have invested in everything else, they're not really inclined to purchase more. But multimedia, including adding video to slideshows, will become a bigger part of my studio in the future.

And then, of course, prints. Every wedding client gets prints.

How do most clients prefer to review their images?

Everyone wants the DVD. That's the thing they're almost trained to ask for. Most of them don't understand the value of online proofing until they experience it. Ninety percent of my clients don't even do anything with those DVD images. They still order from my studio. I think the DVD is more for more peace of mind.

How have social media sites such as Facebook changed the way you present images to clients?

I avoided posting images on Facebook for a long time because of rights issues. However, I'm starting to understand the value of it. I'm just starting to get written permission from my 2009 clients to post their slideshows. I'm posting slideshows in a Flash file format, rather than single images, because I feel like they're less likely to be used somewhere else. Also, anything that I put on the web has my logo attached to it somewhere.

What about consumer-oriented, photo-sharing sites such as Flickr?

I'll be using Flickr in the future. I'm evolving with the technology. It's important to get on as many platforms as possible, and to be adaptable to new technologies

because they're not going to go away. Young people are on social media sites more than they are on email. Don't be scared by it. Push your fear aside so that you're not inhibited, and you can take advantage of the opportunity it provides.

Because the web is so immediate, are clients seeing images earlier in the process?

Just because I can make images available on the web right away doesn't mean I will. I see myself as an artist, and having impact on the final product is important. I share the retouched slide-show with them first. It's a finished product. It's the thing that's going to make them cry. Then I'll make the unretouched proofs available a week or so later.

Do you present to potential clients in different mediums?

Clients fall in love with their photographer online, so having an amazing website is key. When they come in to meet you, they already know that they want to hire you. The in-person meeting, where they can look at albums or see prints hanging on the wall, seals the deal.

What is your color management process for print output?

I grew up in the darkroom, and I feel that there is something to be said for printing your own work. I print in-house so I can manage color in real time and offer my clients the best product. My Epson printer, in particular, has helped bring the control of the darkroom into my studio.

I use Datacolor's Spyder3Studio SR for color management, which does monitor and printer calibration. It's had a huge positive effect on my business. If you're printing your own work, calibration is extremely important, and prevents waste of a lot of time, paper, and ink.

Poised on the leading edge, Hall is prepared for photo-sharing technologies to come and go. Her work, on the other hand, will remain timeless.

Corrective and Creative Image Editing

6

Lesson Files | APTS Aperture Library

Time | This lesson takes approximately 90 minutes to complete.

Goals | Add and remove adjustments
Read a histogram display
Correct overexposed images
View hot and cold areas
Adjust contrast and definition
Create new versions
Apply adjustments using Lift and Stamp tools

Performing Nondestructive Editing

Now that you have an organized, efficient photo library, your next step is to shape the tone, color, and point of interest for a few selected images. The Aperture Adjustments inspector handles this process with a wide range of nondestructive image-editing tools, so called because you can modify or remove any adjustment on any image at any time.

The image-editing tools in Aperture can be grouped into four areas:

► Basic edits—You covered basic adjustments such as straightening and cropping in Lesson 1, but other fundamental adjustments include exposure, black point, and brightness.

► Tonal correction—These tools add more subtlety and precision and permit correction of contrast, highlights, and shadows.

► Color adjustments—Shifting and warping the color in an image is done primarily through hue, saturation, and vibrancy adjustments, as well as discrete tinting of shadows, midtones, and highlights.

► Local adjustments—The adjustments mentioned previously typically impact an entire image. Local adjustments allow you to modify a selected area using Quick Brushes such as cloning, skin smoothing, dodge, and burn; but you can also create a brush from many standard image adjustments.

In this lesson, you'll discover that adjustments in Aperture are never destructive and can always be undone. You'll master the Adjustments panel by previewing and applying presets, reading the built-in histogram, and modifying basic adjustments. By mastering these fundamentals in the Adjustments inspector, you'll be ready to tackle more advanced image-editing tasks in upcoming lessons.

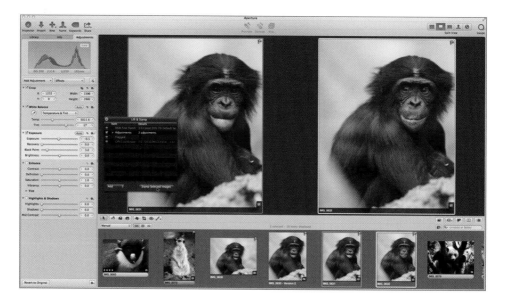

Working in the Adjustments Inspector

The Adjustments inspector is the central location for all image editing in Aperture. By default, it displays a set of commonly used tools to adjust white balance, exposure, and contrast; but you can add and remove adjustments to create your own default set.

1 In the Inspector pane, click the Library tab.

2 Select the San Diego Zoo project and clear the search field, if necessary.

3 In the Browser, select the panda in a tree image, **IMG_0079**.

4 Press V until you see the Split View.

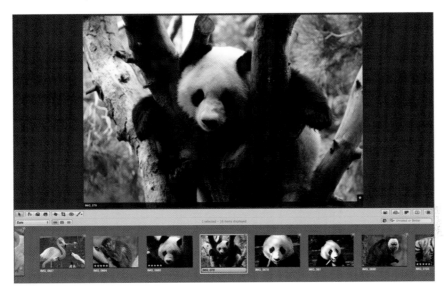

5 In the Inspector pane, click the Adjustments tab.

The Adjustments inspector falls into four main sections:

▶ Histogram, a graphical display for the distribution of color and luminance in your image

▶ Camera/color information

▶ The Add Adjustment and Effects menus and the Auto Enhance button

▶ The Adjustments areas, which occupy the majority of the inspector

▶ The Adjustment Action pop-up menu

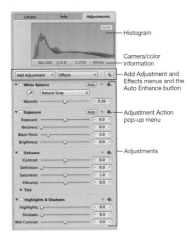

Adding an Adjustment

Using the Add Adjustment pop-up menu, you can add adjustments to the inspector.

1 Make sure **IMG_0079** is still selected.

2 From the Add Adjustment pop-up menu, choose Flip.

A group of parameters, called a *brick*, is applied, and the image flips horizontally. You can select the direction of the flip in the Flip Type pop-up menu.

> **TIP** ▶ You can add any adjustment brick to the default adjustment set by choosing the brick in the Add Adjustment pop-up menu. Then from the Adjustment Action pop-up menu, choose Add to Default Set. Similarly, you can remove an adjustment from the default set by choosing Remove from Default Set from the Adjustment Action pop-up menu for that adjustment brick.

Adding Effects

Rather than tweaking all the sliders of multiple adjustment bricks in the inspector for every image, Aperture provides adjustment presets known as Effects as a quicker solution for some image-editing tasks. An *Effect* is a collection of multiple adjustment settings designed to correct common problems or apply a stylized look to an image.

1 Still using the panda image, from the Effects pop-up menu, choose White Balance.

As you look through the White Balance presets, a thumbnail of the image previews the results of that preset. The panda image requires white balance correction. The Daylight preset seems to work well for this.

2 In the Adjustments inspector, from the Effects pop-up menu, choose White Balance >
Daylight.

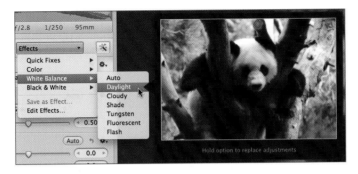

You can combine and apply multiple effects for greater impact.

3 Choose Effects > Color > Toy Camera.

The image remains white balanced and has a toy camera look added to it.

TIP Hold down the Option key when choosing an effect to replace the current
adjustment settings.

Duplicating a Version

Because Aperture works with versions and not the actual files on disk, you can create
additional versions of the same image with little storage cost. Additional versions can be
used to apply and compare different adjustments. Let's continue to adjust our panda.

1 In the Browser, verify that the panda image, **IMG_0079**, is still selected.

2 Choose Photos > Duplicate Version.

A new version of the image is created with the Daylight and the Toy Camera presets applied. The new version's name is **IMG_0079 - Version 2**.

NOTE ▸ To create a version of the original without any adjustments applied, choose Photos > New Version from Original.

Disabling and Deleting Adjustments

You can disable and delete adjustments from an image at any time. To improve the **IMG_0079 - Version 2** version you just created, let's modify the effects and then compare the results with the original version.

The effects you applied included a vignette, but it makes the image a bit too dark. Let's disable the Vignette adjustment temporarily to compare before and after.

1 In the Adjustments inspector, locate the Vignette brick.

2 Deselect and select the Vignette checkbox to compare the image with and without the adjustment.

3 Deselect the checkbox to disable the Vignette.

4 Press the Left Arrow key to compare this new version with the original version.

The new image without the vignette is the preferred one (just go along with this conclusion, even if you like the previous image).

5 In the Browser, make sure that **IMG_0079 - Version 2** is selected.

6 From the Vignette's Adjustment Action pop-up menu, choose "Remove this adjustment."

The Vignette adjustment is removed from the image and from the Adjustments inspector.

Creating Effects from Adjustments

Your image is now brighter without the vignette in the Toy Camera effect. Now, you'll save your customized version of the effect.

1 From the Effects pop-up menu, choose Save as Effect.

2 Type *Brighter Toy Camera* as the name of the altered effect, and then press Return.

3 Drag the Brighter Toy Camera effect to the Color preset group to add it to that group.

4 Click OK.

5 Click the Effects pop-up menu, and browse through the Color effects to find your new Brighter Toy Camera effect.

Resetting Adjustments

When effects are applied to an image, or you have modified and added a few adjustments to an effect, things can sometimes go in a wrong direction. Returning to the default

adjustment settings is occasionally the easiest recourse. In Aperture, you can reset individual parameters, entire adjustment bricks, or all of the adjustments in the inspector. In the next exercise, you'll modify an adjustment that needs resetting.

1 From the Exposure brick, click the Auto button.

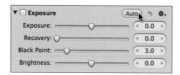

The combination of the auto exposure settings and the effect that is already applied has overexposed the image. You'll want to reset the Exposure settings to their default values.

2 Click the Reset button to reset the entire Exposure brick.

The Toy Camera and the White Balance effects still look wrong on this image. Let's compare this version with the original image and see if it might be best to reset the entire Adjustments inspector.

3 Press M.

The original image appears in the Viewer. This shortcut key allows you to temporarily bypass all the adjustments applied to the image and see the original image.

4 Press M to toggle between the version and the original and compare the two.

The adjustments aren't looking good, so let's reset all the adjustments.

5 Press M to view **IMG_0079 - Version 2** and verify that the words Original Image do not appear at the top of the image.

6 For each adjustment brick, click the Reset button.

> **TIP** ▶ To reset a single adjustment slider, double-click it.

You have a lot of freedom to experiment because you can modify, reset, or remove effects and adjustments at any time. This ability is a great example of the nondestructive work-flow in Aperture.

Fixing Underexposed and Overexposed Images

In some cases, preset effects are a great quick fix. Other times, your image may require a bit more hands-on adjustment. Fortunately, fundamental image editing is a well-supported process in Aperture with precise tools to help you secure the exact look you want.

Understanding a Histogram

Histograms are graphical displays that show the distribution of pixels in your image from dark to light. A histogram can show if an image is too bright or too dark. It can help you see subtle color casts and, most importantly, it points out any clipping or loss of detail in your blacks and whites.

Before you make any image adjustments, you should be able to "read" a histogram. Let's look at a diagram to understand how a histogram is set up:

In the histogram, the horizontal axis represents shades of gray, or "tone," and the vertical axis represents the number of pixels in an image at any given shade. The histogram shows 256 shades from pitch black to pure white.

Still confused? That's OK. It's not so easy to grasp at first. Let's look at real histograms for a few images.

1 In the Inspector pane, click the Library tab, or press W to cycle through the tabs until you get to the Library inspector.

2 Select the Flagged item.

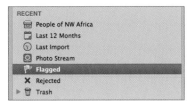

NOTE ▶ The Flagged item displays flagged images from every project.

3 Select the first rhino image, **IMG_2277**.

4 Click the Adjustments tab, or press W until you get to the Adjustments inspector.

The histogram shows the three individual color channels and where their channel information overlaps. This Rhino image is fairly evenly exposed. There are some very dark areas and some very light areas, but the majority of the image is in the midrange of luminance values. The histogram extends broadly from the left to the right.

5 Select the second rhino image, **IMG_2278**.

This image is underexposed, made up mostly of shadow areas with very few high-lights. The histogram is weighted heavily toward darks (on the left side) with some

of the graph being clipped on the left edge of the histogram. When the histogram is cut off on the left, it means that the shadows are clipped, resulting in a loss of shadow detail.

6 Select the third and last rhino image, **IMG_2279**.

This image is overexposed. It is fairly bright all over with very few shadow areas. The histogram displays the majority of pixels on the right side with some being clipped on the right edge. When the histogram is cut off on the right, it means the highlights are clipped, resulting in a loss of detail.

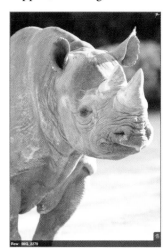

Displaying Hot and Cold Areas

Before you begin to correct the exposure of your rhinos, it would be nice to see where the clipped highlights and the clipped shadows are located in the actual image. Aperture can identify clipped pixels using color overlays.

1 Select the overexposed rhino image, **IMG_2279**.

2 Choose View > Highlight Hot & Cold Areas.

The clipped highlights, or "hot" areas, of the image are shaded in red. Now you can see precisely where in the image that the highlights are losing detail.

You'll use the Exposure controls to bring down the highlights until all the red overlay is removed from the image.

Adjusting Exposure

Just as you would correct exposure in your camera, you can correct it in Aperture using the Exposure controls in the Adjustments inspector. By dragging the Exposure slider, you can make the overall image darker or brighter, similar to changing your camera exposure.

How much you can adjust the image will depend on what image format you are using. A JPEG file has significantly less dynamic range to work with than a RAW file.

NOTE ► You will learn more about working with RAW files in Lesson 10.

Let's adjust the exposure of an image, and then see how the histogram reflects that adjustment.

1 In the Adjustments inspector, drag the Exposure slider left (to about –1.55), until the red overlays are removed from the image.

2 Examine the histogram to observe the results.

None of the pixels are clipped on the right side, and the graph is more centered overall.

TIP ▸ Although the overlays for hot and cold areas are not exclusive to RAW images, you will have more success bringing detail back into these areas when using a RAW file image because of that format's wider dynamic range.

Adjusting the Black Point

In many cases you might like your image overall but want to return detail to the overexposed or underexposed areas. In those situations, applying exposure adjustments is like using a jackhammer when you want a small mallet. Aperture has more subtle tools for these jobs. For example, the Black Point parameter controls can raise or lower the black threshold of your shadows while leaving your highlights unchanged. Let's adjust the black point of your underexposed rhino.

1 Select the underexposed rhino image, **IMG_2278**.

2 Make sure View > Highlight Hot & Cold Areas is still chosen.

 In this image, you see a dramatic contrast between the shadows on the rhino's body and the bright highlights on his horns and forehead. It's a look that you want to try to retain. But the area at the top of the image shows some blue overlay, which indicates that some shadows are clipped. Applying Exposure adjustments to brighten the shadows would cause his horns to clip and compromise the highlights. Using the Black Point parameter controls can raise or lower the threshold for shadow detail, which allows more or less detail to come through.

3 Drag the Black Point slider left until all the blue overlays disappear.

NOTE ▸ It's generally acceptable to crush blacks a bit as you adjust the image to create the right tonal value for shadows.

Underexposed digital images are usually more tolerable than overexposed digital images. The introduction of noise aside, it's easier to recover detail in the shadows because clipping in the blacks can be passed off as an artistic choice. It's much more difficult to deal with loss of detail in the highlights.

Recovering Clipped Highlights

Highlight detail can be clipped just as easily as shadow detail. You could use the Exposure adjustment controls to fix this, but those tools are, once again, a little bigger than the job and can negatively impact the overall image quality. Using the Recovery slider will help recover highlight detail without damaging your midtones or shadows.

The Recovery slider pulls in detail that potentially exists beyond the highlights range of the working color space in Aperture. This extra detail in the highlights is found only when you are working with your camera's RAW files.

1 In the Browser, select the final rhino, **IMG_2277**.

 This image is nicely exposed, except for the slight highlights on the horns and forehead.

2 Drag the Recovery slider to the right until the red clipping overlay is removed.

 Let's take a closer look at the results.

3 Choose View > Highlight Hot & Cold Areas to disable the overlays, or press Shift-Option-H.

4 Press M to show the original image and then press M repeatedly to compare the two versions. The results may be too subtle to see with the Viewer zoomed to this level.

5 Choose View > Show Loupe—or click the Loupe button in the toolbar, or press the Grave Accent (`) key.

6 Drag and resize the Loupe until you can see the Rhino's two horns.

7 To view the detail that has been recovered, press M to display the original image, and then press M again to toggle back to the modified version of the image.

8 Move the Loupe over the rhino's forehead.

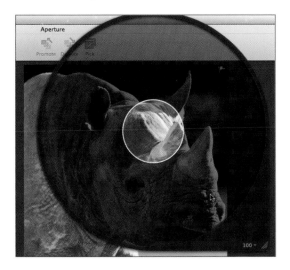

9 Press M to see the original image, and then press M again to return to your version.

The results are subtle, but the adjustment removes the highlight clipping and restores some of the bright details. You'll work more with this rhino in the next lesson to restore even more detail using the Highlights controls.

10 Choose View > Hide Loupe, or press the Grave Accent (`) key, to hide the Loupe.

Identifying Color Clipping

There are times when you might want to know exactly which color channel is being clipped. While the Hot & Cold highlight shows only that one or more channels are clipped, Aperture does have a way to show you which color channels are involved. When adjusting exposure, black point, levels, or curves, press the Command key to display color overlays on a white background for white point adjustments, and a black background for black point adjustments. This feature also makes the clipping overlays easier to see on a busy image.

Let's begin by examining how the color clipping works in Aperture, then move on to correct an image with clipping.

1 Select the San Diego Zoo project.

2 Click the Panda image, **IMG_0081**.

Depending on the parameter you adjust, you'll view either highlight or shadow clipping. You'll first view highlight clipping using the Exposure parameter.

3 In the Adjustments inspector, Command-click the Exposure parameter.

By Command-clicking this parameter, the Viewer now shows a black background with some blue and white overlays. The black overlay indicates areas with no highlight clipping. The white overlay indicates that all three color channels are clipping. The blue overlay indicates that the blue channel is clipping.

Let's look at shadow clipping using the Black Point parameter.

4 In the Adjustments Inspector, Command-click the Black Point parameter.

Shadow color clipping uses a white background overlay to indicate areas with no shadow clipping. The black overlay indicates areas where all color channels are clipping in the shadows. The slight blue overlay indicates that the blue channel is clipping. A fair bit of cyan overlay is also present in this image, yet there is no cyan color channel. The cyan overlay indicates that both the blue and green channels are clipping in the shadows.

The following table shows which parameters indicate highlight clipping and which indicate shadow clipping when making the adjustment while holding down the Command key.

Parameters Showing Highlight or Shadow Color Clipping

Adjustment Brick	Parameter	Highlight or Shadow Clipping
Exposure brick	Exposure slider	Shows highlight clipping
Exposure brick	Recovery slider	Shows highlight clipping
Exposure brick	Black Point slider	Shows shadow clipping
Curves brick	Black Point slider	Shows shadow clipping
Curves brick	White Point slider	Shows highlight clipping
Levels brick	Black Levels slider	Shows shadow clipping
Levels brick	White Levels slider	Shows highlight clipping

The next table shows how color overlays indicate the various combinations of color channel clipping.

Colors Indicating Clipping by Channel

	Red	Green	Blue	Yellow	Magenta	Cyan	White	Black
Exposure	Red	Green	Blue	Red & Green	Red & Blue	Blue & Green	All	None
Recovery	Red	Green	Blue	Red & Green	Red & Blue	Blue & Green	All	None
Black Point	Red	Green	Blue	Red & Green	Red & Blue	Blue & Green	None	All
Black Curves/ Levels	Red	Green	Blue	Red & Green	Red & Blue	Blue & Green	None	All
White Curves/ Levels	Red	Green	Blue	Red & Green	Red & Blue	Blue & Green	All	None

Now let's put this into practice. You'll use the Exposure controls while viewing the Highlight Hot & Cold Areas overlay to correctly expose an image.

5 Switch to the Library inspector, and select the San Diego Zoo project, if necessary.

6 In the filmstrip view, select the Meerkat image, **IMG_0073**.

This image is considerably overexposed, so the highlights are clipped. You can verify this by turning on and off the Highlight Hot & Cold Areas overlay.

7 Press Shift-Option-H to enable the overlays, and then press it again to disable the overlays.

8 Command-click the Exposure slider to display the color clipping areas.

The clipping areas are clearly shown on the black background. Based on the chart shown earlier, you can see the primary clipping is in the blue channel, but on the right side all color channels are clipping. The easiest way to correct this is to use the Exposure controls.

TIP ▶ If clipping is present in only one color channel, it might be best to correct it using the Curves controls, which allow you to isolate color channels.

9 Command-drag the Exposure slider to the left until the overlays disappear.

10 Press M to view the original image, and then press M again to return to your version.

The change is pretty obvious, but let's take a closer look to see the detail that has returned to your image.

11 Position the pointer over the ear of the meerkat.

12 Press Z to zoom into the image.

13 Press M to view the original image, and then press M again to return to your version.

Original image

Adjusted version

By zooming in, the amount of detail that has returned to the fur under the meerkat's ear is clear to see. But he still looks cold because of the faulty white balance. You can fix it by applying the white balance skill you learned in Lesson 1.

14 If you zoomed in, press Z to zoom out and display the entire meerkat image.

15 In the White Balance adjustment brick, change the pop-up to Natural Gray and then click the eyedropper.

16 Position the pointer somewhere over the sand to left of the meerkat—an area that should be neutral gray.

When locating a neutral gray point as a white balance reference point, look for a spot that reads around 125 in the RGB values.

17 When you find an appropriate spot, click the spot.

Now you have a perfectly exposed meerkat with no color clipping issues and no white balance issues.

Adjusting White Balance with the Histogram

Occasionally, you'll perform an automatic white balance, and later tweak it using the White Balance parameter controls. Or maybe you want to manually white balance an image from that start. An RGB histogram can show the clipping of each color channel,

and it can also help resolve white balance problems. The Temperature and Tint parameters in Aperture allow you to correct white balance problems or make color adjustments purely for aesthetic reasons, completely by eye.

1 In the filmstrip view, select the chimpanzee image, **IMG_0630**.

This image has a blue tone, which is obvious in the image, but also obvious in the histogram. Notice how the blue is predominant throughout. First, you'll try using the Auto-White Balance and then test your skills at manually white balancing.

2 In the Adjustments inspector, click the Auto button located in the White Balance brick.

In most instances the Auto-White Balance does a great job, however, sometimes it may not. You can further adjust the Auto settings or, as you'll do now, reset the White Balance adjustment and try your hand and eye at white balancing. Remember, the Histogram at the top of the Adjustments inspector is there to guide you.

3 Click the Reset button for White Balance to cancel the Auto-White Balance.

You'll work with manual controls, so let's activate them by changing the White Balance pop-up menu to reveal the needed controls.

4 From the White Balance pop-up menu, choose Temperature & Tint.

5 Drag the White Balance Temperature (Temp) slider slowly to the right until blue and red overlap in the histogram.

6 Drag the Tint slider to the right (away from green) until you are pleased with the overall color balance. Watch the histogram to align all three color channels.

As you move the slider, all three colors align in the histogram, making this Bonobo chimp much happier because he no longer looks as if he is freezing in the Arctic.

7 Press M to view the original image, and then press M again to return to your version.

TIP ▶ A white balance adjustment is generally made before all other color and tone adjustments because it achieves a baseline from which the image can be further refined.

Adjusting Brightness

Tweaking brightness in Aperture is one way to adjust midtones while mostly leaving your white and black points intact. Let's enhance the intrigue of this chimp by subtly darkening his midtones.

1 In the Browser, keep the Bonobo chimp selected, **IMG_0630**.

2 In the Exposure adjustment controls of the Adjustments inspector, drag the Brightness slider slightly to the left to about –0.1.

The difference between brightness and exposure is subtle but important. Unlike exposure, brightness does not slide the histogram, but moves the center point, effectively boosting midtones without significantly affecting the brightest highlights or deepest shadows.

Cropping a Photo

Although you touched on cropping in Lesson 1, you still have more to learn about cropping. When a printed copy is an image's final destination, the Crop HUD can target a specific aspect ratio, and the Crop adjustment brick can be used to set a specific pixel height and width.

Setting an Aspect Ratio Using the Crop HUD

The Crop tool is an easy way to remove distracting objects from a photo or improve the framing. As you saw in Lesson 1, the Crop tool is nondestructive, so you can adjust the crop or revert to your original image at any time.

1 Keep the Bonobo chimp image, **IMG_0630**, selected from the previous exercise.

2 In the tool strip, select the Crop tool, or press C to open the Crop HUD.

3 Drag the Crop tool to draw a selection rectangle over the image.

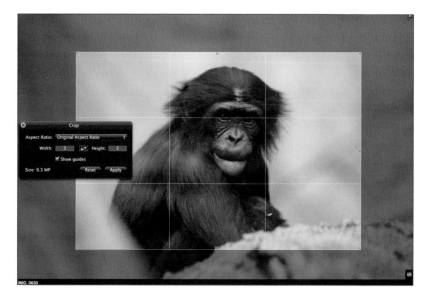

4 In the Crop HUD, from the Aspect Ratio pop-up menu, choose 3 x 4.

The crop rectangle changes from the default setting to show the new 3 x 4 aspect ratio.

5 In the Crop HUD, click Apply to confirm this crop setting.

The crop updates as soon as you select a new aspect ratio, so it's easy to try different ratios on an image.

TIP ▶ After cropping an image, you also can change its size and shape. One method is by dragging a resize handle; another is to adjust the crop in the Crop HUD or Adjustments inspector.

Setting a Crop Size for Printing

If you anticipate printing the image at "magazine quality" (300 pixels per inch), you can easily calculate the resolution an image needs to be.

Assume you want to print an 8x10 image:

(8 x 300 ppi) x (10 x 300 ppi) = megapixel size

2400 x 3000 = 7,200,000 = 7.2 megapixels

Aperture displays the megapixel size in the Crop HUD and the pixel height and width in the inspector.

You'll create a new version of the chimp image and apply a new crop setting that meets the minimum requirement for printing on a 300 ppi printer.

1 With the Bonobo chimp image still selected, choose Photos > Duplicate Version.

A new version of the image is created that has all the same adjustments and the name **IMG_0630 - Version 2**. You'll crop the new version in a different way.

2 With the **IMG_0630 - Version 2** chimp selected, select the Crop tool, or press C.

The crop handles are displayed, and the entire image becomes available.

3 In the Crop HUD, change the Aspect Ratio to create a 4 x 5 crop.

It looks good, but you'd like to have this image in portrait orientation and not a landscape orientation.

4 In the Crop HUD, click the Switch Aspect Ratio button to change the orientation to portrait.

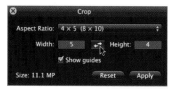

5 If necessary, select the "Show guides" checkbox to show the rule of thirds guides.

TIP ▸ As you modify the position and size of a crop, you can Command-drag to temporarily display the rule of thirds guides.

6 Resize and reposition the crop overlay until the upper-right intersecting guidelines are directly over the chimp's nose. As you resize the crop overlay, remember if you are monitoring it in the Adjustments inspector, the width should be no smaller than 2400 and the height no smaller than 3000. If you want to monitor the HUD, you should not go below 7.2 megapixels.

7 When satisfied with the crop, click Apply.

> **NOTE** ▶ The Crop controls measure the starting position of the crop using X and Y coordinates. Both the X and Y values are measured from the lower-left corner of the image. The shape of the crop is determined by the Height and Width settings (which are also measured in pixels).

Using Lift & Stamp Tools

You used the Lift & Stamp tools in Lesson 2 to copy metadata from one image to others. You can use the same Lift & Stamp tools to copy adjustments from one image to many images. The portrait crop is the nicer crop, so you'll lift and stamp all the adjustments from one chimp image to the other two.

1 In the Browser, select the Bonobo chimp image, **IMG_0630 - Version 2**.

2 In the toolbar, click the Lift tool. All the lifted adjustments are displayed in the Lift & Stamp HUD.

> **TIP** ▶ You can delete items in the Lift & Stamp HUD when you only want to stamp a few adjustments.

3 In the Browser, to the right of the selected chimp image, click **IMG_0631**.

4 In the Browser, Command-click the last chimp image on the right, **IMG_0632**.

5 In the Lift & Stamp HUD, click the Stamp Selected Images button.

6 Close the Lift & Stamp HUD.

From here you could choose to modify the crop or brightness adjustments on any of the images.

You've gone through the basics of making adjustments. These are the fundamental controls that many photographers rely on during a first pass. Sometimes these are all the adjustments that a photo requires, but you can do so much more if you choose. In the next three lessons on image adjustments, you'll explore more corrective controls and some incredible creative controls.

Lesson Review

1. When you apply an effect such as Toy Camera, can you further adjust the effect?
2. If a graph is cut off at the right edge of the histogram, what does this indicate?
3. Where would you adjust the exact pixel width and height for the Crop tool?
4. True or false: Adjusting the black point will also adjust your highlights.
5. True or false: Exposure controls can be used to recover highlights in an image.
6. What key press allows you to quickly compare the look of an adjusted image to it's original?

Answers

1. Yes, Aperture allows you to apply effects and then adjust the parameters, even deleting adjustments used to make the effect, in the Adjustments inspector.

2. Highlights are being clipped and causing a loss of detail.

3. The Adjustments inspector provides numeric control over the precise width and height of the Crop tool.

4. False, the Black Point slider adjusts only your shadows, leaving your highlights unaltered.

5. True. Although you would more commonly use the Recover parameter controls, the Exposure parameter controls also lower your white point, thereby recovering clipped highlights.

6. Pressing the M key allows you to toggle the selected image between displaying the adjusted version and the original image.

7

Lesson Files APTS Aperture3 Library

Time This lesson takes approximately 90 minutes to complete.

Goals Adjust images in Full Screen view

Apply contrast and definition

Recover highlights and shadows

Adjust levels with the Quarter-Tone Levels controls

Convert color images to black and white

Examine versions using the compare feature

Lesson **7**

Correcting Tone

Every photographer needs to deal with the fact that the eye sees a wider range of brightness values or tones than a camera can capture. You inevitably sacrifice some part of the dynamic range when you take a picture. So, one goal of performing tonal adjustments is to retrieve as much detail from sacrificed areas as possible.

As you've learned, Aperture has controls to modify the exposure, black point, and brightness of an image. But other adjustments in Aperture—such as Levels, Highlights & Shadows, and Curves—can perform even more precise tonal changes.

In this lesson, you'll correct and improve tone in several images, primarily using the Levels and the Highlights & Shadows controls. You'll also explore filters for converting color images to black and white; and you'll do the majority of your work in the Full Screen view.

Making Adjustments in Full Screen View

Full Screen view is a fully functional workspace. Because images display here in full screen against a black background, it becomes easier to make qualitative adjustments.

1 In the Library inspector, select the Uganda The Pearl of Africa project.

2 Press V to set the main window layout to display just the Viewer.

3 To switch to Full Screen view, do one of the following:

▶ Choose View > Full Screen.

▶ Press F.

▶ Above the toolbar, click the Full Screen button.

Full Screen view can display the Browser or the Viewer. When the Viewer is displayed, the images can be accessed in filmstrip view at the bottom of the window.

4 If necessary, move your pointer near the bottom of the screen to cause the filmstrip to appear.

5 In the filmstrip view, select the last image of the lion, **IMG_2208**. With an image selected, you are ready to access the Adjustments inspector.

6 Move your pointer to the top of the screen, and in the toolbar, click the Inspector HUD button, or press H. In Full Screen view, the inspector is displayed as a HUD. You still have access to the tabs for the Adjustments, Info, and Library items.

TIP ▶ By default, the toolbar does not appear in Full Screen view until the pointer is moved to the top of the screen. To keep the toolbar visible, move the pointer to the top of the screen in Full Screen view, then in the toolbar, click the Always Show Toolbar control.

Now you can make some adjustments. This image lacks a bit of detail in the highlights, so let's apply the Exposure adjustment. Aperture has a handy way to temporarily hide the HUD while you make this modification.

7 In the Inspector HUD, click the Adjustments tab.

8 Shift-drag the Exposure slider to about 0.3 or 0.4.

Holding down the Shift key temporarily hides the Inspector HUD so that you can see more of the image. You'll use that trick again as you continue to improve this lion image.

Enhancing an Image

The Enhance brick in the Adjustments inspector contains a number of controls that can be used to add more clarity and visual pop to an image.

Using Contrast

On flat images in which highlights and shadows are dull and muddy, adding contrast can simultaneously stretch the highlights to become whiter and the shadows to become darker. The histogram can help you choose the amount of contrast to apply. You can increase an image's contrast to add depth, but it usually comes at the expense of detail in the midtones.

1 Make sure the lion image, **IMG_2208**, is still selected.

Notice that the curves are squeezed into the center of the histogram. This indicates a low-contrast image—there are no very bright or very dark areas. Using the Contrast adjustment, you can stretch the highlights and shadows to generate a broader transition from darks to whites in the image, which is usually desirable.

Because you'll make the shadows darker and the highlights brighter, it's a good idea to enable the Highlight Hot & Cold Areas overlays to view any clipping that may occur.

2 Press Shift-Option-H to enable the overlays.

3 In the Adjustments HUD, scroll down to the Enhance brick.

4 Shift-drag the Contrast slider to the right to increase image contrast to around 0.3.

> **TIP** ▶ Instead of dragging the slider, you can click the numeric value of a parameter and press the Arrow keys to change it in increments of 0.5. Holding down the Option key while pressing an Arrow key will change the parameter in increments of 0.01. Pressing Tab will move to the next parameter.

You might notice that a bit of red and blue overlay is displayed. A small amount won't impact the image too much, so just ignore them.

5 Press Shift-Option-H to disable the overlays.

6 Press M to view the original image, and then press M again to return to your version.

See what that tiny bit of contrast adjustment did? The image now displays a much greater range from shadows to highlights. Adding a bit of contrast is often the easiest way to improve those flat-looking images. Just be aware that too much and you'll begin to lose detail in your blacks and whites, so keep an eye on that histogram.

Next, you'll further enhance this image and use another method to ensure that the Adjustments HUD stays out of your way.

Adding Definition

Definition adds pop to flat-looking images by increasing contrast in local areas, unlike the Contrast adjustment, which works on a more global level. First, let's lock off our Adjustments HUD to the side so it no longer overlaps the image.

1 Position your pointer over the Adjustments HUD title bar.

2 Drag the HUD to the left side of the screen. You can move any HUD by dragging its title bar.

3 In the top-right corner of the Inspector HUD, click the Always Show Toolbar control. This control locks the HUD in place and then scales and repositions the image so the two never overlap.

TIP ▶ When you are in Full Screen view, an Always Show Toolbar control is found on the filmstrip view and the toolbar.

4 In the Enhance brick, drag the Definition slider right to 0.5.

5 Select the Enhance checkbox to compare the image before and after all the enhancement adjustments.

6 Leave the Enhance checkbox selected because it makes the image look better.

Although this is a subtle change, not every image will benefit from increased definition. It can add notable clarity to photographs of people, but that is not always flattering. On the other hand, it can do wonders for images shot with less-expensive lenses.

Removing Camera Vignetting

Your adjustments have enhanced the image, but they have also enhanced the vignetting in this image. Vignetting is the result of light falloff in a lens, when more light hits the center of the image compared to its outer areas. You can remove this effect using the Devignette adjustment.

1 In the Adjustments HUD, from the Add Adjustment pop-up menu, choose Devignette.

2 In the Devignette brick of the inspector, drag the Radius slider to about 1.

3 Select the Devignette checkbox to compare the image before and after the adjustment.

You can see the effectiveness of this adjustment in reducing the lens' vignette artifact. Although the adjustment works well, the image looked better with the vignette effect. In fact, it might look even better with a more pronounced vignette.

4 From the Devignette Adjustment Action pop-up menu, choose Remove this adjustment.

Now let's look at enhancing the natural vignette that is already present in the image.

Adding a Vignette

Let's test our theory that this lion will look even more dramatic with a more pronounced vignette effect added. In this exercise, you will use the Vignette adjustment to darken the edges of the image.

1 In the Adjustments HUD, choose Add Adjustment > Vignette.

Applying the Vignette adjustment has slightly enhanced the naturally existing vignette artifact. But you can enhance it even more.

2 Drag the Radius slider to 1.

The Radius slider modifies how much the vignette encroaches upon the image. The Intensity slider modifies the darkness of the vignette. For a subtler, yet more natural lens effect you can change the Type from Gamma to Exposure. Gamma is similar to creating the vignette with a Brightness control that mostly adjusts your midtones, and Exposure is similar to using an Exposure control.

3 From the Type pop-up menu, choose Exposure.

4 Drag the Intensity slider to 1.

5 Drag the Radius slider to 1.5.

Let's compare the original against the version with all the changes you've made.

6 Press M to view the original image, and then press M again to return to your version.

Original image

Adjusted version

The vignette combines with the contrast and definition adjustments to make a huge increase in the visual impact of this image.

Understanding the Order of Adjustments

As you removed and added adjustments in the previous exercises, you may have noticed that they were sometimes inserted at the top and sometimes at the bottom of the Adjustments pane. Aperture has a fixed order of operations. Each adjustment has a place in the order, and you cannot change that order in the inspector. Adjustments are processed from the top downward in the Adjustments inspector. Aperture automatically inserts the adjustments in the proper order so you get consistent results all the time.

1 From the tool strip, select the Crop tool, or press C.

2 In the Crop HUD, reset the Aspect Ratio pop-up to Original Aspect Ratio.

3 Drag a selection rectangle from the upper left of the image to the lower right, framing tightly around the lion. This draws out a crop rectangle around the lion.

4 Adjust the crop rectangle to place the lion's face on the upper-left third.

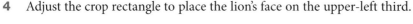

5 Click Apply to close the Crop HUD.

Notice that the crop is placed at the top of the Adjustments inspector. Because the Vignette adjustment is added at the bottom of the Adjustments pane, the crop is processed first and then the vignette is updated around the new framing from the crop. This fixed order saves you from rearranging the bricks in the Adjustments inspector to get the results you want.

Improving Highlights and Shadows

Compared to your camera, the human eye can perceive a substantially wider range of luminance, from near-darkness to the brightest light. So for instance, while your eye might see detail in the bright sky and in the shadows of a forest simultaneously, your camera probably will not. No, laser eye surgery can't help here, but the Highlights & Shadows adjustment controls can.

These controls allow you to adjust the shadows or highlights independently, which is helpful when fixing images with mixed lighting, intense shadow areas, or unusually bright areas such as snow and clouds.

The Highlights & Shadows controls are very simple to use. If you drag the Highlights slider to the right, the bright areas of your image grow darker. If you drag the Shadows slider to the right, the dark areas of your image get brighter.

Controlling Highlights

As you learned in Lesson 6, the Recovery adjustment in Aperture brings back any high-light details that may be clipped. But it's not designed to bring out the detail in nonclipped highlights. The Highlights adjustment does just that. It won't find any detail in blown-out highlights, but it can help increase the visibility of detail in the normal highlights range. The Recovery and Highlights adjustments also work together. You can bring back the blown-out highlights using the Recovery adjustment and then turn to the Highlights adjustments to perfect what you retrieved.

1 With the Uganda The Pearl of Africa project still selected, press V to show the Browser.

 TIP ▶ In the Browser view, you may verify the current project using the Library Path Navigator at top-left of the Browser.

2 Double-click the image of the students, **IMG_9602**.

You'll first use the Recovery slider to bring in any detail that may exist outside the normal highlights range. Then you'll build upon those results using the Highlights slider.

3 If necessary, press H to reveal the Inspector HUD.

4 In the Exposure brick, drag the Recovery slider until no more clipping exists in the histogram.

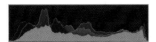

 TIP ▶ Command-drag the Recovery slider to view the color clipping overlays and improve accuracy when retrieving clipped highlights.

5 If necessary, click the disclosure triangle to open the Highlights & Shadows brick.

6 Drag the Highlights slider to the right until you are satisfied with the amount of image detail in the white shirts.

> **TIP** Dragging the slider too far will cause the highlights to go flat. You can press Z to zoom in on the shirts to see the detail more clearly.

7 To view the improvement, select the Highlights & Shadows checkbox to compare the image before and after the Highlights adjustment. Select and deselect the checkbox a few times to observe the change. When you're finished, make sure that the checkbox is selected.

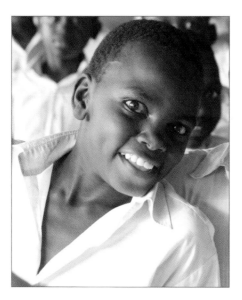

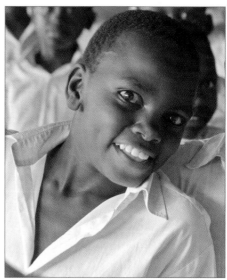

Original image Adjusted version

The highlights in the image now have better detail in them. Using the combination of Recovery and Highlights adjustments together will usually get you the most detail from your highlights even though on occasion they don't appear to provide much on their own.

Controlling Shadows

Shadows play a very important role in the impact of a photo. Getting shadow detail right can help create balance between objects in the photo and can affect the perception of the photo.

The Black Point parameter controls set the point at which your shadows become black; the Shadows control creates more separation in your shadows by lightening the pixels in the shadows area.

1 In the Inspector HUD, click the Library tab, and then select the Tasmania project.

2 Double-click the horse and barn scene, **SJH2501201019**.

 The area under the homestead's overhang is pretty dark. This is a perfect place to apply the Shadows control because you want to bring out the detail lost in the shadows while leaving the rest of the image unchanged.

3 Click the Adjustments tab, and drag the Shadows slider to the right to suit yourself (probably a value between 10 and 30). You instantly see the Shadows parameter working. The details on the wall and the shadowed/dark areas of the horse are much clearer.

4 Press M to toggle between the original image and the version with the shadow details increased. Press M again to return to your version.

 Lastly you'll adjust the midtones contrast. This will bring out the shaded area even further.

5 Drag the Mid Contrast slider to around –10 to –20.

6 Press M to toggle between the original image and the version with the shadow details increased. Notice how much more detail the version has in the shadow areas compared to the original. It's almost like you added an extra fill light. When you're done comparing the images, return to your version.

Before

After

The Highlights & Shadows controls are going to be your regular tools for fixing many images. They are simple to use and sophisticated enough to work in multiple situations.

Adjusting Image Levels

Levels is among the most popular Aperture adjustments because within one fairly simple, graphical window, you can individually push and pull the darkest areas, midtones, and lightest areas to make precise and elegant corrections.

Correcting Levels Automatically

Aperture includes several automatic adjustment controls that attempt to fix problems with a single click. These controls analyze an image and then apply an adjustment based on that analysis. You can use a one-click method as a basic quick correction and then refine the results using manual adjustment controls.

Automatic adjustments work for exposure, but it's also possible to fix some color issues with them. By clicking the Auto Levels Separate button, you can tell Aperture to analyze the image and automatically adjust the levels for each color channel.

Let's compare the two Auto Levels controls, first using the combined method and then the separate method.

1 Press V to return to the Browser view.

2 From the Library Path Navigator pop-up menu, click Projects and then choose Around San Francisco from the top of the list.

3 In the Browser, double-click the San Francisco bay image, **IMG_3132**. This image has a significant blue color cast, and it lacks a bit of contrast.

4 From the Add Adjustment pop-up menu, choose Levels.

5 In the Levels brick of the Adjustments HUD, click the Auto Levels Combined button.

Aperture performs an analysis and then applies a Levels adjustment for luminance. Because it is adjusting only for luminance, the adjusted image has improved contrast but its blue color cast remains. This automatic fix would be a good choice if you didn't want Aperture to change the color. In this case, however, you do want a bit of help with that color cast.

6 Click the Reset button to return to the unadjusted image.

7 Click the Auto Levels Separate button.

Before After

Aperture performs an analysis and then applies a Levels adjustment for all three color channels in the image. Because the red, green, and blue channels are calculated independently, both contrast and color cast are improved.

Adjusting Image Luminance Levels

To manually perform level adjustments to your image, you can drag the sliders at the bottom of the histogram. By doing so, you are shifting the highlights, shadows, or midtones darker or lighter.

1 Press V to switch to the Browser view.

2 In the Library Path Navigator pop-up menu, choose Projects > Brinkmann Photos.

3 Double-click the seashore image, **2009_08_30_175420**.

4 From the Add Adjustment pop-up menu, choose Levels to add the Levels brick.

5 Click the Levels adjustment disclosure triangle, if necessary, and select the Levels checkbox to display the histogram. The histogram in the Levels brick shows the original image's histogram, whereas the histogram at the top of the Adjustments pane is the resulting histogram after all adjustments have been applied.

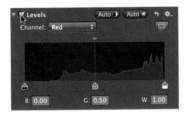

Since you'll adjust the black clipping point, it might be wise to view the Levels RGB histogram. Because the RGB histogram displays each channel individually, it will provide a clear indication if any single channel is clipping.

6 From the Channel pop-up menu in the Levels brick, choose RGB.

Now set the appropriate black point in this low-contrast image. The Black Levels slider is against the left edge of the histogram, and there is a large gap between that and the darkest region of the histogram.

7 Drag the Black Levels slider to a position under the darkest point of the histogram. Adjusting the Black Levels slider is identical to adjusting the Black Point slider in the Exposure controls.

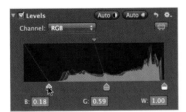

Moving the black levels performs a dramatic adjustment to the image. The shadows are much richer, and the histogram curve at the top of the inspector is now spread across the entire range.

NOTE ► When adjusting the black and white points, look at your image and decide whether it actually should have completely black or white areas. For instance, on a foggy day, the shadows probably won't be completely black and the whites will probably be duller as well. After you make that judgment call, you can make the appropriate adjustment.

When you adjusted the black levels, your midtones were also adjusted because the center point of your range changed. However, you can adjust the image midtones without impacting the white or black points. Dragging the Gray Levels slider to the right will remap that region to be darker, and dragging the slider to the left will lighten the midtones.

8 Drag the Gray Levels slider to suit yourself, until the brightness values for the midtones are slightly brighter or darker. Adjusting the gray levels slider will have a similar effect to adjusting the Brightness slider.

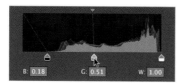

The ability to modify your black point, white point, and midtones makes Levels a handy control set to have around. But the Aperture Levels adjustments go even further, by adding controls for your highlights and shadows.

Using the Quarter-Tone Levels Controls

If you need even greater control over tonal values, Aperture offers Quarter-Tone Levels controls. These allow you to adjust the shadows and the highlights.

NOTE ▶ Unlike the Black Levels and White Levels sliders, which push the midtone around, Quarter-Tone Levels sliders independently affect only the tonal range of the pixels they represent. As a result, they precisely adjust the pixels that fall between the black point and midtones, or midtones and the white point.

1 Click the Quarter-Tone Controls button to activate the Quarter-Tone Levels sliders.

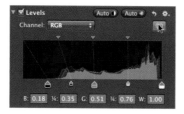

The Levels histogram updates with new controls for adjusting two discrete tonal ranges of the image, thereby allowing you to make finer adjustments.

TIP ▶ You can change the brightness of the shadows, midtones, and highlights with the small triangular Brightness sliders above the Levels histogram.

2 Drag the 1/4 Shadow Brightness Levels and 3/4 Highlight Brightness Levels sliders until the shadows and highlights suit your taste.

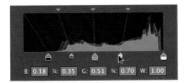

TIP ▶ You can zoom in to full resolution by pressing Z, and see the subtle changes that the Quarter-Tone adjustments are having on the image.

The addition of Quarter-Tone controls in the Levels controls means many of the tasks people performed using Curves adjustments now can be accomplished in the much simpler Levels adjustment interface.

Adjusting Color with Levels Controls

This lesson is all about tone, but we are still going to touch on some color adjustments using the Levels controls while we are here. Levels are not limited to only luminance corrections. You can also do a fair number of regional color adjustments. Remember two important things as you adjust colors using the Levels sliders in the histogram. First, moving an individual color slider to the right will decrease that color, and moving it left will increase that color. Second, when you reduce an individual color, you increase the relative amount of its opposite color. Know your RGB color wheel! Reducing blue increases yellow, increasing red reduces cyan, and so on. Let's enhance the color by adjusting individual color channels, starting with green.

1 From the Channel pop-up menu, choose Green.

2 Drag the Black Levels slider slightly to the right to remove a bit of green from the shadows and bring out the magenta in those hills.

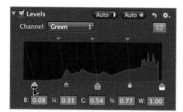

NOTE ▶ These adjustments are not specific. Move the sliders as much or as little as you like. The point is to understand what they do, not the precise value.

3 Drag the 3/4 Highlights slider to the left slightly to bring out more green in the crests of the waves.

4 From the Channel pop-up menu, choose Blue.

5 At the top of the histogram, drag the Highlight Brightness slider to the right to decrease the green highlights.

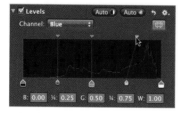

What!??? Didn't you just read that moving the slider to the right will decrease the selected color? You just moved blue to the right and it increased the color! Calm down, the rule still applies. You adjusted the Highlight Brightness slider for blue, often called the *output* slider.

6 When you are done playing with the adjustments, press M to compare your changes with the original image.

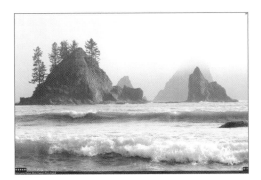

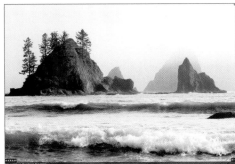

Before

After

The benefit of using Levels controls to adjust color is the simplicity of having an all-in-one tool with which you can change highlights, shadows, and midtones purely as tonal adjustments or color.

Converting Color Images to Black and White

Although most digital cameras shoot in color, many photographers choose to display their photos in black and white to focus on highlights, shadows, shapes, and textures.

Aperture offers an easy way to convert color images to black and white while providing precise control over the process.

> **TIP** Converting RAW files to black and white provides more options than JPEG files when manipulating shadows and highlights. As mentioned previously, RAW files have a wider dynamic range than JPEG.

The Black & White adjustment offers complete control over the tonal relationships and contrast in an image. The Black & White adjustment allows you to independently adjust the red, green, and blue channels, an effect similar to using color filters in traditional black-and-white photography. To make the process easier, you can start with preset effects that mimic common color filters.

NOTE ▶ Although you could create a black-and-white photo by simply desaturating the image, you would attract massive eye rolling and snide glances in your direction. You wouldn't want that, would you? Also, dragging a saturation parameter to zero can sometimes make an image look faded and cannot compare to the artistic control offered by the Black & White adjustment.

Let's begin by switching to a new project while in Full Screen view and making a few versions to compare multiple black-and-white adjustments.

1 Press V to return to the Browser, and then click the Projects button to display the Projects view.

2 Double-click the Landscapes project, and select **IMG_4532**.

3 Control-click (or right-click) the image and choose Duplicate Version from the shortcut menu, or press Option-V. A new version of the image is created, **IMG_4532 – Version 2**.

4 Press Option-V twice. Your Aperture project now contains four versions of **IMG_4532**.

5 In the Browser, double-click **IMG_4532 – Version 2**.

6 In the Inspector HUD, click the Adjustments tab.

7 Click the Effects pop-up menu and scroll to Black & White.

A submenu to the right includes all the preset Black & White conversion filters in Aperture. As you hover over each effect, a preview appears showing the affect on your image.

8 Slowly scroll down and preview the effects starting with Red Filter and ending with Blue Filter.

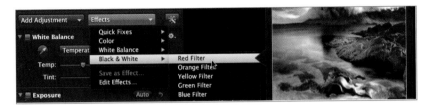

TIP ▶ When selecting a filter, you can bring out the most contrast by selecting a filter color that is the color wheel opposite of the dominant color in your image. Once again, it helps to know the colors on a color wheel.

Let's make three versions using the Red, Yellow, and (for a dramatically different result) Blue filters. You can't be right or wrong here; it all depends on the artistic "look" you are trying to achieve.

9 With **Version 2** shown, choose the Red Filter effect.

10 Press the Right Arrow key to view **Version 3**, and then choose the Yellow Filter effect.

11 Press the Right Arrow key to view **Version 4**, and then choose the Blue Filter effect.

When you choose a Black & White preset, the Black & White adjustment is added to the Adjustments inspector. Here you can further adjust each individual channel to get the perfect mix. Let's make a version that sits somewhere between the Blue Filter and the Red Filter versions. Consult your color wheel:

Let's pick a lovely magenta between blue and red.

12 Control-click **Version 4** and choose Duplicate Version from the shortcut menu. A new version is created based on **Version 4** with the Blue Filter applied. The new **Version 5** is displayed in the Viewer.

13 With **Version 5** selected, adjust the sliders in the Black & White brick with the following values:

▶ Red: 50%

▶ Green: 0%

▶ Blue: 50%

NOTE ▶ The individual percentages for the Red, Green, and Blue channels in the Black & White adjustment should always total 100% to preserve the general brightness of the image. Values below 100% lead to a darker image; values above 100% produce a brighter image.

The differences in the filters are obvious, but the flexibility that the Black & White adjustment provides means you can make and save your own subtly different Black & White effects. With more subtlety comes the need for a better way to see and compare those subtleties. Compare mode in Aperture gives you exactly what you need.

Comparing Image Versions

You now have four versions plus the original of your image to compare. Instead of browsing each image one by one, switching between them to see which you prefer, you can use the compare feature to help speed the comparison.

Similar to using Stack mode in Lesson 3 to compare images in a stack, the compare feature pairs a selected image with a second image of your choice so you can evaluate them side-by-side even though they are not in stacks.

1 Select the first black-and-white image, **IMG_4532 - Version 2.**

2 In the toolbar, from the Viewer Mode pop-up menu, choose Compare, or press Option-O.

Your selected image becomes the compare image outlined in green to the left. The image immediately to the right in the filmstrip view is selected as the first image you want to compare with that compare image.

After evaluating the two images, if you decide that the second image is the best, you can set it to become the compare image.

3 Control-click the rightmost image in the Viewer and choose Set Compare Item from the shortcut menu, or press Return.

The second image becomes the compare image, and the image immediately to the right in the filmstrip view is selected as the alternate. You can press the Arrow keys or click any image in the filmstrip view to examine it beside the compare image.

4 Press the Right Arrow key to move to the last image in the filmstrip view.

5 Click the original color image in the filmstrip view.

If you have decided that the compare image is still the best version, you can select it and close the compare feature.

6 Press Option-Return to close the compare feature with the compare image as the selected image in the Viewer.

7 Press 5 on the keyboard to rate this image as your five-star select image.

You can use the compare feature in any number of situations but especially to whittle down your selection quickly to the best shot in your project.

Lesson Review

1. Name two of the three ways you can select another project while in Full Screen view.

2. How does adjusting the Highlights & Shadows controls affect an image?

3. How do you adjust just the highlights or shadows without impacting the midtones, black point, or white point in the Levels adjustment?

4. True or false: Black-and-white filters from the Effects menu cannot be changed after they are applied.

5. Are stacks required to use the compare feature?

Answers

1. The three ways to select projects in Full Screen view are using the Library Path Navigator pop-up menu at the top of the Browser, from the Library tab in the Inspector HUD, or selecting Projects in the top left of the Browser to see the Projects view.

2. If you drag the Highlights slider to the right, the bright areas of your image will get darker. If you drag the Shadows slider to the right, the dark areas of your image will get brighter.

3. Enabling the Quarter-Tone controls in the Levels adjustment will display sliders for highlights and shadows.

4. False. The filters can be adjusted using the Black & White adjustment brick that is applied when you select a Black & White filter effect.

5. No, stacks are not required. The compare feature uses a selected compare image, outlined in green. The image immediately to the right in the filmstrip view is then chosen as the first image you want to examine next to the compare image.

8

Lesson Files	APTS Aperture3 Library
Time	This lesson takes approximately 90 minutes to complete.
Goals	Enhance an image using the Saturation and Vibrancy controls
	Adjust individual colors in an image using the Color controls
	Use curves to correct luminance and color
	Correct chromatic aberration
	Specify and use an external editor

Lesson 8
Correcting Color

Everyone judges color differently, but everyone can learn fundamental concepts about color perception. You can know which colors convey a calm feeling, happiness, or regal elegance. Understanding complementary and harmonizing colors can help you make color adjustments to achieve your desired visual impact.

This lesson concentrates on color tools and the tasks they serve. But as you perform these exercises, keep color theory basics in mind.

When making color adjustments, you should also pay attention to your physical work environment. Your workspace influences the way you see color and luminance. The amount of ambient light and the color of the walls in the room can skew your perception. If possible, when making color adjustments try to work in a color neutral room.

In this lesson, you'll continue to make adjustments using the Full Screen view to remove any distracting colors outside the image you are working on. You will focus on enhancing and fixing colors on several photos using tools ranging from simple saturation to more complex Curves controls.

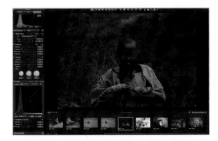

Working with Color in the Enhance Controls

You may discover that some images lack the precise color intensity you desire. In some cases the image may be washed out, and in other instances you may want to reduce saturation to make the colors less intense. Aperture offers two primary controls for adjusting the intensity of color: Saturation and Vibrancy. Additionally, the Tint controls can add or remove color casts in selected regions.

Adjusting Saturation

The saturation control is the tool to boost or reduce the purity of hues in your image. You make saturation adjustments somewhat subjectively, based on the impression you want the image to convey.

Be careful not to oversaturate images. Although boosting the saturation will make colors appear more pure or intense, you don't want people looking like orange-colored aliens.

Desaturated colors can give a pastel or old appearance to an image. Let's find an image in which you mute colors using the Saturation adjustment.

1 In the Library inspector, select the Uganda The Pearl of Africa project.

2 Press F, or click the Full Screen button to enter Full Screen view, if necessary.

3 Double-click the lion image, **IMG_2208**.

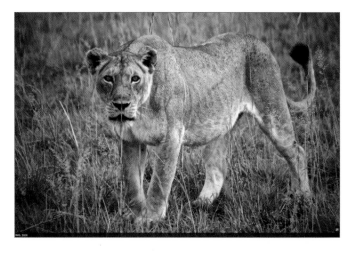

4 Click the Adjustments tab of the HUD.

5 In the Enhance brick, drag the Saturation slider to 0.7. Moving the slider to 0.7 sets the saturation at 70 percent, which gives our lion a muted, weathered look.

The Saturation values represent a percentage. So the default value of 1.0 is 100 percent saturation. Although the slider goes only to 2.0, you can type a value up to 4.0.

Using Creative Tint Controls

The Enhance brick also contains Tint controls for shadow, midtones, and highlights. The tint controls can introduce color casts into an image to create a mood. In this exercise, you apply midtone and shadows tints to simulate a predawn setting for your lion.

1 In the Exposure brick, drag the Brightness slider down to around −0.3 to help create a nighttime look.

2 In the Adjustments pane's Enhance controls, click the Tint disclosure triangle to reveal the Tint color wheels.

3 Drag the Gray point around in the Gray Tint color wheel to get an idea how the control works.

4 When you're ready, drag the Gray point to the blue area to create a slight bluish tint.

5 In the Black Tint color wheel, drag the Black point into the blue area until you feel you have the best dawn simulation.

You don't have to drag to the very edge to get a strong color cast. Sometimes moving the tint point slightly off center is all that's needed. Whenever you are making adjustments, always switch between the original and your modified version to evaluate your changes.

Applying Corrective Tint Controls

The Tint eyedroppers can also be used to correct color casts in the shadows, midtones, or highlights. These regional color casts occur most often when shooting in mixed-light situations, such as when both natural and electrical light are present.

1 Press V to return to the Browser view.

2 From the Library Path Navigator pop-up menu, choose Projects > Around San Francisco.

3 Double-click the San Francisco Bay image, **IMG_3144**. This image has a heavy blue color cast, especially in the shadows.

4 In the Adjustments inspector, click the Black Tint eyedropper.

The Loupe appears and shows a magnified view of the pointer location. You'll move the pointer over the image to find an area that should be pure black, such as the shadows of the tree. By clicking, Aperture balances the red, green, and blue channels to remove the color cast.

5 Position the pointer over the darkest pixels in the image, and then click.

Let's check out the blacks correction by comparing this version with the original image.

6 Press M to view the original image, and then press M again to return to the adjusted version. Notice that the blacks have a more neutral tint, with a lot less blue in the shadow areas.

Now that you've removed the color casts from the shadows, let's adjust the midtones.

7 Click the Gray Tint eyedropper.

8 Locate an area that should be a medium gray. The shadowy side of the Transamerica pyramid works well, but feel free to try other spots.

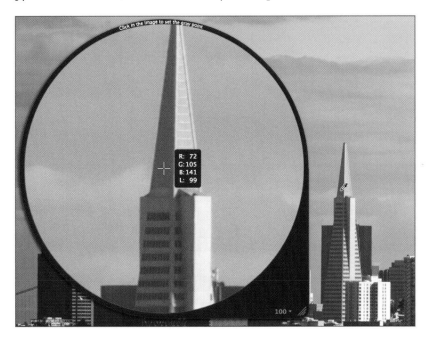

9 Click to remove the color cast from the midtones.

Although you could adjust the highlights, too, it might introduce too much yellow into the clouds, so let's stop adjusting. Although tweaking the White Balance adjustment will correct the majority of color casts, for those tricky situations where mixed lighting has wreaked havoc on your image it's good to know you can turn to the Tint controls to apply more precise corrections.

Controlling Image Vibrancy

Oftentimes saturation increases have a bad effect on skin tones. So although skies, grass, and water might benefit from a color boost, skin tones can look fake. For these situations, Aperture offers the Vibrancy parameter, which boosts (or reduces) saturation while avoiding changes to skin tones.

1 In the Inspector HUD, click the Library tab and select the Uganda The Pearl of Africa project.

2 Double-click the image of the school children, **IMG_9602**. The image could use a slight color boost to bring out the bright colors in the back of the classroom.

3 In the Inspector HUD, click the Adjustments tab.

4 In the Enhance controls, drag the Vibrancy slider to the right to suit your taste, probably around 0.4.

> **NOTE ▶** A value of 1.0 is the maximum boost you can perform using the Vibrancy slider. If you need more color, you'll need to use the Saturation slider.

5 Click the Enhance checkbox to enable and disable the Vibrancy adjustment, comparing before and after.

The Vibrancy adjustment is specific, but you'll find yourself using it more often than saturation, especially when working with portraits. It can also provide interesting results with landscapes and wildlife.

Selectively Improving Color Using the Color Controls

The Color controls in Aperture include independent adjustments for up to six specific colors—by default these six are preset to red, green, blue, cyan, magenta, and yellow. Once you pinpoint a color in your image, you can modify it using Hue, Saturation, Luminance, and Range controls.

Changing a Single Color

When using the Color controls, the first step is to identify the color that you want to change. The easiest way to do so is to click one of the preset color buttons and then modify the preset color by changing the Hue, Saturation, Brightness, and Range parameters.

When making those changes, remember your color wheel principles: When you decrease blue, it will appear to add yellow; when you decrease magenta, it will appear to add green, and so on.

1 In the Inspector HUD, click the Library tab and select the San Diego Zoo project.

2 Double-click the image of the three flamingos, **IMG_0657**.

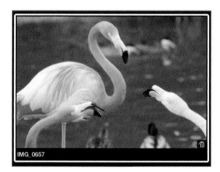

This image contains two predominant colors that you can enhance. Let's work first with the greens in the water and make them less muddy by introducing more cyan. Begin in the Color control by selecting a preset hue that is closest to the color you want to adjust, which is green in this case.

3 In the Inspector HUD, click the Adjustments tab.

4 Click the Add Adjustment pop-up menu and choose Color from the list.

5 In the Color controls, click the green hue preset.

If the hue color you want doesn't exist, or you want to be more precise, you can use the eyedropper to replace a preset hue with a hue from the image.

6 Click the eyedropper and click anywhere over the muddy green water. The preset hue is replaced with the green hue from the water.

7 Drag the Hue slider all the way to the right, pushing the greens toward a more pure green.

8 Drag the Saturation slider a bit to the right to slightly increase saturation.

9 Drag the Luminance slider to the right to lighten the cyan areas to your taste. You've replaced the muddy water with a cooler, more refreshing pond.

The Range slider limits or expands the spread of colors that are impacted by the previous adjustments. Adjusting the Hue, Saturation, and Luminance sliders produced a good result; but all the shades of green in the water are not converted, so you'll use the Range slider to increase the range of greens affected.

10 Adjust the Range to around 1.3 to slightly increase the range of greens that are affected.

11 Press M to view the original image, and then press M again to return to the adjusted version.

The water now has a nicer emerald look compared to the muddy green of the original. Using a knowledge of complementary colors, you also can push the flamingos' color closer to pink to complement the green in the water.

Expanding Color Controls

The Color controls are not limited to isolating a single color. You can use them to adjust up to six colors, but to work with more than one color at a time, it's sometimes easier to expand the list to show all six simultaneously. Let's make a second color adjustment on the flamingos using the expanded view of the Color controls.

1 In the Color controls, click the Expanded View button.

2 Click the red preset eyedropper.

NOTE ▶ If screen display space is a concern, you can stay in compact view and click a hue button to switch the colors that you're affecting.

3 Click a color on the flamingo's neck.

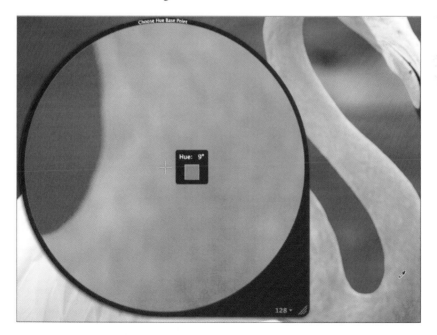

4 Drag the Hue slider left to push it more toward pink, around –25.

5 Increase the saturation a bit by dragging the Saturation slider to the right, somewhere around 5 to 15.

> **TIP** ▶ Rather than drag the sliders, you can click the numeric field of a parameter and press any of the Arrow keys to change it. Holding down the Option key while pressing any of the Arrow keys will change the parameter in finer increments. Press Tab to move to the next parameter.

6 Lower the Luminance slider to around –15 until you've produced a more subdued pink flamingo.

7 Increase the Range value to around 1.5 to make sure the entire flamingo is included.

8 Press M to view the original image, and then press M again to return to the adjusted version. You now have a classic pink flamingo against a cool green pond versus the original with the orange flamingo against a murky green pond.

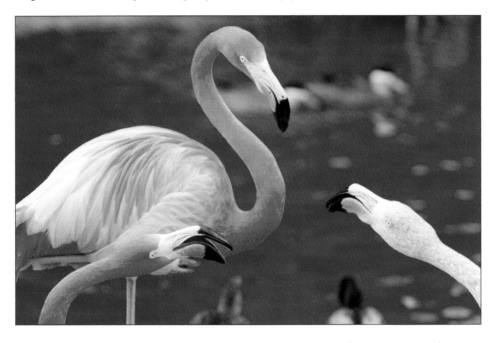

The Color controls group is a simple tool that you'll probably use frequently to make subtle color shifts to specific hues.

Working with Curves

Curves—either you love 'em or you hate 'em, but no one can deny that they provide the most flexibility when making color and tonal adjustments in Aperture.

Conceptually, curves are not all that different from levels. You modify your midtones, shadows, and highlights by pushing and pulling points along a line. But instead of being limited to just five points as you are with levels, curves can have dozens of points, resulting in much more adjustment precision.

Adjusting Luminance Curves

There are two types of tonal curves: luminance curves, which only impact luminance; and RGB curves, which impact both luminance and color.

You are going to create a quick, lo-fi, cross-processed look for an image, which will start off with a high-contrast adjustment using a luminance curve.

1 Press V to return to the Browser.

2 In the Library Path Navigator pop-up menu, choose Projects > Uganda The Pearl of Africa.

3 Double-click the image of the single child, **IMG_1187**.

4 From the Adjustments HUD, choose Add Adjustment > Curves.

 The Adjustments inspector is getting crowded. A quick and easy way to clean things up is to close all the adjustment bricks except the one you are using.

5 Option-click any disclosure triangle to close all the bricks. Then, click the Curves disclosure triangle to expand the Curves controls.

6 From the Curves Action pop-up menu, choose Luminance.

You begin adjusting curves in the histogram by identifying the region you want to adjust. Then you add points to the curve and move those points to increase or decrease the values of the region. To create high contrast, you need to crush your shadows and boost your highlights, leaving very little in the midtones.

7 Position your pointer where the curve intersects with the lower left of the histogram. This area corresponds to the image shadows.

8 Click to add a point, and drag the point about two-thirds to the bottom of the histogram.

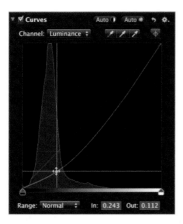

By dragging the curve point up or down along the Y-axis, you can increase or decrease the brightness level of the region.

Notice that the entire curve is now arched down, which indicates that the entire image has been made darker. The dimmed diagonal guide line indicates where the original level was set. You want only the shadows darker, so let's add another curve point to bring up midtones and add more contrast.

This time, you'll use the input and output values at the bottom of the Curves brick to set each curve point's location. When you move a curve point left or right, you are

changing the In value; moving the point up and down changes the Out value. When the In and the Out values are the same, your curve point will be on the dimmed guide line, producing no change in the image for that particular luminance range.

9 Position the pointer over the arched line at the approximate midpoint of the histogram.

10 Click to add a new curve point for the midtones of the image.

> **TIP** You can remove a control point by Control-clicking (or right-clicking) the point and choosing Remove Point from the shortcut menu. You can reset a curve in the same shortcut menu.

11 Drag up the new midtones curve point until the Out value reaches around 0.90.

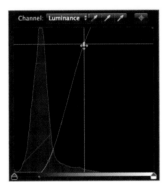

That's pretty high contrast. Maybe a bit too far on the shadows, so let's readjust the shadows so that a smaller range is crushed. To make subtle shadow adjustments easier, you can zoom the histogram into the shadows area.

12 From the Range pop-up menu, choose Shadows.

> **TIP** When whites are clipped, you can set the Range pop-up menu to Extended. This will move the view beyond the histogram so you can reset the white point to include the clipped portion. It's similar to using the Recovery slider.

13 Drag the shadows curve point to the left until the point reaches the diagonal line.

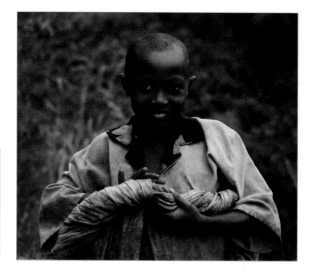

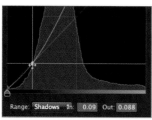

14 From the Range pop-up menu, choose Normal.

A steeper curve represents more contrast. The closer that two points are over each other vertically, the more contrast you are introducing. The closer two points are horizontally, the less contrast between them.

15 Drag the midtones curve point slightly left until it sits in the center of the grid box.

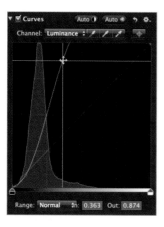

16 In the inspector, deselect the Curves checkbox to view the image without the adjustment applied, and then select it to return to your adjusted version.

This image now looks very high contrast, which is what you want. However, you may have one problem that you typically want to avoid. In the main histogram, which is displaying the RGB values, notice that the red channel has spikes that are evenly spaced.

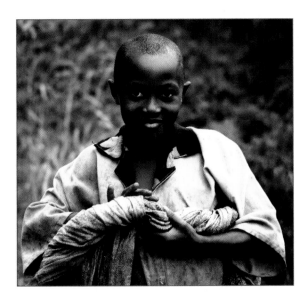

These spikes indicate that you are stretching the red channel so much that it is causing *quantization* in the image. Remember that each channel has only 256 shades that it can reproduce. If you stretch the values apart too much using any adjustment, you'll eventually get quantization, or distinct steps in the color shades. In this case, we'll fix it by using curves to adjust color.

> **NOTE** ▶ In the Curves Action pop-up menu, you can choose from two tonal curve types when making Curve adjustments: Linear—the default option—applies the Curves adjustment evenly from black point to white point; Gamma-Corrected applies the Curves adjustment logarithmically, adding additional emphasis on the shadows.

Correcting Color Using Curves

So far you've adjusted only luminance in your curve, but you can also adjust color channels individually. To add to your lo-fi, cross-processed look, let's remove green and red from the shadows and boost those channels in the highlights. Then you will do the reverse in the blue channel. The adjustment settings for this type of cross-processed look are completely subjective, so you can go back and make your own choices after going through this exercise.

1 From the Curves Channel pop-up menu, choose Red.

You first want to correct the region in the red channel that is quantizing. Instead of guessing where to put the curve point, you can easily find it on the image using the Loupe and the Add Point button.

2 Click the Add Point button and position the pointer over the child's forehead.

The main histogram at the top of the HUD displays red, green, and blue lines to indicate where the pixels under the pointer are located on the histogram. All you need to do is move the pointer until you find a location that includes pixels in the same location as the evenly spaced red spikes.

3 Move the pointer to the right, across the child's forehead. When the lines in the histogram line up over the spikes in the red channel, click with the eyedropper. A curve point is added to the curve that corresponds to the area you selected on the image.

4 Find the red curve point that was added and drag it down until most of the evenly spaced spikes are removed. This sets the Out field to around 0.20.

5 Click the Add Point button, and then click the tip of the child's nose to add a high-light curve point.

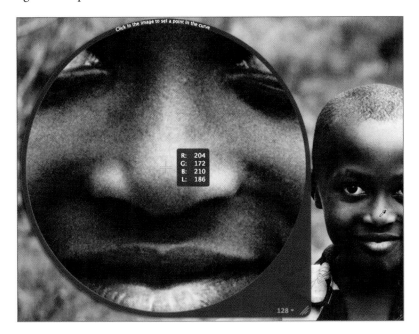

6 On the red curve, drag the newly added point up until the Out value is around 0.9.

Now you'll create a slightly different, simplified blue curve by just adjusting the black and white points and not adding any other points along the curve.

7 From the Channel pop-up menu, choose Blue.

8 Click the blue channel's white point in the upper-right corner of the histogram.

9 Drag the point down, until the Out value is around 0.90.

10 Click the blue channel's black point in the lower-left corner of the graph.

TIP If it's difficult to see the black point, choose Shadows from the Range pop-up menu to zoom in to the area.

11 Drag the point up slightly until you have an image you like. You've now added some blue to the shadow areas of the image.

Finally, let's crop this image to create a nicer portrait.

12 Press C, or from the toolbar, choose the Crop tool.

13 Drag a selection rectangle around the child.

14 In the Crop HUD, click the Switch Aspect Ratio button.

15 Position and scale the selection rectangle to produce an interesting framing, following the rule of thirds.

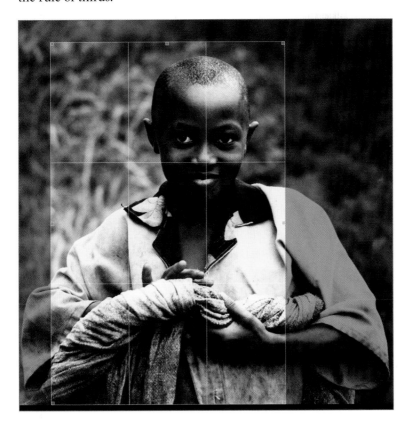

16 In the Crop HUD, click Apply.

17 In the inspector, deselect the Curves checkbox to show the color of the original image, and then select it to return to your version.

You've significantly adjusted the color channels on this image to create a lo-fi, cross-processed look. By now, you've probably seen enough of the Curve adjustments to understand their incredible flexibility. Some people gravitate to them for most adjustments, while others never touch them. It's a choice. Try using curves to manipulate some of your images and then decide how you want to use them in the future.

Correcting Chromatic Aberration

Chromatic aberration is an artifact that is most often seen as a blue or red fringing around high-contrast transition areas. Chromatic aberration is basically due to the lens acting as a prism. Different color wavelengths do not focus on exactly the same plane. The amount of chromatic aberration depends on the amount of color separation in the lens, with less expensive lenses showing more of this artifact. There are other, similar artifacts that are the result of sensor issues but fortunately the Chromatic Aberration adjustment can deal with both these cases.

1 In the Uganda Pearl of Africa project, press V to show the Browser.

2 Double-click the papyrus image, **IMG_1459**.

3 Position the pointer over the tall stalk on the lower right and then press Z to zoom in to it.

4 Use the navigation box to zoom in to around 150%.

You should be able notice a bluish-purple fringe along the left side of the papyrus. It isn't egregious, but it is noticeable. The more you zoom in to this image, the more it can be seen in other areas as well. This stalk just happens to be the most noticeable.

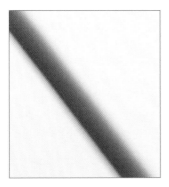

5 In the Add Adjustment pop-up menu, choose Chromatic Aberration.

6 In the Chromatic Aberration brick, drag the Blue/Yellow slider toward yellow until the bluish fringe disappears.

7 Press M to view the original image, and then press M again to compare the original with the corrected version. The purple aberration is gone.

Toggling between the original and the version clearly shows the color differences along the edges. Again, it initially takes a keen eye to spot these artifacts, but once you fix a few you'll start to recognize the situations in which these artifacts are most likely to appear.

Working with an External Editor

Although Aperture provides great tools for adjusting tone, contrast, and color, it does not have compositing capabilities. For these functions, Aperture is designed to work seamlessly with an external editing program such as Adobe Photoshop.

Aperture provides a built-in "round-trip" facility for importing and exporting images to an advanced image-editing/compositing application. This capability allows you to open Photoshop within Aperture and integrate it easily into your Aperture workflow.

Choosing an External Editor

To use an external editor, you need to identify the application for Aperture. Because Aperture creates a new original file that is sent to the external application, you must also select what format and bit depth that file should be. You have to set these preferences just once, and then the settings will be used for all future adjustments.

1 Press F to exit Full Screen view.

2 Choose Aperture > Preferences, and then click the Export button.

3 Click the Choose button next to the External Photo Editor field.

4 In the dialog that appears, navigate to the application you'd like Aperture to use when editing an image in an external editor. For these exercises, we'll use Adobe Photoshop, so choose it if you have it installed on your system.

> **NOTE** ▸ If you don't have Adobe Photoshop installed, you can use an image-editing application of your choice or follow the exercise without performing the specific steps.

5 Click the Select button, and close the dialog, if necessary. The application's name appears in the External Photo Editor field.

6 In Preferences, set the External Editor File Format pop-up menu to the file format you'd like Aperture to create and use for exchanging files.

Let's select 16-bit PSD because you'll be using Photoshop as the external editor. You could have selected 16-bit TIFF, but PSD will support all of the Photoshop features that you might choose to use.

NOTE ▶ Aperture never alters your original image. It creates a new original as a PSD or TIFF format file at 8-bit or 16-bit resolution. The 16-bit resolution exports with greater color and tonal fidelity but not all external editors can support this. It also takes up more space on your hard disk.

7 Next to the External Editor File Format pop-up menu is a small field labeled dpi (dots per inch). This defaults to a value of 300, which is fine for this exercise. This value specifies that the image should be exported with a resolution of 300 pixels per inch.

8 Close Preferences.

Switching Between Aperture and an External Editor

As you know, Aperture keeps all of your images organized using its library. When you want to edit an image elsewhere, the easiest way to do so is by using the specified external editor. Aperture will then use its round-trip capability to automatically re-import the image for you. In this exercise, you'll use Photoshop to composite an image over itself to create a glowing effect. Compositing is a common reason you might use Photoshop with Aperture.

1 In the Library inspector, select the Catherine Hall Studios project and press V to view the Browser.

2 In the Browser, select **51_0952_HJ-532_2**.

3 Choose Photos > Edit With Adobe Photoshop, or press Command-Shift-O.

NOTE ▶ This menu changes depending on the external editor you chose. For instance, if you chose Pixelmator, the menu would read "Edit with Pixelmator."

If it's not already running, Aperture will launch the application you specified in Preferences, and your image is opened automatically.

NOTE ▶ When you open an image with an external editor, Aperture automatically creates a new original of the selected image. If the original image is stored in your Aperture library, the new original also will be stored there. If the image is a referenced image, the new original will be stored in the same location as the referenced image on the hard disk.

4 In Photoshop, choose Layer > Duplicate Layer to create a copy of the Background layer.

5 Name the layer *glow*, and click OK.

6 Choose Filter > Blur > Gaussian Blur.

7 Set the Radius setting to 20.2 and click OK.

8 In the Layers panel, set the blending mode to Screen.

9 From the Layers menu, choose New Adjustment Layer > Levels, and click OK in the naming dialog that appears.

10 In the Layers adjustments, drag the Midtones slider to the right to darken the midtones.

11 Press Command-S to save the document, and then close the document in Photoshop.

12 Return to Aperture. The new version that appears in your project reflects the Photoshop edits.

> **TIP** ▸ Images that have been edited in an external editor have a small circular badge in the lower right of the thumbnail or the Viewer image.

13 Select the new version and press Command-Shift-O to open it in Photoshop. Then return to Aperture.

Note that this time, Aperture didn't create another new version. Instead, it opened the Photoshop file you were just working on.

> **TIP** ▸ If you'd like to create a new version of your image when you open the external editor, hold down the Option key when you send the image to the external editor.

14 Quit Adobe Photoshop and return to Aperture.

The goal of Aperture is to provide a single application that tends to all of your postproduction workflow needs. Because Aperture handles all of the file management, version control, and archiving, exporting an image to another program for additional editing is very simple and works seamlessly as part of your Aperture workflow.

Lesson Review

1. When editing with an external editor, what file does Aperture send to the external application?
2. What does the Add Point button do in the Curves adjustment?
3. What's the functional difference between the White Balance and Tint controls?
4. Can curves be used to correct white balance issues?
5. True or false: It's impossible to adjust the hue, saturation, and luminance of a color that does not appear in the Color controls.
6. Which of these two controls adjusts the color of an image without affecting skin tones: Saturation or Vibrancy?

Answers

1. Aperture creates a new original file, which is sent to the external application. You can choose to create a PSD or TIFF format file in 8- or 16-bit resolution.
2. The Add Point button can be used to select a point on the image, which is then mapped to the curve editor to place a curve point.
3. The White Balance control makes uniform adjustments to all tonal values in an image. The Tint Controls can selectively neutralize color casts that affect only the shadows, midtones, or highlights.
4. Curves can adjust both luminance and color. Because it can adjust individual RGB color channels, you could use it to correct white balance issues.
5. False. You can use the Color eyedropper to identify any image hue that needs adjusting.
6. The Saturation control affects the entire color range within an image while Vibrancy affects the colors outside of the skin tone range.

9

Lesson Files	APTS Aperture3 Library
Time	This lesson takes approximately 150 minutes to complete.
Goals	Use Quick Brushes to correct problematic areas
	Add blur to simulate shallow depth of field
	Smooth skin imperfections
	Darken shadows and midtones with the Polarize brush
	Repair images with the Retouch tool
	Remove purple fringing artifacts
	Create a brush from an adjustment
	Use multiple instances of an adjustment

Making Local Adjustments with Brushes

Generally you have been applying your adjustments to the entire image. Some worked on ranges of luminance and hue, but those were your limits over where adjustments were applied. More-specific local adjustments can be made in Aperture using brushes.

Brushes are a way for you to "paint" a mask that determines where an adjustment is or is not applied. Using the nondestructive brushes, you can repair damaged photos, blur images to enhance a shallow depth of field, and smooth skin blemishes. Additionally, almost any adjustment in the Adjustments inspector can be made into a brush.

In this lesson, you'll use a number of brushes to learn how they can be used to improve landscapes, wildlife photos, and portraits.

Using Brushes

Brushes are accessed in two areas. Primarily, you'll access brushes in the Quick Brush pop-up menu. Quick Brushes include unique adjustments not found in the Adjustments pane because they are designed to be applied locally. Brushes such as Skin Smoothing, Clone, Repair, and Blur are good examples. Other Quick Brushes are common adjustments that are typically used locally, including Sharpening, Saturation, and Vibrancy.

In addition to Quick Brushes, you can make brushes from most adjustments in the Adjustments inspector, the second place where you can access brushes. Whether you use a Quick Brush or create a brush from adjustments in the inspector, the methods of working with them are the same in the Aperture nondestructive environment.

Adding and Erasing Brush Strokes

The Aperture Blur brush can be used for a number of things, but it's perfect for extending the blurred parts of your image to simulate additional depth of field.

1 From the Library inspector, select "People of NW Africa."

2 Press V to view the Browser, and double-click the image of the woman in the multi-colored veil, **Mauritania 2006-11-06 at 15-46-49**.

Let's enhance this image by adding some blur that outlines her veil, or hijab. All Quick Brushes can be found in the tool strip in the Quick Brush pop-up menu.

3 From the Quick Brush pop-up menu, choose Blur.

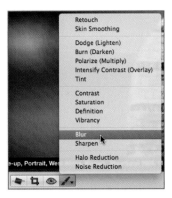

The Brush HUD appears, and the Blur adjustment is added to the Adjustments inspector. As you move your pointer over the image, you can see the size of the brush you'll use.

4 In the Brush HUD, drag the Brush Size slider to around 55.

5 Begin painting by dragging the brush over the very top of the hijab on the woman's head. Continue painting down the left side of her head until you get to her shoulder. End the blur by making a nice falloff around her shoulder.

> **NOTE ▶** The red overlay in the following figures has been inserted to help you identify where to apply the blur. You do not see a red overlay when you paint.

6 Continue painting down the right side until the point where the hijab comes across her shoulder.

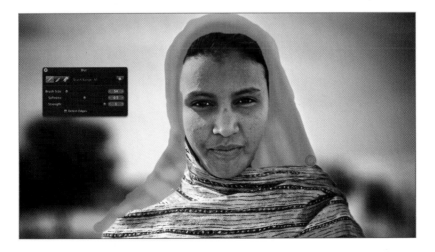

Follow your instincts on where and how the blur would end, but if you make a mistake, it's easy to erase a stroke. Aperture offers two tools for cleaning up the brush strokes.

7 Choose the Eraser tool to remove any stray strokes in areas that are too blurred. You can change the brush size to remove small areas or to more effectively taper edges.

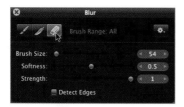

8 Choose the Feather tool to smooth the transition from the blurred areas to the non-blurred areas.

9 Once you finish touching up your blur, close the Brush HUD.

10 In the Adjustments inspector, drag the Blur Amount slider down to around 2.0 to make the brush more transparent.

11 If you'd like to compare the results with the original image, press M to toggle between the original image and your version.

12 If you would like to make additional changes, click the Brush button in the Blur brick of the Adjustments inspector to open the Brush HUD.

> **TIP** Brushes are pressure sensitive if you are using a pen and tablet interface.

The basics of using brushes are the same for every brush type. So when you learn one, you've learned them all. Let's continue with another brush and build from there.

Smoothing Skin

Skin Smoothing is a simple brush that is handy when doing weddings, portraits, or fashion photography. It adds a slight blur to soften pores and wrinkles.

1 In the Library inspector tab, select the Flagged category.

2 Select the first image in the browser, **Senegal 2006-11-03 at 09-59-29**.

3 Press V twice to display the Viewer only.

4 On the tool strip, click the Quick Brush pop-up menu and choose Skin Smoothing.

5 Paint over the woman's forehead, down her nose, and under her eyes. Remember that the red overlay in the figure has been added to help guide your brush. You will not see it in Aperture.

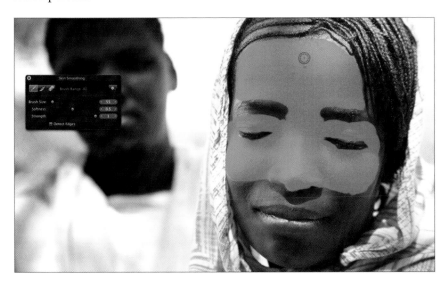

TIP Using an Apple Magic Mouse or a Multi-Touch trackpad, you can change brush size by sliding two fingers up or down.

The smoothing does a nice job, even with the default settings. Details still remain, but her face is smoother. Be careful not to paint over her eyelashes, eyebrows, or any place else that doesn't really require smoothing.

Viewing Painted Areas as Overlays

When using such a subtle effect, it can be easy to forget which areas you have painted and which still need adjustment.

1 In the Brush HUD, from the Action pop-up menu, choose Color Overlay. A red overlay appears on areas that you painted, making it easy to locate areas that still need painting, and maybe a few areas where you have gone too far.

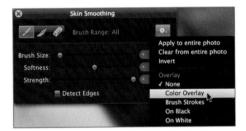

2 Paint any remaining areas on the woman's face.

3 Choose the Eraser tool and remove any stray strokes in areas that should not be smoothed, such as her eyebrows or eyelashes.

4 Choose the Feather tool and smooth the stroke edges.

5 In the Brush HUD, from the Action pop-up menu, choose None to remove the red overlay.

After you finish painting an image, you can modify the adjustment in the inspector just as you would any other adjustment.

Modifying Brush Strokes in the Inspector

Different brushes have different parameters that you can modify even after you have painted. Some, such as Blur, have one for the amount of the filter applied. Others, such as Skin Smoothing, have more.

In Skin Smoothing, the Radius parameter sets the number of pixels used for blurring. Or more concisely, a higher Radius value equals more blurriness. You adjust Intensity to mix

the blur with the original image. An Intensity of 0.0 means you are looking at the original image. If you set the Detail slider higher—yup, you got it—you increase the detail. Let's try these out.

1 In the Skin Smoothing brick of the Adjustments inspector, click in the Radius slider's value field and enter *15*, and then press Return.

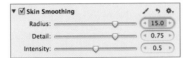

2 Press Tab to move to the Detail value field, and then press Tab again to move to the Intensity value field.

3 Press Shift-Right Arrow to increase the Intensity value by 0.1. Press repeatedly until the value is 0.7.

4 Press Shift-Tab to return to the Detail value field.

5 Press Shift-Right Arrow to increase the Detail by 0.1 increments until you reach 0.90. Press Return.

6 Compare your results with the original image by pressing M. When you're done, be sure you're looking at the version, not the original.

Before After

Even though this brush is called Skin Smoothing, you can use it to smooth textures on any image. It's similar to painting with a small blur, but with more controls for detail.

Brightening Areas Using the Dodge Brush

Dodging is the process of brightening an image in specific areas. It's a good tool for reducing harsh, unwanted shadows, especially around eyes. In this exercise, you'll apply it to a wedding photo from Catherine Hall Studios to diminish the dark shadows on a bride.

1 From the Library inspector, select the Catherine Hall Studios project.

2 Press V to view the Browser, and double-click the image of the bride and her father entering the church, **0591_HJ_314**. Let's lighten the shadows that fall on the bride's face and shoulders.

3 In the tool strip, from the Quick Brush pop-up menu, choose Dodge (Lighten). The Brush HUD appears, and the Dodge adjustment is added to the Adjustments inspector.

4 Position the pointer over the bride's face, and press Z to zoom in.

5 Set the Brush Size to around 45 and the Softness to 0.75. Then brush over the shadows on the right side of the bride's face, as indicated by the red overlay we've added to the following figure to guide you.

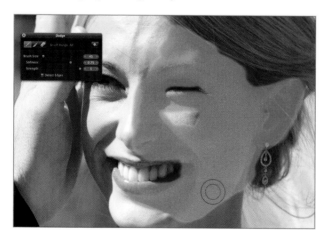

The brush defaults work well to reduce the shadows, but almost every brush has a few options you can use to increase the precision of your painting, as you'll see in the next exercise.

Limiting Brushes to Shadows, Midtones, or Highlights

The Brush Range limits the luminance range that the brush paints into. By limiting your brush to brushing only in the shadows, it should be easier to lighten the face and shoulder shadows without altering midtones and highlights.

1 From the Brush Action pop-up menu, choose "Clear from entire photo" to remove your previous paint job.

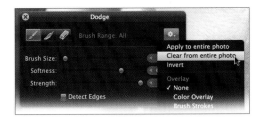

2 From the Brush Action pop-up menu, set the Brush Range to Shadows.

3 Brush over the shadows on the right side of the bride's face.

4 Choose the Eraser tool and remove any stray strokes in areas that are lightened too much. Compare your results with the original image.

It's always a good idea to check your work against the original just to make sure it's coming along the way you expected.

Detecting Edges While Painting

The bride's shoulders are slightly easier to modify than her face because they represent one continuous area of shadows. You can make it easier still by enabling edge detection, which will help you "paint within the lines," so to speak. Edge detection can prevent you from painting into areas that have a dramatic change in luminance levels. It doesn't give you a license to be sloppy, but edge detection can provide a bit more latitude when you're swinging those brushes.

1 In the Brush HUD, choose the Brush tool.

2 Select the Detect Edges checkbox.

3 Set the Brush Size to around 75.

4 Use the navigation box to position the Viewer over the bride's shoulder on the left.

5 Paint on the bride's shoulders. Go slowly near edges so you can place the center point of the brush close to the edge. Don't forget to paint over her neck and arm.

TIP Zooming in closer than 100 percent can be helpful when painting along edges. You can use the Scale Size adjustment in the navigation box to zoom in. When you need to move the Viewer, press the Spacebar. The pointer will change to a hand icon. Then drag to pan the view.

6 Choose the Feather tool and smooth the edges around her shoulders and arms and remove any overzealous edge detection.

7 After you are finished, press Z to view the entire image. Then compare the original to your lightened version by pressing M. Be sure to end with your version.

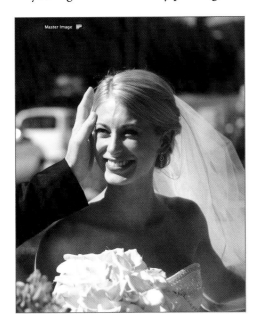

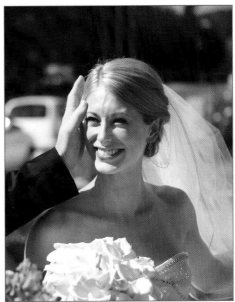

Before

After

Enabling edge detection at all times might seem like a good idea, but it can cause problems. As you brush over various textures, edge detection may incorrectly identify boundaries that the stroke should avoid, potentially causing a gap in the center of the area you want to fill. Use edge detection around the rim of the area you are trying to fill in, not the center.

Darkening Areas Using the Burn Brush

Burn is the opposite of Dodge. It selectively darkens the highlights and midtones. Both dodge and burn are terms related to the traditional photography printing process. When working with a film negative, a photographer could mask most of the image and expose an area to additional light, or *burn* it. This would darken the exposed area. Let's darken the back of the father's head, along with the bright white flowers.

1 In the tool strip, from the Quick Brush pop-up menu, choose Burn (Darken).

2 In the Brush Action pop-up menu, set the Brush Range to All, because you no longer want to paint only the shadows.

3 Set Brush Size to 120 and Softness to 0.5.

4 Make sure Detect Edges is not selected. In this case, you'll cross many edges and don't want edge detection to prevent the application of the adjustment.

5 Paint the bright areas on the back of the father's head and paint down his shoulder to remove the light creases in his jacket. (Once again, the red overlay has been added to the figure as a guide.)

6 Use the Feather and Eraser tools if you need to clean up any areas.

7 Select Detect Edges.

8 Paint over the bright areas of the white flowers (as indicated by the mask added to the figure). Try to avoid the darker shadows of the flowers or they will end up looking like they are dying—not a good look at the wedding.

Now that you have applied the basic strokes, you'll notice some edges along the painted areas. You can use the Feather tool to smooth those transitions, but they'll be easier to correct with another overlay view.

9 From the Brush Action pop-up menu, set the Overlay to Brush Strokes.

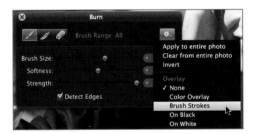

This overlay removes the image and shows you only the mask of your brush strokes. Since you are interested only in feathering the edge of the mask, it doesn't matter at this point what the image is. You are going to feather the right inside edge of the father's mask and the right edge of the flowers.

10 In the Brush HUD, choose the Feather tool, and begin brushing all the way down the inside right edge of the father's mask, making sure it is all nice and feathered.

11 When you're finished with the father's mask, feather the right edge of the flowers, leaving the hard edges on the top and left side.

12 After you finish painting the flowers, in the Brush Action pop-up menu, set the Overlay to None. Close the Brush HUD.

13 In the Adjustments inspector, increase the Burn Amount slider to around 0.55 to fur-
ther darken the burn areas. You should have a seamless transition from the burned
area to the original image. If you see some areas that need to be touched up, use the
Feather tool to soften them.

14 Press M to compare the original to the version with Dodge and Burn applied. Be sure
to end viewing your version.

Before

After

A small amount of time applying Dodge and Burn to selective areas made a significant
difference in the overall even tone of this image.

Applying a Brush to an Entire Image

In some cases, it's much easier to apply a brush to an entire image and then erase the
adjustment in a few areas.

1 In the Library inspector, select the Brinkmann Photos project.

2 Press V to show the Browser.

3 Double-click the glaciers image, IMG_8735.

4 Press F to enter Full Screen view.

5 Press H to open the Inspector HUD, and click the Adjustments tab.

You can make the sky, mountains, and green water appear much richer by applying a Polarize filter. Actually the only place you wouldn't want to filter is the face of the glaciers. The Polarize filter darkens the shadows and midtones, making color much richer in those areas, but it leaves your highlights alone. Because the majority of the image could use filtering, you'll polarize the entire image, and then use the Eraser tool to remove the filter's effect from the face of the glacier.

An alternative way to access Quick Brushes is through the Adjustments inspector or the Full Screen view Inspector HUD.

6 In the Adjustments inspector, from the Add Adjustment pop-up menu, choose Quick Brushes > Polarize (Multiply).

7 From the Brush Action pop-up menu, choose "Apply to entire photo."

With the entire photo now darker from applying the Polarize filter, let's remove it from selected areas using the Eraser tool.

8 In the Brush HUD, choose the Eraser tool, and set Brush Size to around 80.

9 Deselect the Detect Edges checkbox, if necessary.

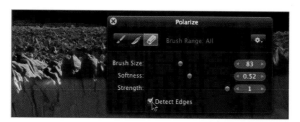

10 Begin by painting along the bottom of the glacier's face. When you are ready to paint the top of the glacier's face, select Detect Edges. Because a distinct edge exists between the surface of the glacier and its face, Detect Edges should work well in limiting stray strokes. Don't worry too much about the hard edges that are caused from detecting the edges. You'll fix those in a moment.

11 Use the Brush tool to add the Polarize filter in areas where you've gone too far with the Eraser tool. To more clearly see specific areas, press Z to zoom in, and pan using the navigation box, especially when painting along the top face of the glacier.

12 Choose the Feather tool, and set the Brush Size to about 30.

13 Brush along the top of the glacier's face, feathering any areas that appear as unnaturally hard edges caused by edge detection.

14 Press Z to zoom out and view your entire image.

15 Compare the original to the Polarized version by pressing M. Be sure to end viewing your version.

Before After

Curious minds may want to compare the Polarize Quick Brush to the Intensify Contrast Quick Brush by making a new version from the original and using the same steps to apply Intensify Contrast. You'll notice subtle differences, mostly in the clouds. That's because Intensify Contrast darkens from your black point up to the 50 percent Gray midtone point, whereas Polarize darkens from your darkest shadows up through the entire range of midtones.

Correcting Halo Artifacts

The Halo Reduction Quick Brush removes a specific form of chromatic aberration, seen as purple fringing in high-contrast areas. These artifacts show up mostly with less expensive or older lenses at wider angles, most noticeably where highlights are blooming.

1 Press V to show the Browser.

2 Double-click **060608_194922_002**.

3 Position the pointer over the upper-left window, and then press Z to zoom into it. Typically you need to zoom in even more to really see halo fringing, but not here. Aren't we lucky?

4 Move your pointer to the top of the screen to open the toolbar.

5 From the Quick Brush pop-up menu, choose Halo Reduction.

6 In the navigation box, scale the view to around 200%, and then drag in the navigation box so you can see the entire window.

7 Set Brush Size to around 5, and paint over the purple fringe on the windows. If you feel you are not removing enough of the purple color, increase the Strength in the HUD and repaint over the area.

8 Choose the Eraser tool and remove areas where you've gone too far using the Halo Reduction tool.

9 Press Z to zoom out and view the entire image. Compare the original to the version with halo reduction applied. Be sure to end viewing your version.

It's amazing what the eye picks up now that you are aware of the purple fringing on the windows. The fringing stands out clearly, whereas you probably didn't even notice it when you first viewed this image.

Before

After

Retouching Images

At times, the problem is not in the color, the tone, or framing but in the content of the picture. Aperture includes very nice tools for retouching images. You can use the Retouch tool to fix problems such as sensor dust, cracks, scratches, and other object imperfections; or to remove scenery that just got in the way.

Aperture offers two Retouch brush types that copy from one area of the image to paint over another area:

▶ Repair—Use the Repair brush if the area you need to repair has a high-contrast edge or a high-frequency, busy texture. The Repair brush copies pixels from one area (the source) and paints it over the destination area. The Repair Brush then performs the additional step of attempting to blend the tones and colors of the copied area to match the destination area, while preserving the original texture of the source.

▶ Clone—This brush performs a straight copy/paste from one area of an image to another area. Unlike the Repair brush, the Clone brush does not blend pixels in the area surrounding the brush stroke. On occasion, if the Repair brush introduces blurry, smudged edges, try using the Clone brush to remove them.

The brush type you choose for a particular job will depend upon the area you are trying to cover.

> **NOTE** ▶ Aperture also includes a Spot & Patch control that is mostly preserved for consistency and compatibility with older versions of the software. If you are starting new touch-up operations, bypass the Spot & Patch control and head straight for the Retouch brushes.

Repairing Images

For most jobs, you'll probably start by using the Repair brush for everything, including removing sensor dust, telephone wires, and in this exercise, a blade of grass over the face of a lion. All three of those elements are too tricky to remove when you are taking the photograph, so you'll fix them here using the Repair brush.

1 In the Library inspector, select the Uganda Pearl of Africa project, and then double-click the lion photo, **IMG_2208**.

2 Press F to enter the Full Screen view, if necessary.

3 Position the pointer over the lion's nose, and press Z to zoom in.

4 Use the navigation box to scale the image to 150%.

5 Pan the image until you can see as much of the blade of grass running from the bridge of her nose to just under her white chest fur.

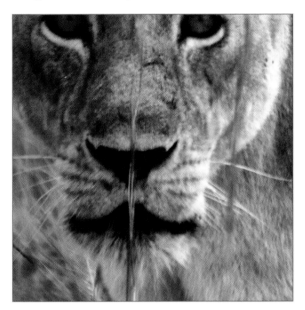

You've worked on this lion photo a number of times, and each time that blade of grass running down the center of her face has probably been bothering you.

The first rule of retouching is to never believe the magic demos you see on the web and at trade shows. It takes work to retouch properly. It also takes time to make it look perfect. Don't try to do everything with one brush stroke. When a texture changes or you come to a hard edge, start a new brush stroke.

6 From the Quick Brush pop-up menu in the toolbar, choose Retouch.

Let's begin at the top of the blade of grass where it's fairly thin and work down. You don't need a large brush, and you need only a moderate amount of softness on the brush.

In the Brush HUD, you can select the source area that the Repair brush samples, or you can have Aperture select it automatically. To start, you'll take the easier route and have Aperture select the source area.

7 In the Brush HUD, set the Radius to around 15 and set Softness to about .50.

8 Start at the very top of the blade of grass, just above the scar on the right side of her nose, and click once over the small green area.

The small green speck of grass is removed and the area blends perfectly with the rest of the image.

That worked well, didn't it? But that was also the easy part. The Repair brush is very reliable on small areas that can be fixed with a single click, such as sensor dust or this small speck of green grass.

Deleting Retouch Brush Strokes

Let's continue down the lion's nose using the same settings. Start at the top of the green grass on her nose and follow down, stopping just before her nose turns black.

1 Position the pointer on the green grass that appears just under the scar on her nose.

2 Drag down along the blade of grass and stop just before her nose turns black.

You'll see a lot more smudging with this brush stroke because of all the changes in color and texture, not to mention the size change in the blade of grass. Let's delete the previous brush stroke and try again using smaller chunks.

3 In the toolbar, click the Inspector HUD button, or press H to display the Inspector HUD, if necessary.

4 In the Retouch brick in the Adjustments pane, you can see that the number of saved strokes. Click Delete until the number of strokes is 1.

The Stroke count is now 1. The smudgy stroke is removed from your image, but the first small dab you made remains.

5 Once again, position the pointer on the green grass that appears just under the scar on her nose.

6 Drag down along the blade of grass and stop just before the fur turns darker and the grass blade grows thicker.

7 For the next stroke, because the blade of grass is larger, enlarge the brush Radius slightly to around 17.

8 Drag down along the blade of grass and stop just before the fur turns paler.

Those are much better results for a few reasons: You made the task much easier by performing it in sections, and you increased your brush size to make sure that none of the grass color blended in.

Repairing Using Automatic and Manual Source Selection

For the paler area above the black nose, you'll make two clicks to cover the area. The second click will center on the edge between the pale fur and the black nose. The automatic source selection combined with edge detection will help a great deal here.

1 Position the pointer at the top of the green blade of grass and click once to remove that portion.

2 Position the pointer so the center of the brush sits directly over the edge between the pale fur and the black nose, then click once.

The hard edge remains but the green blade of grass is gone. For the next step, you'll choose the source spot manually instead of automatically because it's a fairly tricky

area with two edges at the top and bottom of the nose and the large blade of grass in the middle. You want to be sure to select the source from the black area.

3 In the Brush HUD, deselect the "Automatically choose source" checkbox.

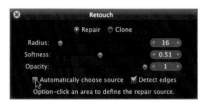

4 Set Radius to 20 because the blade of grass gets a bit larger here.

Because you'll paint from the top of the black nose to the bottom, you need to make sure to select a source area that can provide enough flat black texture. Selecting an area nearby, to the left of where you'll paint, should work fine. You'll notice some texture on her nose that differentiates her nostrils from the tip, or "leather," of her nose. You want to retain that distinction as you paint. Her nose isn't one giant nostril.

5 Option-click the top of her nose just to the left of the blade of grass.

6 Paint down from the top of the blade of grass. Stop painting when the source brush crosshair icon reaches the pale furry edge of the nose.

Next you'll select a new source area for the hard edge of the nose and the upper lip. The area that looks most similar is to the right of your brush stroke.

7 Option-click to the right of your brush stroke, directly on the edge between the nose and the pale fur.

8 Click the edge of her black nose and furry upper lip to remove the blade of grass and blend the edge between her nose and upper lip.

The next two brush strokes are short, single-click dabs. You'll select the source from the pale fur to the right on her upper lip. For the second click, let Aperture do the work and set the Repair brush to automatically choose the source. You'll also need a slightly larger brush because the grass is even thicker here.

9 Set the brush Radius to 25. Option-click to the right in the pale fur of her upper lip.

10 Position the brush directly in the center of her upper lip, covering the blade of grass, and then click once.

11 In the Brush HUD, select the "Automatically choose source" checkbox.

12 Position the brush over the black edge of her upper lip and mouth, and then click once.

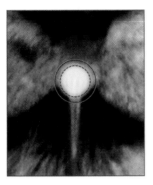

If you aren't happy with your results, don't hesitate to delete the strokes and try again. Try selecting the source from a slightly different area, or letting Aperture choose the source. Also try increasing or decreasing the brush size by 3 to 5 points. All of these changes can provide different results. The main thing to avoid is any repetitive textures. That's always a dead giveaway that you've retouched the image.

Cloning an Image

In addition to performing repairs, the Retouch tool helps you clone within an image. You can copy pixels from one area of an image to another to hide imperfections or repeat objects. Cloning is faster to brush on than Repair because it doesn't blend pixels. You'll use it here to clean up any imperfections inside the lion's mouth, as well as continuing to remove the blade of grass.

1 In the Brush HUD, click the Clone button.

Notice that the automatic source selection and edge detection checkboxes disappear. Because cloning requires that you select the source—and it's a straight copy/paste of pixels from one area to another—those two options aren't available.

Let's begin by selecting a source from the black area inside her mouth. You may need to pan down to see this area if your display isn't large enough.

You don't have a large area to work with, so you'll want to pick a source area, paint a little, and then pick another source area. As you paint, keep your eye on the source crosshair icon so you'll be aware when you are running close to the edge of her mouth. That's when you'll need to select a new source area. It will also help to select smaller Radius and Softness values for your brush when working in this tight area.

2 In the Brush HUD, set Radius to 10 and Softness to 0.5.

3 Option-click to the right, in the black area of her mouth.

4 Position the brush over the blade of grass and being painting.

You won't be able to paint much before you run out of source area and need to select a new source point. Just repeat the process until the blade of grass is removed from her mouth and all your smudges are gone. Stop painting when you get to the lower lip since that hard edge is a nice place to switch to the Repair brush and let it blend that transition.

5 Click the Repair button.

6 Select "Automatically choose source," if necessary.

7 In the Brush HUD, set Radius to 20.

8 Click directly over the edge of her mouth and bottom lip.

The Repair brush does a truly amazing job on those difficult edge areas. What it isn't made to handle are the areas such as the last bit coming up. The fur on her chin doesn't have hard edges and it is not an area of dense tonal changes, or high frequency. It's relatively smooth. So let's return to the Clone brush for the final retouch process.

9 Click the Clone button.

The blade of grass is thinner here so you can make a smaller brush. It might help to increase the softness as well, because you are dealing with fur. A softer brush will make it blend more effectively.

10 In the Brush HUD, set Radius to 15 and Softness to 0.75.

11 Hold down the Option key. From the top of the blade of grass, move your pointer to the right and click to select a source area.

12 Position the brush over the top of the blade of grass and begin painting down until the grass splits into two blades.

13 Press Z to view the entire image.

14 Compare the image before and after you used the Retouch tool by deselecting and selecting the Retouch checkbox in the Adjustments HUD. Be sure to end with the checkbox selected.

Before

After

This is about as far as you need to go. You removed the blade from her face using the Clone and Repair tools to get clean results.

The Quick Brushes include several brush types. You are familiar with some of them in their guise as adjustments because you've used them in previous lessons. You'll use the remaining two in the next lesson.

- ▶ Retouch—Retouches all types of imperfections
- ▶ Skin Smoothing—Smoothes people's skin by subtly blurring an area
- ▶ Dodge (Lighten)—Lightens an area of the image
- ▶ Burn (Darken)—Darkens an area of the image
- ▶ Polarize (Multiple)—Deepens colors by specifically darkening the shadows and mid-tones while preserving the highlights
- ▶ Intensify Contrast—Corrects shadow areas that appear washed out by intensifying the contrast between pure black and 50% gray
- ▶ Tint—Adds a color cast to an image using an Angle parameter to select the tint color
- ▶ Contrast—Selectively increases the contrast of an area

- ▶ Saturate—Increases the intensity of color

- ▶ Definition—Increases local contrast of an area

- ▶ Vibrancy—Increases the intensity of some colors while leaving skin tones unchanged

- ▶ Sharpen—Allows you to sharpen an area with brush strokes

- ▶ Halo Reduction—Removes blue and purple fringes

- ▶ Noise reduction—Reduces noise caused from high ISO settings

Making a Brush from an Adjustment

Quick Brushes aren't the only brushes available in Aperture; they are just the most common brush types. Almost any adjustment you can place in the Adjustments inspector can be made into a brush and applied locally to an image. While still working in Full Screen view in this exercise, you'll mix a black-and-white filter with subtle color into a wedding photo to focus attention on the bride and groom.

NOTE ▶ Exposure, White Balance, and RAW decoding are the only three adjustments that cannot be made into a brush.

1 In the Library inspector, select the Catherine Hall Studios project, and if necessary, press V to display the Browser.

2 Double-click the image of the couple hugging on the mission steps, **48_0912_AT_418-3**.

This is a great shot, but the couple is a little lost in the surrounding color and architectural detail. You'll remove the color distractions by using the Black & White controls. Then, using a brush, you'll focus attention on the couple by brushing away some of the filter to surround them in subtle color.

3 In the Adjustments HUD, choose Effects > Black & White > Green Filter to get a nice, contrasty image.

4 In the Black & White adjustment brick, from the Adjustment Action pop-up menu, choose "Brush Black & White away."

The Adjustment Action pop-up menu includes two options when creating a brush. You can choose to brush the adjustment into selected areas of the image or have the adjustment applied to the entire image and brush it away from selected areas. In this case, you will brush the Black & White adjustment away from the couple, the stairs, and the doorway of the building. First, decrease the Strength parameter in the Brush HUD to decrease the amount of original color that comes through.

5 In the Brush HUD, set Brush Size to 200, set Softness to 0.25, and Strength to 0.7. Deselect Detect Edges because you will be painting over a number of edges.

6 Begin painting across the bottom of the stairs and work your way up to paint over the couple and the entire façade of the building. Close the Black & White HUD.

TIP ▸ If the brush does not appear to respond, ensure the eraser is active in the Brush HUD.

This adds a nice old world, romantic look to this wedding image, but no one wants to get married on a gray day. You should add color into the sky and intensify the subtle color on the couple.

7 In the Adjustments inspector, click the Brush button to access the Brush HUD.

8 In the Brush HUD select the Eraser, set Strength to 0.9, and select Detect Edges so you don't add any color into the rooftops.

9 Paint over the entire sky, keeping the center point of the brush away from the rooftops so that edge detection can limit the color to the sky.

Brushes add an amazing amount of control over the color, tone, and focus of your images. Combined with the ability to paint in multiple instances of an adjustment, you can use brushes to create amazingly sophisticated images without learning multiple applications or dealing with complex layering and masking techniques. And best of all, it's done in a nondestructive environment that encourages you to play and try out different scenarios without consequences.

Creating Multiple Instances of a Brush

On occasion, one adjustment setting might work well in one area of your image, while another setting works better in a different area. Aperture can apply multiple instances of

the same adjustment and uses brushes to create masks where each adjustment should be applied. This capability is especially handy when creating black-and-white images. Let's convert a color image to black and white by using two different black-and-white filters in separate areas of the image.

1 Make sure you are still in Full Screen view. Then press V to view the Browser.

2 From the Library Path Navigator pop-up menu, click Projects and choose Landscapes.

3 Double-click **IMG_3627**.

In this image, the orange filter will work well on the sky, but the green filter will bring out the most detail on the wall. Let's use them both.

4 In the Adjustments HUD, choose Effects > Black & White > Orange Filter.

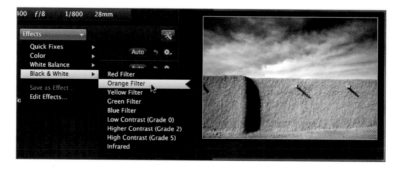

The filter is applied to the entire image, so you will create a brush for this adjustment and brush it away from the stone wall.

5 In the Adjustments HUD, from the Black & White Adjustment Action pop-up menu, choose "Brush Black & White away."

6 In the Brush HUD, deselect Detect Edges because the wall has too many edges for this to be effective.

7 Starting at the bottom of the wall, brush away the Black & White adjustment, working up until you completely reveal the colored wall.

8 In the Adjustments HUD, from the Black & White Adjustment Action pop-up menu, choose "Add New Black & White adjustment."

The new adjustment is added and highlighted below your other Black & White adjustment. You need to set it to 100% green and then brush it onto the wall because, at present, it's applied to the entire image.

9 In the new, lower Black & White adjustment, drag the Green slider to 100% and the Red and Blue sliders to 0%.

TIP ▶ The slider is centered at 0%.

10 From the lower Black & White adjustment brick, in the Action pop-up menu, choose "Brush Black & White in."

11 Begin brushing from the bottom of the wall and work up until the entire wall is black and white.

Using multiple instances of an adjustment is an advanced feature that has been made simple in Aperture. You have no layers to deal with, no complex masking tools, and no export and import of images. It's right there as a nondestructive tool in the same application in which you organize photos, rate images, add metadata, and make basic adjustments. Here's where you really can see the benefit of having an all-in-one application.

Lesson Review

1. Name two of the three places you can access Quick Brushes.

2. What is the major difference between the Repair brush and the Clone brush?

3. What two brushes does Aperture offer for cleaning up brush strokes?

4. If you wanted to darken your image but retain the highlights, is Polarize or Burn the better Quick Brush to use? Explain your answer.

5. True or false: Only brushes created from the Adjustments inspector are nondestructive. Quick Brushes create new 16-bit TIFF or PSD format original files.

Answers

1. You can access Quick Brushes in the Adjustments Inspector's Add Adjustment pop-up menu, from the Quick Brush pop-up menu in the tool strip, and from the toolbar in Full Screen view.

2. The Repair brush copies pixels from one area (the source) and paints it over the destination area. The Repair Brush then performs an additional step, attempting to blend the tones and colors of the copied area to match the destination area, while preserving the original source texture. The Clone brush is a straight copy/paste from one area of an image onto another area. Unlike the Repair brush, the Clone brush does not blend pixels in the area surrounding the brush stroke.

3. Aperture has two tools for cleaning up brush strokes: The Eraser tool is used to remove stray or errant strokes; the Feather tool is used to create gentler blends along the edges of a stroke.

4. Polarize would be the better Quick Brush to use. The Polarize brush darkens the shadows and midtones, making the color in those areas much richer. It leaves highlights unaltered. Burn darkens the highlights, midtones, and shadows of an image.

5. False. All adjustments and brushes in Aperture are nondestructive. Original files are created only when you use an external editor.

10

Lesson Files APTS Aperture book files > Lessons > Lesson 10 > Memory_Card_03.dmg

Time This lesson takes approximately 30 minutes to complete.

Goals Update RAW decoding method

Refine the RAW decoding process using the Fine Tuning controls

Work with DNG files

Working with RAW Images

JPEG is a standard image format that is used by almost every digital camera and every digital photographer. JPEG files are compressed and processed in the camera to remove mosaic blocking, correct white balance, and sharpen images, along with other camera-based adjustments. This processing causes a subtle loss of detail and limits the range of post-processing changes that can be applied to an image.

Alternatively, most DSLR cameras and even some point-and-shoot cameras can capture images in the camera's native RAW format. RAW files can offer some significant benefits—and a few liabilities—compared to JPEG files, depending on what and how much you shoot.

In this lesson, you'll compare the benefits of making adjustments on RAW and JPEG images. You'll modify how the RAW decode is done using Aperture's RAW Fine Tuning controls. Finally, you'll learn about the various sharpening and noise reduction adjustments found in Aperture.

Working with RAW+JPEG Pairs

RAW files are image files saved directly from the camera's sensor without any in-camera processing. RAW files have become a popular camera format because they retain more detail and offer more image-editing flexibility than JPEG files. The downside of RAW formats is their proprietary nature and file size. JPEG is a universally understood format that can be opened by almost any application. In contrast, every camera manufacturer has its own camera-specific RAW format, which makes RAW files potentially less reliable for long-term archival purposes.

When making the decision to shoot RAW or JPEG images, you may have a third choice. Many DSLR cameras can shoot RAW+JPEG images simultaneously. Doing so gives you the speed and reliability of JPEG files with the flexibility of a high-quality RAW file when needed. The cost of shooting this way is the additional space these file pairs occupy on your memory card and hard disk. Aperture makes managing the image pair as easy as managing one file. In this exercise, you'll use the import settings to choose how Aperture handles RAW+JPEG files.

1 In the Dock, click the Finder icon.

2 In the Finder, navigate to APTS Aperture book files > Lessons > Lesson 10 > **Memory_Card_03.dmg**.

3 Double-click **Memory_Card_03.dmg** to mount the disk image. The card may take a moment to appear. When it's mounted, you'll see a removable media icon called **NO_NAME** on your desktop.

Aperture will automatically come to the front, displaying the Import browser and all the images stored on the simulated memory card.

4 In the Library inspector, select the RAW Examples project to place the incoming images into that project.

5 To prepare for importing the card's images, click the Import Settings pop-up menu and deselect File Types and Backup Location.

6 In the Import Settings pane on the right, verify that RAW+JPEG Pairs was automatically added. Set the Store Files pop-up to In the Aperture Library.

In the RAW+JPEG Pairs settings, you can choose to import one or both file types. When you import both types, Aperture manages them as one file, but you select one as the primary original file that you view and use. The other file stays behind the scenes.

Which one should you choose as the original file? It depends on how much image editing you think you'll be doing. If you'll only perform minor image editing such as cropping, straightening, and modest tonal or color corrections, opt for the JPEG file. It's faster to work with as you navigate through Aperture. Then, you can switch to the RAW file when you come across an image that requires a lot of adjustment. No matter which file format you choose now, you can always choose either format on a photo-by-photo basis.

7 In the RAW+JPEG Pairs Import pop-up menu, choose Both (Use JPEG as Original).

TIP ▶ If you decide to import only JPEG, back up the RAW files. You can always import them later and match them with their companion JPEG files using the "Matching RAW files" selection in the RAW+JPEG Pairs Import pop-up menu.

8 Make sure that all photos are checked and click Import Checked.

When importing is complete, Aperture displays a dialog that allows you to eject the memory card, as well as delete or keep the items.

9 Select the Eject No_Name checkbox and click Keep Items.

10 If necessary, cycle the main window layout by pressing V until you see the Split View.

In the lower-right corner of the two imported images, you'll see a small badge with the letter *J*. The letter indicates that this is a RAW+JPEG pair with the JPEG as the viewable original.

You can switch to view the RAW file at any time. When switching between RAW and JPEG pairs, the only visual indicators are the badge and the Adjustments inspector. You'll use the Adjustments inspector to view additional parameters that are added as you switch from JPEG to RAW.

NOTE ▶ The Info inspector will also display RAW or JPEG images in the Camera Info section, depending on which is selected as the viewable original.

9 Select the sunset image, **CRW_2725**, and then choose Photos > Use RAW as Original.

The badge updates on the thumbnail to display the letter *R* to indicate that you are now viewing the RAW image. Now that you are viewing the RAW file, you are ready to take advantage of its extended capabilities.

Comparing RAW and JPEG Files

Whether you choose to shoot RAW or JPEG files is important, but no matter which format you choose, their use is seamless inside Aperture. When viewing them in the Viewer or Browser, RAW and JPEG files are almost indistinguishable. Although RAW files can occupy two to five times as much storage space as JPEG files, RAW files offer more flexibility when making adjustments. In this exercise you will compare the results of adjustments made to a RAW image with the same adjustments made to a JPEG version of the image.

1 Make sure **CRW_2725** is still selected.

2 In the Adjustments inspector, drag the Exposure slider to the left to about -1.5.

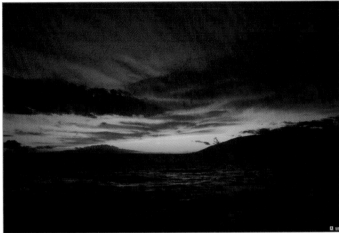

RAW image

As expected the image grows darker, but it retains very nice detail in the red clouds. The Exposure adjustment will remain at the same setting when you switch to view the JPEG version, and you'll notice a significant difference.

3 Choose Photos > Use JPEG as Original.

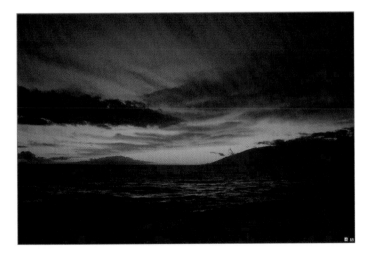

JPEG image

Notice that the clouds now appear flatter and have lost their luster. The reason is the wider dynamic range found in the RAW file compared to the JPEG file. The RAW file

retains more detail in the highlights and shadows. That extra detail is the primary reason to use RAW files when performing image-editing tasks.

4 After you have inspected the images, reset the Exposure brick.

Decoding a RAW File

Aperture supports over 150 cameras and their RAW formats. Each RAW type supported by Aperture has preset calibration data that Aperture uses to produce an optimal decode in most situations. If you have a special case image, you may find that it can benefit from a custom decode or some fine-tuning. The RAW Fine Tuning controls let you modify the way OS X decodes RAW files on an image-by-image basis. Additionally, you can create custom settings to use with specific image types shot with a particular camera.

> **NOTE** ▶ Depending on the type of RAW file you're using, some controls may be dimmed. This indicates that the RAW decode method or the camera model is not fully supported.

Updating the RAW Decode

A RAW file must be decoded to view it on your display. To do this, Aperture uses a RAW decode engine. If your library was started in an earlier version of Aperture, your RAW files are using an older RAW decoder. Aperture 3 employs a new decode engine that delivers improved processing.

Because changing the RAW decode could slightly change the image's appearance, Aperture, by default, does not change the RAW processing for existing images. If you are done editing a project, you needn't update it unless you want to reedit its images using the new tools. If you want to migrate a project forward, you can do it selectively for one or two images, for an entire project, or for all the images in your library.

With large libraries, you can apply search filters to determine which photos are not yet using updated RAW processing.

1 In the Library inspector, select the RAW Examples project.

2 Click the Filter HUD button on the far right of the tool strip.

3 In the Filter HUD, from the Add Rule pop-up menu, choose File Type.

4 Select the File Type checkbox.

5 From the Add Rule pop-up menu, choose Adjustments.

6 Set File Type to "is" and "RAW," and set Adjustments to "does not include" and "RAW Decode Version 3.0." The filmstrip will now show only those RAW photos in your library that do not use updated RAW processing.

NOTE ▶ If updated RAW processing is available for a photo in the library, a Reprocess button will be available on the Adjustments panel.

You may now choose which photos to update.

7 Close the Filter HUD, and in the Browser, select **Milford Road, South Island NZ**.

8 Choose Photos > Reprocess Original and click Reprocess Photos in the dialog that appears. Click OK to the "Reprocessing completed" dialog when it appears.

As you just did, you can upgrade the RAW processing on an image by image basis. You may also upgrade the entire library.

9 To reprocess all the photos in your library, click the Library tab in the inspector, and select Photos.

10 Choose Photos > Reprocess Original.

A Reprocessing dialog appears with options that allow you to select which images are reprocessed. In this case, you'll reprocess all the existing photos so your entire library is brought up to date.

11 Make sure the "All photos" and "Reprocess existing images" checkboxes are selected. Click Reprocess Photos.

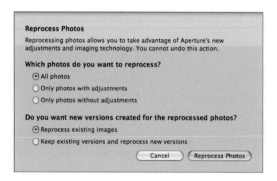

NOTE ▸ Because updated RAW processing may change the appearance of your images, and because reprocessing a large number of photos at once can be time consuming, you may wish to selectively update older photos.

12 Since all images are now using RAW Decode version 3.0, clear the Filter HUD setting by clicking the Search field reset button.

You probably won't see much of a change in the Viewer, but you will notice that all your RAW images now have RAW Fine Tuning controls at the top of the Adjustments inspector and you have access to new adjustments. Next, you'll explore how to use these RAW Fine Tuning controls.

Adjusting Boost and Hue Boost

Now let's look at two adjustments in the RAW Fine Tuning controls: Boost and Hue Boost. As mentioned earlier, Aperture includes a set of camera profiles for all supported cameras. These profiles include specific details about each camera's imaging characteristics and are used to determine how the color and contrast adjustments should be set for their RAW files. These adjustments are made to apply the optimal decode for most images from a specific model of camera, but you'll often want to adjust unique images.

Boost controls the strength of the contrast. This adjustment will not have the same impact as modifying the contrast. It is a much subtler effect.

1 Select the RAW Examples project, clear the search field, and then in the Viewer, select **CW_2725**. From the Photos menu, choose "Use RAW as Original."

2 Press F to enter Full Screen view, and then press H to open the Inspector HUD. Click the Adjustments tab.

3 In the Adjustments tab, click the Add Adjustment pop-up menu and choose RAW Fine Tuning, if necessary.

 In the RAW Fine Tuning brick, several controls are available. Let's start at the top with Boost. A Boost value of 0.00 applies no contrast adjustment to the RAW file during decode. A value of 1.00 applies the full Apple-recommended contrast adjustment for the specified camera model. Depending on the image, you may need to lower the Boost value.

3 Drag the Boost slider all the way to the left to view the image with no boost applied.

4 Slowly drag the Boost slider to the right to add boost. Set it at a point that you think is appropriate.

Default Boost

Less Boost

The Hue Boost control works in conjunction with Boost. Hue Boost maintains the hues in the image as Boost increases the contrast. For example, if Boost is set to 0, Hue Boost won't produce any results. If an image has both the Boost and Hue Boost controls set to 1.00, the colors will be pinned to their pure color values. This works very well for nature shots but can create oversaturated skin tones, so be careful applying these settings to portraits.

5 Verify the Hue Boost slider is at full right to view the image with maximum hue boost applied.

6 Slowly drag the Hue Boost slider to the left to reduce the hue boost. Set it at a point you think is appropriate.

Your image should appear slightly darker, with significant color changes in the red clouds and yellow sun. When adjusting Boost, monitor your highlights and midtones. When using Hue Boost, blues and greens show less change than reds and yellows. These adjustments are subtle, so it helps to look in the right locations.

Before Hue Boost

After Hue Boost

Using Sharpening and Noise Reduction

A variety of issues can cause photos to appear soft: it can be the lens at a certain focal length, it can be your camera's internal processing, and it can come from the shooting environment. To some extent, softening can be mitigated with simple postproduction sharpening, but don't confuse this with improving out-of-focus shots. Sharpening is more of a trick with contrast than it is a focus correction.

One of the side effects of sharpening is that the process often increases the noise in your image. At the same time, noise reduction can result in a softening of your image. It's a cruel joke, isn't it? To help ease your pain, you'll usually want to apply sharpening and noise reduction adjustments at the same time to achieve a balance between the two.

Aperture provides two forms of sharpening as adjustment bricks as well as more subtle sharpening parameters in the RAW Fine Tuning controls. In this exercise, you'll work with the Edge Sharpen adjustment brick, which provides the most impact and control.

Applying Edge Sharpening

When dealing with RAW files, Aperture automatically tries to sharpen your images based upon the model of camera, using the Sharpening parameters in the RAW Fine Tuning controls. Like all RAW Fine Tuning controls, the Sharpening control applies a very subtle sharpening process. For a more impactful sharpening effect or if you are working with JPEG files, go right to the Edge Sharpen adjustment.

> **TIP** ▶ Aperture includes a Sharpen adjustment, but an overall Sharpen adjustment will tend to sharpen the entire image, including noise. You don't want that, so choose Edge Sharpen, which is a superior sharpening tool.

1 While still in Full Screen view, press V to show the Browser.

2 If necessary, clear the Filter HUD settings by clicking the Reset button in the search field.

3 Double-click the mountain gorilla image, **IMG_9896**, to display it full screen.

4 Move the pointer over the forehead of the gorilla and press Z to zoom the image to 100%.

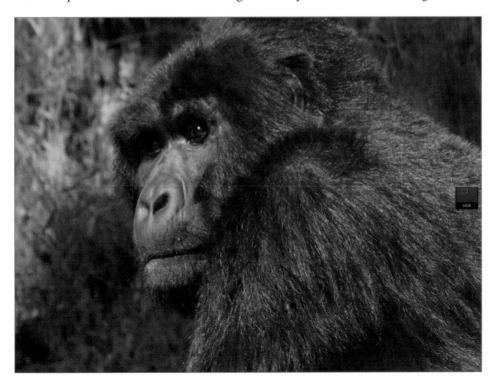

This rare glimpse of a mountain gorilla was shot using a slightly soft lens. It would be nice to get a little more crispness in this image, especially around the eyes. Let's take a closer look at the eyes and then apply edge sharpening.

5 Position the pointer over the navigation box to display the preview thumbnail.

6 Drag the Zoom slider to the right until the image is scaled to 150%.

7 From the Add Adjustment pop-up menu, choose Edge Sharpen.

On high-contrast areas, the Edge Sharpen adjustment runs three passes to increase the contrast by darkening the dark pixels and lightening the light pixels, which makes the edges appear sharper.

Edge Sharpen provides three controls: Intensity, Edges, and Falloff. Intensity controls the strength of the effect. Edges is a threshold parameter that determines what constitutes an edge. Falloff determines how strongly to apply the second and third passes of sharpening.

The Intensity parameter is already set to 0.8, so you'll leave it there and adjust Edges and Falloff to give this image a sharper appearance.

8 To emphasize the creases around the gorilla's eyes, drag the Edges slider to around 0.5.

9 Drag the Falloff to 0.8 to increase the subsequent sharpening passes.

To see the impact this sharpening has had on the image, you'll compare it with and without the adjustment.

10 Deselect the Edge Sharpen checkbox to return the image to its unsharpened state. By selecting and deselecting the checkbox, you can see the change in sharpness.

Before Edge Sharpness

After Edge Sharpness

TIP ▶ Edge Sharpen is particularly a good candidate for a saved preset, as most camera/lens combinations consistently produce images with the same sharpness issues. Once you find a good set of sharpness settings for your camera and lens, those settings will probably work well for all images from that camera/lens combination.

Using RAW Fine Tuning De-noise

As you sharpen an image, it's important to watch for noise. Although Aperture will attempt to eliminate noise when it decodes the RAW file, the addition of the Edge Sharpen adjust-

ment requires additional noise reduction. On RAW files from some Canon, Nikon, and Sony cameras, a De-noise adjustment appears in the RAW Fine Tuning controls. If you are lucky enough to have access to that adjustment, you can get some great results.

1 With the gorilla still selected, drag the De-noise slider all the way to the left to see what this image looks like with no noise reduction.

You can clearly see the increased noise around his eyes and forehead. Even with the default amount of noise reduction, this image is greatly improved. Let's reset this image to use the default noise reduction and then look at another image that could use an increase in noise reduction.

2 In the RAW Fine Tuning adjustment, double-click the De-noise slider to reset it to 0.50.

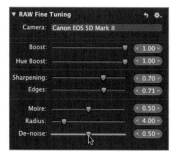

3 Press Z to view the entire gorilla image.

Let's look at another image that is noisy not because of any sharpening, but because the ISO is very high.

4 Double-click the gorilla image to return to the Browser.

5 Double-click the image of the Ugandan kids, **IMG_9619**, to see it full screen in the Viewer.

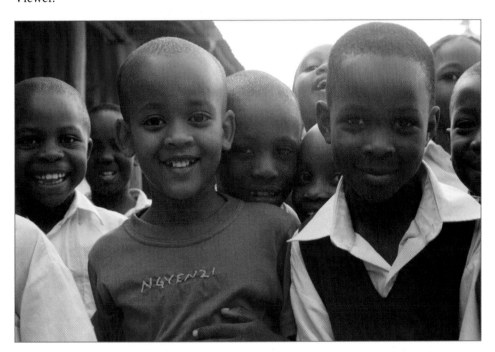

6 Move the pointer over the face of the child on the right, and press Z to zoom the image to 100%.

7 In the RAW Fine Tuning adjustment, drag the De-noise slider all the way to the right to see what this image looks like with maximum noise reduction. Notice how much smoother the noise is with the increased De-noise setting.

You can compare the De-noise setting at 1.0 with the default setting at 0.50 by double-clicking the slider to return to the default and then clicking once on the far right edge of the slider to return to 1.0.

8 In the RAW Fine Tuning adjustment, double-click the De-noise slider to reset it to 0.50.

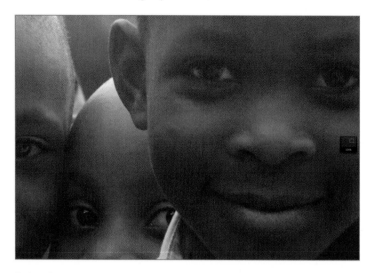

Before De-noise

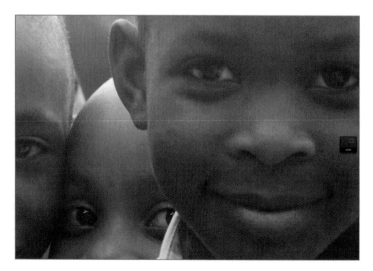

After De-noise

As with all sharpening and noise-reduction tools, you'll usually perform a balancing act with these sliders, as you try to sharpen your image without making the noise more visible.

It doesn't really matter whether you apply noise reduction before or after sharpening. Thanks to Aperture's nondestructive editing, you can continue to tweak these adjustments to get them properly balanced.

Using the Noise Reduction Adjustment

On some RAW images, you'll probably find that you can achieve all of the necessary noise reduction using the RAW Fine Tuning sliders. If you are using JPEG files or an older DSLR, you might not have access to those controls and you'll need to apply the standard Noise Reduction adjustments.

1 Press Z to view the entire Ugandan kids image.

2 Press V to return to the Browser, and double-click the sunset image, **CRW_2725**, to view it full screen.

3 Position the pointer over the hillside shadow on the right, and press Z to zoom in to that area.

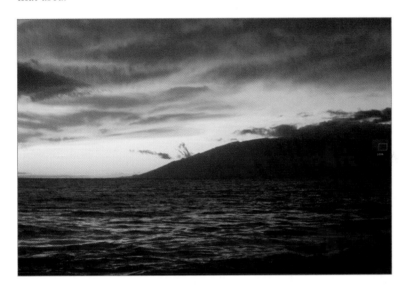

Although this is a RAW file, it is from an older camera, so the noise reduction isn't as powerful as in the other RAW files you have been using. You can still apply additional noise reduction using the Noise Reduction adjustment.

4 In the Adjustments HUD, from the Add Adjustment pop-up menu, choose Noise Reduction. A Noise Reduction controls group appears in the Adjustments HUD.

The Radius slider lets you select the size of the noise you want to reduce. The Edge Detail slider gives you some control over the softening of your image by telling Aperture how much edge detail to preserve. Again, high-contrast areas are usually edges, so if you don't apply as much noise reduction to those areas, there's a good

chance that your image will suffer less from softening. There's no right or wrong when applying noise reduction. Try it for yourself.

5 Adjust the Radius and Edge Detail sliders and decide which effect you like best.

6 Now set the Radius slider to 1.5 and the Edge Detail slider to 2.

7 Deselect and select the Noise Reduction checkbox. You should notice a slight reduction of noise, especially in the dark shadow areas of the hillside.

Before Noise Reduction

After Noise Reduction

As you can see, you can still perform significant noise reduction even if your particular RAW file doesn't include the De-noise parameters in the RAW Fine Tuning controls. The Noise Reduction adjustment can do a respectable job for those RAW images, as well as JPEG images.

Removing Moire from RAW Images

Images with high-contrast, linear patterns—such as the windows of a skyscraper or a wooden fence—can cause color artifacts due to the noise created by digital camera sensors.

To counter this effect, Aperture includes the Moire and Radius sliders. These controls can reduce color fringing in high-contrast edges and moire pattern artifacts. The Moire controls specifically correct aliasing issues that can appear during the RAW decode process. The Moire parameter modifies the amount of high-frequency signal that the adjustment applies. The Radius parameter adjusts the area to which the adjustment is applied.

1 Press Z to view the entire sunset image.

2 In the filmstrip, select **Woodpecker**.

3 Position the Loupe to show the shoulders of the bird.

4 From the Loupe pop-up menu, choose 100%. Reduce the Loupe size by dragging its corner. If you look closely, you can see color fringing and noise.

5 If necessary, click Add Adjustment and choose to add the RAW Fine Tuning controls.

6 Drag the Moire slider all the way to the right until the slider reads 1.00.

> **NOTE ▸** Like the other controls in RAW Fine Tuning, the image must decode when you release the slider. As you make adjustments, you'll need to release the slider and let the image update.

7 Drag the Radius slider all the way to the right to increase the area to which the Moire adjustment is applied.

By adjusting the Moire slider and increasing the Radius, the amount of colored arti-facting is reduced in the image.

8 Close the Loupe.

Saving RAW Fine-Tuning Presets

You'll often find that similar camera images always need to be fine-tuned in the same way. To speed up that fine-tuning process, you can save presets for your RAW fine-tuning adjustments.

You might find that you consistently use one preset for daylight images and another for tungsten images. Or, you might develop a preset that's particularly suited to the noise and sharpness issues that arise when shooting at a high ISO.

1 In the Adjustments inspector, from the RAW Fine Tuning Action pop-up menu, choose Save as Preset. The RAW Fine Tuning Adjustment Presets dialog opens and prompts you for a name.

2 Give the camera preset a descriptive name, and click OK.

You can apply your preset to an image by selecting the preset from the RAW Fine Tuning Action pop-up menu.

If you find that *all* of your images need a particular fine-tuning adjustment, the RAW Fine Tuning Action pop-up menu also allows you to save your settings as the camera default.

> **TIP** ▶ If you change your mind and want to use the Apple-recommended camera default settings, you can restore them. In the RAW Fine Tuning area, from the Preset Action pop-up menu, choose Apple – Camera Default.

Working with DNG Files

Many different RAW file formats exist, each one specific to the camera sensor that takes the picture. Therefore, Adobe has attempted to create a universally compatible, open archival format called the DNG (Digital Negative) format. To help facilitate the use of DNG, Adobe offers the Adobe DNG Converter as a free download. This software can convert most RAW files into DNG files. As a result, RAW file formats that are not currently supported by Aperture may be imported into Aperture as a DNG version of the image.

If Aperture already supports the RAW format found within the DNG file, the RAW decode for that camera is used to open the RAW file. If Aperture does not support the RAW format found within the DNG file, the camera information stored in the DNG file is used to decode the image.

> **NOTE** ▶ If you're using DNG files generated with the Adobe DNG Converter, you can't use the "Convert to Linear Image" option in the Adobe DNG Converter application.

Aperture 3 supports the RAW formats from more than 150 digital cameras and camera backs. Aperture also lets you work with most DNG files. For an up-to-date list of supported cameras and formats, go to www.apple.com/aperture/specs/raw.html.

Lesson Review

1. What is the benefit of working with a RAW file compared to a JPEG file?

2. If you were using a JPEG file, where would you access the Edge Sharpen controls?

3. True or false: RAW files are the same size as JPEG files, but RAW files provide more detail in the highlights and shadows.

4. If you find that all RAW images from the same camera need the same adjustments, how can you apply the adjustments you made to a single image to all RAW images from that camera?

Answers

1. RAW files retain more detail and dynamic range and offer more flexibility for image editing than JPEG files.

2. Edge Sharpening for JPEG files can be applied only by using the Edge Sharpen adjustment from the Add Adjustment menu.

3. False, RAW files do provide more detail in the highlights and shadows, but they are much larger than JPEG files.

4. When you've completed your adjustments, choose Save As Camera Default.

Cameo: Don Holtz
Seeking the Element of Spirit

SEVENTY-FIVE THOUSAND. That's the number of photographs in Don Holtz's Aperture library. If you took 20 photos a day for 10 years, you'd still fall

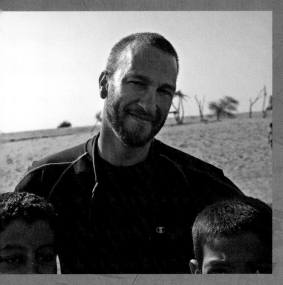

short. With high-profile clients like *National Geographic Traveler*, *Sports Illustrated*, the History Channel, and HBO, Holtz is well qualified to provide some helpful tips for image organization.

What do you shoot more often, landscapes or people?

It's about 50-50. I find it hard to shoot one without the other. Shooting the people of a certain location gives me a deeper appreciation for the land, and vice versa.

How are your images organized?

Mostly by subject matter. However, I do keep multiple files in different albums to cross-reference. For example, a portrait of a Senegalese woman would be kept in an album labeled *People* and in one labeled *Places*.

You often work in remote locations. Can you describe your on-location setup and how you transfer images to your MacBook Pro?

If I'm able to bring whatever I want, I shoot with two, sometimes three, Canon 5D cameras, multiple lenses and accessories, two tripods, five 4 GB compact flash cards, a 160 GB portable hard drive, and a large-format 4x5 film camera.

I typically transfer all images via card reader into Aperture. If I have time, I'll also back up the images on my portable hard drive. The compact flash card is then put away and used only if all the other cards have been filled up. This way, I have three

copies of each image while still in the field. Back in the studio, I transfer from the original card onto my iMac and burn a DVD of the originals.

Do you cull your photos in the field, or wait until you are back in the studio?

I edit in the field as much as possible. Starting from the source, I'll delete all images that are obviously unusable to save on downloading and editing time.

What is your thought process when rating images?

Most importantly, does the photograph have soul or depth to it? Before I look at sharpness, exposure, composition, and so on, I consider whether the image has that intangible element of spirit that makes the viewer want to look at it for a moment longer than the average photograph.

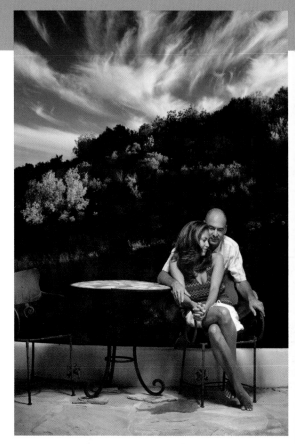

How do you separate out your selects?

I use both star ratings and stacks together. The star ratings are used initially for editing. Afterward, I'll use stacks to organize different shots of the same subject, keeping the highest-rated shot on top of each stack.

Will you use the geotagging feature on future projects?

I travel a lot, so it will be extremely useful. I also take a lot of spontaneous road trips with little to no itinerary, which means I get lost on a lot of backroads. In the past, many of these locations I could never find again. Geotagging will help me get back to them should I ever want to reshoot, or if a client needs specific location information.

When seeking the intangible, who needs an itinerary? With backroads beckoning, Holtz can rest assured that Aperture will find order in his adventures.

Sharing Your Work

11

Lesson Files	APTS Aperture3 Library
Time	This lesson takes approximately 90 minutes to complete.
Goals	Navigate slideshow presets
	Customize slideshow albums
	Add titles, transitions, and photo effects
	Mix main and secondary audio tracks
	Edit a slideshow to a musical beat
	Share to YouTube

Lesson **11**

Creating Dynamic Slideshows

The lessons you've studied have finally brought us to the main reason we take photographs: to share them with others. For professional photographers, this often means showing images to a client. For hobbyists, the only clients may be friends, family, and ourselves.

No matter how you want to share your photos, Aperture offers easy yet customizable options that you'll learn in the next few lessons. The most dynamic way to share photos is to create a slideshow. You can assemble photos, videos, and music into a dynamic multimedia presentation that showcases your photos and increases their impact.

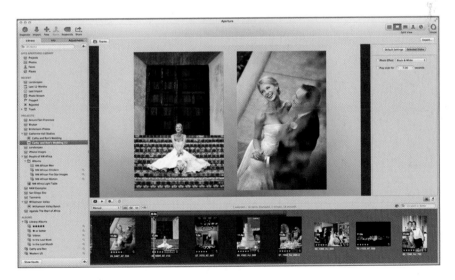

Using Slideshow Presets and Albums

There are two ways to create slideshows in Aperture: slideshow presets and slideshow albums. Slideshow presets give you the quickest and easiest way to create slideshows, but you cannot export or save them. Slideshow albums are more customizable and can be saved in your library like any other album. You can then export slideshow albums to your iPod, the web, or Apple TV. You'll start by creating a couple of different slideshow presets.

Using Slideshow Presets

Using a slideshow preset is the easiest way to assemble your images into a slideshow. It's a perfect solution when you want to quickly create a slideshow that you don't need to save or export for later use; or when you want to manually click through slides, as you give a presentation.

1 In the Library inspector, select the NW Africa Five Star Images album.

2 Press V until only the Browser is displayed. This project contains your best photographs from the "People of NW Africa" project. You will use these shots to create your slideshow.

 Currently, the images are organized by date from left to right, top to bottom, and they will show in this order in the slideshow. You can rearrange photos in the Browser to change their slideshow order.

3 Drag **Senegal 2006-11-03 at 07-30-35** to be the first image in the Browser.

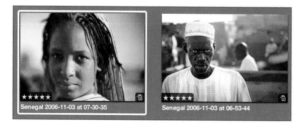

 Now you'll play your slideshow.

4 Choose File > Play Slideshow. The window that appears displays a preview of the slideshow with your images and includes a pop-up menu in which you can select a preset.

5 From the Slideshow Preset pop-up menu, choose Snapshots.

The preview window now shows your images using the Snapshots preset.

6 From the Slideshow Preset pop-up menu, choose Photo Edges.

7 Click Start to play your slideshow in full-screen mode.

8 Press the Esc (Escape) key to stop the slideshow and return to the Browser.

Manually Navigating a Slideshow Preset

Ease of use is certainly one of the most important advantages of using slideshow presets, but presets have another distinction: manual navigation.

Depending on the slideshow preset selected, each image usually displays for a specific number of seconds and then changes automatically. While this suits most situations, at times you will want to manually control when slides change. Manual navigation is especially useful in a live presentation when you may need to vary the length of time you show each slide.

1 Choose File > Play Slideshow.

2 From the Slideshow Preset pop-up menu, choose Manual.

3 Click Start to display the first image in the Browser in full-screen mode.

4 Press the Spacebar or the Right Arrow key to move to the next image.

> **TIP** ▶ You can press the Left Arrow key to display the previous image.

By default, the images change using a simple dissolve, but you can customize the presets and even save your own preset settings.

5 Press the Esc key to return to the Browser.

6 Choose File > Play Slideshow.

7 From the Slideshow Preset pop-up menu, choose Edit to show the Slideshow dialog.

> **TIP** ▶ You can also access the Slideshow dialog by choosing Aperture > Presets > Slideshow.

You can modify many of the preset settings and create your own presets in the Slideshow dialog. Let's create a new preset based on the Manual preset but modified to use the Photo Edges theme.

8 Click the Add (+) button to create a new preset.

> **NOTE** ▶ Because the Manual preset was selected when you clicked the Add button, the new preset is based on the Manual preset.

9 In the Preset Name column, change the Manual copy name to *Manual Photo Edges*.

You now have your own preset that has the Timing set to "Manually navigate slides." You'll now set the Theme to Photo Edges and change the background color to a neutral gray color.

10 From the Theme pop-up menu, choose Photo Edges.

11 Click the Background disclosure button to display the pop-up color palette.

TIP You can also click the color well to open the OS X Colors window.

12 Move the pointer over the gray strip near the bottom of the color palette.

13 To select a color, click the center of the gray strip, when the RGB values display around 130.

14 Click OK to close the Slideshow dialog and save the preset settings.

15 Click Start to play the slideshow.

16 Press the Spacebar or the Right Arrow key to move through the next few images.

17 Press the Esc key to return to the Browser.

Manually controlled slideshow presets help you to more effectively use Aperture in live speaking engagements, but slideshow albums also offer a flexible method for sharing your slideshows over the web, or on your iPad.

Creating a Slideshow Album

Setting up a slideshow album is similar to creating any album. You begin by deciding which images you want to use, and then you drag other images from your library into the slideshow album. Let's create a slideshow using the Catherine Hall Studios five-star wedding photos.

1 In the Library inspector, select the Catherine Hall Studios project.

2 In the Filter HUD, set the Ratings slider to "is greater than or equal to" five stars, and then close the Filter HUD.

The Browser now shows only the five-star images from this project. You'll use these images to create the slideshow.

3 Select an image in the Browser and press Command-A to select all the images displayed in the Browser.

4 From the toolbar, choose New > Slideshow.

A dialog appears in which you can name the slideshow, select a theme, and preview your work. You'll also find a checkbox to add the items selected in the Browser to the new slideshow. You'll leave this box selected because you've selected images in the Browser that you want to use.

5 In the Slideshow Name field, enter *Cathy and Ron's Wedding*.

6 In the Theme column, select Watercolor Panels to see a preview of this theme.

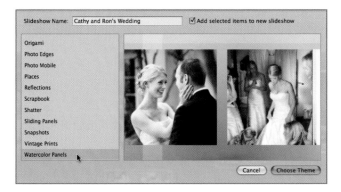

7 Click the Choose Theme button to create the new slideshow.

A slideshow item appears in the Library inspector under the Catherine Hall Studios project. The Browser is now used as a timeline to display images in the order in which they appear in the slideshow. The Slideshow Editor appears above the Browser with controls for modifying the slideshow.

You can use the playhead to preview the slideshow by moving your pointer over the area you want to see.

8 Move the pointer over any image and across the Browser timeline to see a quick slideshow preview.

As you move the pointer across images in the Browser timeline, the playhead info displays the duration of the show at the current location.

NOTE ▶ You must place the pointer over images in the Browser to relocate the play-head. Positioning the pointer in the gray area above or below the images will not move the playhead.

9 To play the slideshow in full-screen mode, click the Play Slideshow button. Press Esc at any time to return to the Slideshow Editor.

You could decide that you are finished with your customization and export your slideshow now, but a few more customizations could make your slideshow much more engaging.

Adding, Deleting, and Rearranging Slideshow Photos

Although you selected most of the images when you created the slideshow, you can add images from any project at any time. You can also delete and rearrange images in the Browser timeline to improve the flow of the presentation.

1 In the Library inspector, select the Catherine Hall Studios project.

2 In the search field, click the Reset button to remove the five-star filter and display all of the images.

3 Drag **03_0079_HBD56CB0**, a shot of the bride and bridesmaids, onto the "Cathy and Ron's Wedding" slideshow to add the image to the show.

Because the slideshow images are presented in order of date and time, this image becomes the first image in the presentation. Let's change that and also rearrange a few other images.

4 In the Library inspector, select the "Cathy and Ron's Wedding" slideshow.

5 Drag **03_0079_HBD56CB0** directly after the image of the rings, **01_0093_i_AT_058**.

Now is a good time to play the slideshow and see if you like the order in which images are displayed. Playing the slideshow in full-screen mode is useful when you want to make a more formal presentation, but you can also play the slideshow in the Viewer when you want a quicker playback option.

6 Position your pointer, and consequently the playhead, all the way to the left of the Browser so your playback will start with the first image.

7 Press the Spacebar, or in the tool strip click the Preview Slideshow button, to play the slideshow.

> **TIP** ▶ Slideshows use previews, and not the originals, to increase playback performance. Because the slideshow output is usually intended for DVD, web, or mobile devices, the lower preview resolution is more than adequate. If you require a different resolution, you can modify the preview image quality and size in Preview preferences, as you did in Lesson 3.

8 When the playhead reaches the fourth image in the Browser, **09_0221_HJ_122**, press the Spacebar or click the Preview Slideshow button to stop playback.

You have much better images of the bride and groom than this, so let's delete this shot. Deleting slideshow images does not delete them from the project; it just removes them from the presentation.

9 In the Browser, select **09_0221_HJ_122** and press the Delete key to remove the image from the presentation.

The next two images seem out of place. In the traditional wedding storyline, the couple hasn't yet been married so we probably shouldn't see them together. You can move these two images to a more appropriate time in the slideshow.

10 To make it easier to see the entire slideshow in the Browser, in the tool strip, click the Show Viewer button.

11 In the Browser, drag a selection rectangle around the images **12_0480_HJ_252** and **24_0487_AT_224**.

12 Drag the two images so that the green line is displayed between the first black-and-white image and the bride sitting on the steps. Release to insert the images.

13 In the tool strip, click the Show Viewer button (top left of the Browser) to return to the Slideshow Editor.

Enhancing Slideshows

Although the selection and presentation order of images are probably the most critical element in a slideshow, many other options can be applied to enhance its impact. The upcoming exercises cover many of those options, starting with themes.

Changing Themes

Just as easily as you selected a theme when you created a slideshow album, you can also change a theme at any time. Applying new themes to a slideshow can alter its entire feeling. The Classic theme and the Ken Burns theme have the most options, so you'll change the current theme to Ken Burns.

1 At the top of the Slideshow Editor, click the Theme button, and choose the Ken Burns theme.

2 Click the Choose Theme button to replace the Watercolor Panels theme with the Ken Burns theme.

3 Press the Spacebar, or in the tool strip click the Preview Slideshow button, to play the slideshow for a few seconds.

NOTE ▸ The themes take advantage of the face-detection capabilities in Aperture, so as the theme crops, pans, or zooms images, faces are never cut off.

4 Stop the slideshow by pressing the Spacebar or clicking the Preview Slideshow button.

As you play through your presentation, you'll notice that the pacing is much quicker. Each theme has a default duration for images, but duration changes can be applied to the entire slideshow or just to a selected slide.

Changing Slide Duration

In a slideshow, you control the viewer's attention and focus by adjusting the timing of the entire slideshow, as well as individual slides.

Because this slideshow plays a little too quickly for a wedding, you'll adjust the entire duration so audience members have more time to enjoy each image. You'll also shorten selected scene-setting images that don't need as much attention.

1 In the lower-right corner of the Slideshow Editor, click the Slideshow Settings button to display the editing options.

2 Click the Default Settings button. The default settings are applied to the entire slideshow. The Selected Slides settings are applied to only the selected slides in the Browser.

3 In the "Play slide for" field, click the right arrow to increase the duration of every slide to 4.00 seconds, or click in the field and type *4*. Press Return.

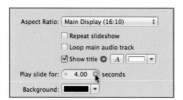

The duration of every slide changes to four seconds, as noted by the 4.0s badge displayed on each slide in the Browser.

TIP ▶ If you are using a Mac with a Multi-Touch trackpad, you can also click in the data field and then swipe two fingers right and left to increase and decrease the duration value. If you are using an Apple Magic Mouse, a single finger swipe does the same thing.

4 Press the Spacebar, or in the tool strip click the Preview Slideshow button, to play the slideshow for a few seconds.

5 Stop the slideshow by pressing the Spacebar, or click the Preview Slideshow button.

It's nice to have a longer duration for the wedding party images, but images of the scenery do not need the same attention. Let's shorten the durations of three of these images.

6 In the Browser, select **57_1070_AT_481**. When you select a slide in the Browser, the Slideshow Editor automatically displays the Selected Slides options.

7 In the "Play slide for" field, click the left arrow to decrease the duration of the selected slide to 3 seconds, or click in the field and type 3. Press Return.

You can also change the durations of multiple slides using the Selected Slides options.

8 In the Browser, select **60_1082_HJ_599**.

9 Hold down the Shift key, and in the Browser, select image **61_1083_HJ_600-2**.

10 Set the "Play slide for" field to 3 seconds. Press Return.

Let's back up the playhead and play through those three slides.

11 Move the playhead over the image of the bride sitting on the steps. Press Spacebar or click the Preview Slideshow button in the tool strip to play the slideshow, which now plays much faster during those three slides.

Timing is a variable parameter in every theme, but not all parameters can be altered in all themes. Some themes offer more options than others, and some options are unique to a theme. Let's look at one of the unique options in the Ken Burns theme.

Modifying the Ken Burns Effect

Ken Burns is an award-winning filmmaker famous for his use of archival photos in PBS documentaries. On many of these archival photographs, he applies a pan-and-zoom technique to direct the viewers' attention. The Ken Burns theme utilizes that technique and includes the ability to modify the pan and zoom.

The second image in the slideshow might look better if you modified the Ken Burns effect so that it starts by focusing on the bride and zooms out to reveal more of the bridesmaids.

1 Select the second image in the Browser, **03_0079_HBD56CB0**.

2 In the Slideshow Editor, click the Crop Edit button to display the crop overlays.

The Viewer shows the start and end overlays for the Ken Burns effect.

3 Click the Preview Slideshow button or press the Spacebar to play the slide with the current Ken Burns effect.

4 To reverse the zoom and pan effect, click the Reverse button. The start and end overlays swap positions.

5 Click the Preview Slideshow button or press the Spacebar to see the reversed results.

The framing on the ending crop could be improved by including more of the bridesmaid on the right.

6 Click the red End overlay to select it.

7 Drag the lower-right corner to the right to expand the crop overlay until it reaches the edge of the image.

8 Drag down the upper-left corner to crop off some of the bedding area.

9 Position the pointer in the middle of the End overlay so the pointer changes to a hand icon.

10 Drag the End overlay so that the bride's hand is not cropped off.

11 Click the Preview Slideshow button or press the Spacebar to play the slide with the new Ken Burns effect.

12 Back in the Slideshow Editor, click the Done button next to the Crop pop-up menu.

Although you have applied the Ken Burns theme, you are not required to have a pan-and-zoom effect on every slide. You can also apply and position a static crop.

Setting Aspect Ratio and Cropping Images

Because slideshows can be exported to a variety of playback devices—such as iPods, iPhones, and HDTVs—you may need to set the aspect ratio for each device. In the next exercise, you'll format this slideshow for HDTV delivery.

1 Click the Default Settings button.

2 From the Aspect Ratio pop-up menu, choose HDTV (16:9).

The Viewer now shows the widescreen aspect ratio and crops the images to fit them correctly within the frame. If you don't like the default crop, you can change it using one of three basic methods:

▶ Pan and zoom using the Ken Burns effect.

▶ Fit the image within a frame that will show the entire image and add pillars along the edges to fill the screen.

▶ Fill the frame that crops/scales the image to fill the aspect ratio.

Let's work with the third method: fill the frame. The first image in the Browser, the wedding rings, is a nice opening, but it might look better without the Ken Burns pan. Adding a border around the shot might also give it a more formal wedding look.

3 Select the first image in the Browser, **01_0093_i_AT_058**.

4 In the Slideshow Editor, verify the Selected Slides button is active.

5 From the Crop pop-up menu, choose Fill Frame to remove the Ken Burns effect and fill the frame with the image. You can also reposition and resize the crop.

6 Click the Crop Edit button to display a green crop overlay.

TIP ▶ You can also crop and pan an image by double-clicking the image in the Viewer to open the Image Scale HUD.

7 Position the pointer in the center of the frame and drag down the crop overlay until it reaches the bottom of the frame.

8 Click Done to apply the new crop settings.

NOTE ▶ Setting a crop in the Slideshow Editor does not change the image crop in your library.

Your final touch for this opening image is to inset it on a black background with a formal white border.

9 In the Slideshow Editor, position the pointer over the Border field. The pointer changes to an I-beam.

10 Drag to the right until the field displays 10 and a white border appears around the image in the Viewer.

11 In the Inset field, type *5* and press Return.

These few adjustments are just indications of the many ways you can make your slideshows more elegant and compelling. Now let's explore a few more.

Using Titles, Transitions, and Photo Effects

Titles, transitions, and photo effects bring potent visual enhancements to your slideshows, but they can become a slippery slope. Because these elements can be added so easily, you may tend to add more than you need. When enhancing a basic slideshow, make sure all your changes serve the topic you are trying to communicate and the mood you are trying to convey.

Creating and Formatting Titles

Although you can add a title to any slide, most of the time you need only one or two titles at the beginning to introduce your presentation and maybe a final slide to provide contact information or a simple ending. In this exercise, you'll create and format those titles for your presentation.

The first step is to add an opening title and format it to fit a wedding presentation.

1 In the Slideshow Editor, click the Default Settings button and select the "Show title" checkbox, if necessary.

A title is added over the first slide using the slideshow's name in the Library inspector as the text.

2 To the right of the checkbox, click the Fonts button to open the Fonts dialog.

3 In the Family column, select the Bodoni SvtyTwo SC ITC TT font.

4 Set the Size to 72, and then close the Fonts dialog.

5 Click the color well's disclosure button to display the pop-up color palette.

> **TIP** ▶ You can also click the color well to open the OS X Colors window.

6 Click in the palette to choose a font color that seems fitting for this wedding slide.

With the opening slide completed, you'll now add an ending slide with contact infor-mation for the photography studio, so this slideshow will be more effective at market-ing events and on the web.

7 Scroll to select the last slide in the Browser, **80_1346_HJ_762**.

8 In the tool strip, from the Action pop-up menu, choose Insert Blank Slide to place a blank slide after the selected slide.

> **NOTE** ▶ You created a blank slide in order to learn how to add a title to a slide in this exercise. However, when you choose Insert Blank Slide With Text, you create a slide with a title text already inserted.

9 Select the blank slide, which is the last slide at the end of the Browser.

10 In the Slideshow Editor, click the Selected Slides button, and then click the Background color disclosure button to display the pop-up color palette.

11 Click to select a deep crimson color.

12 Select the Text checkbox at the bottom of the Selected Slides pane to add text to this slide.

13 From the Text pop-up menu, choose Custom, which allows you to enter any text you desire.

14 In the Viewer, triple-click the text to select it.

15 Type *Catherine Hall Studios* and then press Return to start a new line. On the next line, type *www.catherinehall.net.*

16 Press the Esc key to exit the text entry mode.

17 Click the Text color disclosure button to display the pop-up color palette.

18 Select a light gray color to make sure the text will stand out against the crimson background.

19 To position the text block, drag the text up until the yellow dynamic alignment guide is displayed, ensuring that you have positioned the text in the vertical center of the screen.

The Fonts dialog will also allow you to modify the drop shadow, kerning, and alignment of the title layout. Your title bookends look good, and you can now create transitions between slides.

Applying Transitions

Most themes apply transitions between slides that cannot be modified. Those transitions are complex composites that are specifically designed to fit each theme. Classic and Ken Burns are the only two themes that do allow you to modify transitions.

The Ken Burns theme places dissolve transitions between every slide, and you can change them in the Default Settings pane. However, to change just a few transitions in this slideshow, you'll use the Selected Slides pane.

1 Select the slide of the bride outside with her father, **0591_HJ_314**.

2 From the Transition pop-up menu, in the Slideshow Editor, choose Fade Through White.

The transition between the selected image and the next image in the Browser is changed. Let's preview the results in the Viewer.

3 Press the Spacebar or click the Preview Slideshow button to see the transition.

4 Press the Spacebar or click the Preview Slideshow button again to stop playing as soon as the transition is over.

If you feel the transition is too fast or too slow, you can alter the duration by setting the number of seconds the transition takes to complete. This transition is currently set to a half-second duration, but that still feels too long. You can shorten this transition to make it look like a camera flash.

5 In the Speed field, click the left arrow to lower the number of seconds to 0.25 and speed up the transition.

6 Move the pointer over the selected image, **0591_HJ_314**.

7 Press the Spacebar or click the Preview Slideshow button to see the transition. Then press the Spacebar or click the Preview Slideshow button again to stop playing when the transition is over.

8 Drag a selection rectangle around the next two images of the ceremony in the Browser, **0677_HJ_356** and **0743_HJ_403**.

9 From the Transition pop-up menu, choose Fade Through White.

10 In the Speed field, click the left arrow to lower the number of seconds to 0.25.

11 Move the pointer over the first image with a modified transition, **0591_HJ_314**.

12 Press the Spacebar or click the Preview Slideshow button to see the transition. When you've seen the three transitions, press the Spacebar again to stop playback.

With the transitions set, the three ceremony images make a nice highlight point in the slideshow, but you could tie them together even more by making them look similar. Currently, two of the images are in color and one is in black and white. You could convert the color images to black and white in the Adjustments panel, but there is a more effective way to address this situation in the Slideshow Editor.

Using Photo Effects

The Slideshow Editor includes a few photo effects that are frequently used in slideshows, including black-and-white conversion, sepia tinting, and antique. If you created these effects in the Adjustments inspector, you would also be applying the adjustment to the image in your project. By applying a photo effect in the Slideshow Editor, you limit the effect to the image used in the slideshow.

1 Select the two color ceremony pictures, **0677_HJ_356** and **0743_HJ_403**, if necessary.

2 From the Photo effect pop-up menu, choose Black & White, and select the checkbox.

Both images are converted to black and white using settings similar to the High Contrast (Grade 2) preset found in the Adjustments inspector.

NOTE ▶ Unlike adjustments, when photo effects are applied, thumbnails in the Browser do not reflect the effect. Only the Viewer shows the results of photo effects.

3 Move the pointer back over the first image with a modified transition, **0591_HJ_314**.

4 Press the Spacebar or click the Preview Slideshow button to see the transition. When you've previewed all three black-and-white images, press Spacebar again to stop playback.

The combination of titles, transitions, and photo effects can raise the production quality of your presentation without taking a significant amount of time to create. Used judiciously, these elements can enhance your slideshow and focus attention on your photographs.

Mixing Music and Sound Effects

You've significantly enhanced your slideshow with visual changes, but what about sound? One of the most overlooked enhancements for a presentation is the addition of music and sound. The Slideshow Editor provides a considerable amount of control for adding and mixing music, sound effects, and even narration to create a considerably more compelling presentation.

Adding a Main Audio Track

Music can be a potent tool for creating the right atmosphere. You'll use the Audio Browser in Aperture to access sample music, your iTunes library, and slideshow theme music. In addition, you can choose from the hundreds of royalty-free compositions available for purchase in the iTunes Store.

1 In the lower-right corner of the Slideshow Editor, click the Audio Browser button to switch to the Audio browser.

At the top of the Audio browser is the Source list; below the Source list are songs that are contained within the source you select. If you recorded any audio clips on your digital camera and imported them into Aperture, you can access them by selecting Aperture Audio in the Source list. For now, you'll use the Theme Music source to select a song and add it as your slideshow's main audio track.

2 In the Source list, select Theme Music.

3 From the songs displayed below the Source list, drag **Eine Kleine Nachtmusik** to the Browser and hover over the gray area.

NOTE ► The music provided with Aperture is intended for personal use and is not licensed for commercial use.

When your pointer hovers over the gray area of the Browser, the entire background turns green to indicate that you are about to add the main audio track.

4 Drop the song in the gray area (which turns green) of the Browser. Do not drop it over a slide or it will not automatically fit to the duration of the slideshow.

You don't have to be concerned with the start or end of the main audio track. The main audio track will always start at the very beginning of the slideshow, or if a main audio track is already present, the song you add to the main audio track will start when the first one ends. A background music track automatically ends when the slideshow has completed or when the track ends, whichever happens first.

TIP ▶ If the main audio track music ends before the slideshow is finished, you can add multiple songs to the main audio track or loop the main audio track to repeat as long as slides are playing.

5 Click the Play Slideshow button to play the slideshow from the beginning in full-screen mode. When you finish, press the Esc key to stop playing and exit full-screen mode.

TIP ▶ You can delete the main audio track by selecting the green track and pressing the Delete key.

What a difference music makes, right? But if you played through to the end of the slideshow, you know that the music ends before the slideshow is finished. There are a few ways to fix this, and none of them involve removing slides from your slideshow. In this case, you'll make the slides fit the music.

Fitting Slideshow and Music Durations

When music doesn't exactly match the slideshow length, the last thing you want to do is remove any of the great photos you've selected for your presentation. You could add additional songs or loop the current song to extend the music to fit the slideshow, but you can also adjust the slide timing to fit the music.

In fact you don't even have to do the work. All you have to do is select all the slides, or hand-pick a few slides, and let Aperture figure out the timing that will make the slides end when the music ends.

The first half of your wedding presentation is very important to view slowly. It's the most important part of the ceremony. But you can make the scenery slides and the reception slides shorter.

1 In the Browser, select **57_1070_AT_481**, the first scenery image at the reception.

2 Shift-click the last slide in the Browser, the photography studio's title slide.

3 In the tool strip, from the Action pop-up menu, choose "Fit Selected Slides to Main Audio Track." The selected slides's durations are adjusted so that the last slide is placed exactly where the music ends.

4 Position the pointer over **62_1089_HJ_604**.

5 Press the Spacebar or click the Preview Slideshow button to watch the ending.

Inserting iLife Sound Effects

Ambient sound or sound effects can add another layer of depth to your slide presentation. Although Aperture does not come with sound effects, you can use sound effects from various sources, such as the iLife applications: iMovie and GarageBand.

It takes a small amount of dragging and dropping to access the iLife sound effects from inside Aperture, but once you do so, you can use those effects to add audio polish to your presentation.

NOTE ▶ The iLife applications must be installed to complete this exercise.

1 In Aperture, make sure the Audio browser is selected.

2 If necessary, click the iTunes disclosure triangle to collapse the items in iTunes and make more room in the window.

3 In the OS X Dock, click the Finder icon.

4 From the menu bar, choose Go > Computer.

5 In the Finder, navigate to Macintosh HD > Library > Audio > Apple Loops > Apple.

In the Apple folder, you'll find the iLife Sound Effects folder, which contains over 250 MB of royalty-free sound effects and music. You'll add this folder to the Aperture Audio browser.

5 Drag the iLife Sound Effects folder to the Source list in Aperture.

In the Source list under iTunes, a "Folders" folder appears that contains the iLife Sound Effects folder.

In the iLife Sound Effects folder, you can choose from categories of sound effects. You can select a category in the Source list to display its contents in the lower half of the Audio Browser. You can also browse and search the iLife Sound Effects folder to explore all of the categories.

6 In the Source list, select the Folders folder and then the enclosed iLife Sound Effects folder.

7 In the Search field near the bottom of the Audio browser, type *camera* to search for any sound effects that have the word *camera* associated with them.

8 In the Audio browser, select the Camera Shutter sound effect.

9 In the Audio browser, click the Play button to hear the sound effect.

10 Scroll the Browser until you are viewing the three images to which you applied the Fade Through White transition. Select **0591_HJ_314**.

11 Drag the Camera Shutter sound effect and hover over the slide with the first flash, **0591_HJ_314**.

12 Skim over **0591_HJ_314** until you see the white fade begin in the Viewer and then release the sound effect.

 NOTE ▸ Dropping an audio file onto a slide in the Browser adds a secondary audio track. Dropping an audio file in the gray area of the Browser adds a main audio track.

13 Position the pointer over the image of the bride and her father, **0591_HJ_314**.

14 Press the Spacebar or click the Preview Slideshow button to hear the camera shutter sound effect in the slideshow.

 That works well to enhance the camera flash effect. Let's add the camera shutter sound effect to the two remaining Fade Through White transitions.

15 Drag the camera shutter sound effect and place it where you begin to see the second flash, at the end of image **0677_HJ_356**.

16 Drag the camera shutter sound effect and place it where you begin to see the third flash, at the end of image **0743_HJ_403**.

17 Position the pointer over the image of the bride and her father, **0591_HJ_314**.

18 Press the Spacebar or click the Preview Slideshow button to hear all three camera shutter sound effects in the slideshow, and then press the Spacebar to stop.

If any of the sound effects are heard too far in advance or after the Fade Through White transition, drag the sound effect segment in the Browser to realign it more closely to the flash.

> **TIP** You can delete a secondary audio track segment by selecting the green segment and pressing Delete.

The audio is now fully in place, but the music seems to get quieter when the camera shutter sound effect plays. Your final change to the slideshow will be to improve the relative audio levels of the music and the camera shutter.

Adjusting Audio Levels

Mixing audio tracks carefully is just as important as placing the right music and sound effects into your presentation. If the mix is wrong, the results can almost become comical. To realize the right mix between the music and the camera shutter, you'll need to correct the music from dipping lower whenever the camera shutter is heard.

1 To open the Audio Adjustments HUD, double-click the first camera shutter sound effect in the Browser.

In the Audio Adjustments HUD, notice the checkbox for "Reduce volume of main track to." The value is set to 40%. When this checkbox is selected, the main audio track automatically gets quieter when the selected secondary audio track segment is played. When the selected segment finishes, the main audio track resumes its normal volume. This is called *ducking*. It's a nice feature to use when you have narration on the secondary audio track and you want the music to "duck" temporarily during that narration. Instead of manually tweaking levels to do the temporary ducking, you can click once and solve the problem. Unfortunately, a single click will not work here. You want the main audio track to remain at the same volume throughout the slideshow, so you need to deselect the checkbox for all three camera shutter segments.

2 In the Audio Adjustments HUD, deselect the "Reduce volume of main track to" checkbox.

3 Click the next camera shutter sound effect segment in the Browser, and then Shift-click the third segment.

4 In the Audio Adjustments HUD, deselect the "Reduce volume of main track to" checkbox.

Now the music remains at the same volume level throughout the slideshow. To ensure that this is the case, you'll play the three camera shutter sound effects in the Browser.

5 Position the pointer over **0591_HJ_314**.

6 Press the Spacebar or click the Preview Slideshow button to hear all three camera shutter sound effects in the slideshow, and then press the Spacebar to stop.

Although that helped balance the tracks, the camera shutter sound effects are still too loud. You'll use the Audio Adjustments HUD to lower the volume of all three sound effects segments on the secondary audio track.

7 In the Browser, Shift-click all three camera shutter sound effects to select them.

8 If the Audio Adjustments HUD is not visible, double-click one of the three sound effects segments.

9 In the Audio Adjustments HUD, drag the Volume slider to around 75%, and then close the Audio Adjustments HUD.

10 To watch the entire slideshow in full screen, click the Play Slideshow button.

This slideshow is now complete and ready for export. But before you begin exporting, you can explore a few more features of slideshows. Although these features aren't appropriate for this wedding presentation, other projects in the library may benefit.

Working with Video

It's getting harder to find a new model DSLR camera that doesn't capture some form of video. You can take photos and in a split second switch to record a video clip, all using the same camera and the same memory card. That being the case, it only makes sense for Aperture to manage those video clips. Although not designed to be a movie editor such as iMovie or

Final Cut Pro, Aperture is exactly what a photographer needs to manage the occasional video clip. You can import, organize, sort, sift, rate, and view video clips just as easily as you do photos. You can even use video clips within slideshows, mixed with photos and audio tracks.

> **NOTE ▶** You can also use Aperture to import, organize, and play back audio clips captured from your DSLR camera.

1 In the Library inspector, select the Williamson Valley project.

Video clips can be recognized in the Browser by the white video camera badge in the lower-right corner of the thumbnail.

2 Double-click the **Williamson Valley Ranch** clip to change the main window layout to show only the Viewer.

3 In the video controls, click the Play button.

4 Double-click the **Williamson Valley Ranch** clip to return to the Browser mode.

5 Press Command-A to select all the images in the Browser.

6 Choose New > Slideshow.

7 Select Classic as the slideshow theme and enter *Williamson Valley Ranch* as the slideshow name. Then click Choose Theme.

8 Position the pointer over the first image in the Browser, **IMG_0845**.

9 Press the Spacebar or click the Preview Slideshow button to play the slideshow. Press the Spacebar to stop the slideshow after you play through the **Jake in Field** video clip.

10 Double-click the **Jake in Field** video clip.

11 In the video controls, from the Action pop-up menu, choose Trim.

12 Drag the yellow Start point trim handle to the right just before the horse enters the frame.

13 Drag the yellow End point trim handle to the left just after the horse is out of the frame.

14 Click the Trim button to confirm the new Start and End points for this clip.

15 Click the Play button to view the new Start and End points.

> **TIP**▶ Although you cannot apply adjustments to video clips, you can use the photo effects in the Slideshow Editor to apply Black & White, Sepia, and Antique adjustments.

16 Double-click the **Jake in Field** video clip to return to the Slideshow Editor.

17 Position the pointer just before the **Jake in Field** video clip in the Browser.

18 Press the Spacebar or click the Preview Slideshow button to play the slideshow. After you play through the **Jake in Field** video clip, press Spacebar to stop playback.

Being able to trim and assemble video clips using the Slideshow Editor is a great way to show the full range of your content. And just as with photos, Aperture doesn't modify the original video clip. Any editing you perform is nondestructive.

But if you are more ambitious with regard to video editing, the video clips from the Aperture library are accessible within the iMovie Media Browser.

Editing to the Beat

One of the most difficult aspects of editing a multimedia presentation is making the images and videos clips flow in a visual rhythm. Editing is a skill that takes time to master. Luckily, you can build a simple yet effective rhythm into your presentation by allowing Aperture to synchronize the slides to musical beats.

1 Make sure the Audio Browser is still displayed.

2 From the Source List pop-up menu, choose Jingles.

3 Locate **Acoustic Sunrise**. Drag the jingle to the Browser and make it the main audio track by dropping it in the gray background area of the Browser.

4 From the Action pop-up menu in the tool strip, choose "Align Slides to Beats."

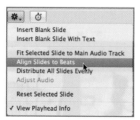

A progress bar appears as the song is analyzed. When analysis is complete, each slide and video clip in the slideshow is shortened or extended to fit to the nearest beat of the music.

5 Position the pointer at the beginning of the slideshow and press the Spacebar or click the Preview Slideshow button to begin playing the slideshow. Press Spacebar to stop playback after you have heard enough of the newly synchronized presentation.

Similar to the unwanted ducking you heard previously, the main audio track volume here is being ducked under the video clips audio. You'll need to deselect the Reduce Volume checkbox, this time using the Slideshow Settings.

6 Command-click all the video clips in the Browser.

TIP Alternatively, you could press Command-A to select all the clips, and then press the Command key to deselect the photos in the slideshow, leaving only the video clips selected.

7 Click the Slideshow Settings button, and then click the Selected Slides button.

8 Deselect the "Reduce volume of main track to" checkbox.

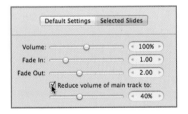

9 Position the pointer at the beginning of the slideshow and press the Spacebar to play the slideshow. After you've heard the consistent level in the main audio track, press Spacebar to stop playback.

Editing to the beat is a quick and easy way to build a rhythm into your slideshow. It works well, but if you have a bit more time, you can use the Slide Duration button to customize which beats or musical cues cause the image to change in the slideshow.

Editing on the Fly

Having Aperture synchronize your slides to the beat of the music ensures that the slides change in a consistent rhythm. But that consistency isn't always what you want. Sometimes you want to coordinate musical cues, such as a cymbal crash or a trumpet blast, with a change in slides. As you play your slideshow, you can enable the Slide Duration button so that tapping the Return key will change to the next slide and alter your slide timings on the fly. It's similar to the manual navigation you used in an earlier exercise with slideshow presets. The difference here is that the timing is saved with the slideshow, so you can play back or export the show with the exact timings you tapped out.

1 In the tool strip, click the Slide Duration button.

2 In the Browser, position the pointer at the start of the slideshow.

3 Press the Spacebar to play the slideshow.

4 When you want to change a slide on a beat or a musical cue, press Return.

5 Position the pointer at the beginning of the slideshow and click the Play Slideshow button to see and hear the results. Press Spacebar to stop playback.

You've explored the extensive functionality built into the Slideshow Editor. At your fingertips are tools for assembling photos into a sophisticated presentation, as well as adding and manipulating audio and video clips. Once you've made your final adjustments to the slideshow, you can decide how you want to distribute it.

Sharing Your Slideshow

The slideshow is essentially a short movie, so when you think about sharing it with others, you have several options to consider. Movie files, like image files, can be saved in multiple formats. Some formats deliver pristine quality but require more powerful computers to play them, some formats are lower quality but perfect for playback on small mobile devices. It's not uncommon to export a show in several movie formats to meet the needs of multiple viewing platforms.

Transferring Slideshows to iPhone, iPad, or iPod Touch

You can transfer your slideshow directly to an iPhone, iPod Touch, or iPad by exporting it to iTunes and then syncing the movie file to your connected mobile device. This way you can show it to potential clients, family members, and friends without being connected to the Internet.

1 In the Library inspector, select the Williamson Valley Ranch slideshow.

2 In the Slideshow Editor, click the Export button in the upper right of the Viewer to open the Export dialog.

3 Type a name for the movie in the Save As field.

> **TIP** ▶ It's a good idea to include the purpose of the movie file in the name, such as Williamson Valley Slideshow for iPod iPhone.

Aperture automatically creates an Aperture Slideshow folder in your Pictures folder where it saves all slideshow exports. This is convenient, but if you want to save the file in another location, select a folder from the Where pop-up menu, or click the disclosure button and browse through the folders on your Mac.

4 From the "Export for" pop-up menu, choose "iPhone, iPod touch" if you plan to play the slideshow on any iPhone, iPod touch, or iPod nano.

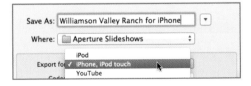

> **TIP** ▶ If you plan to play the slideshow on older fifth-generation iPod models, choose iPod from the "Export for" pop-up menu.

5 Make sure the "Automatically send slideshow to iTunes" checkbox is selected so the movie is sent to iTunes as well as saved in the Aperture Slideshows folder.

6 Click Export to begin compressing and saving the movie file.

When the export is complete, iTunes will automatically open with the Movies category selected in the iTunes Library. Your slideshow will be displayed in the iTunes window. You can double-click it to view it within iTunes.

7 Connect your iPhone or iPod to the Mac using a USB cable.

8 Select the iPhone or iPod when it shows up in the Devices category in iTunes.

9 In the iTunes window, click the Movie tab.

10 Select the Sync Movies checkbox at the top of the iTunes window.

> **NOTE ▸** A warning dialog may appear if you already have movies on your iPhone or iPod and you are syncing it with a new library. It's your choice to replace the movies on your mobile device or cancel the sync operation.

11 Select the checkbox next to the slideshow movie in the list.

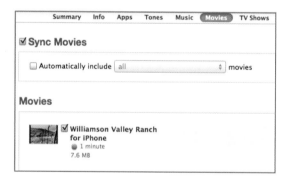

12 Click the Apply button.

13 When syncing is complete, return to Aperture.

> **NOTE ▸** This process also works to sync your slideshow to Apple TV for viewing on an HDTV. However, you would choose the Apple TV setting from the "Export to" pop-up menu and choose Apple TV in your iTunes devices category.

iTunes automatically transfers the movie file onto your iPod or iPhone. Then, you can disconnect your mobile device and view the movie file from the iPod app on your device.

Sending a Slideshow to YouTube

YouTube allows you to post movie files for online viewing. This allows people around the world to see your slideshow on demand. You will create a file that works with YouTube and then upload it via QuickTime.

1 In the Library inspector, select the Williamson Valley Ranch slideshow.

2 In the Slideshow Editor, click the Export button to open the Export dialog.

3 Type a name for your movie in the Save As field.

4 From the "Export for" pop-up menu, choose "YouTube."

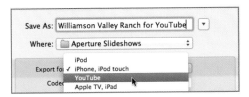

NOTE ▶ Alternatively you could choose HD 720P from the "Export to" pop-up menu to create a higher-resolution movie for YouTube.

5 Deselect the "Automatically send slideshow to iTunes" checkbox because iTunes does not directly upload to YouTube.

6 Click Export to compress and save the movie file.

When the export is complete, the file is saved to the Aperture Slideshows folder in the Pictures folder. Double-clicking the file may open iTunes and play the file depending on your preference settings, but opening it in QuickTime will allow you to easily upload the movie to YouTube. Alternatively, you could go directly to the YouTube website and upload your movie.

7 In the OS X Finder, open the Pictures folder, and then double-click the Aperture Slideshows folder.

8 Right-click the **Williamson Valley Slideshow for YouTube** slideshow movie that you exported.

9 Choose Open With > QuickTime Player.

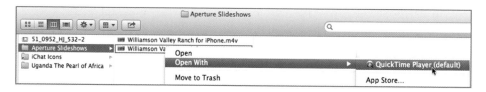

10 In QuickTime Player, choose File > Share > YouTube.

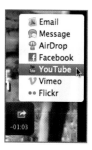

The YouTube login dialog appears. You must have a YouTube user name and password to post to YouTube. If you don't, you can register at www.youtube.com.

11 Click Cancel on the YouTube login dialog.

12 Again, click the Share pop-up menu and notice that additional options are available such as Facebook and Vimeo.

These preset uploaders simplify the process of sharing your creations with your audience over the web.

13 Quit QuickTime Player and return to Aperture.

Now you can reach a wide audience with your photos by uploading dynamic slideshows to video sharing sites. You can also mix in your video work. Your Aperture library becomes the central hub for all your work. Your video is organized and rated in the same projects as your photos. Your slideshows combine the best of both media types, and your sharing sites expose your work to the largest audience around the world.

Lesson Review

1. Why would you choose to use a slideshow preset over a slideshow album?
2. What two themes could you choose if you wanted to customize the transitions between slides?
3. What is the difference between changing the Transition type in the Default Settings pane and changing the Transition type in the Selected Slides pane?
4. What happens when you drag an audio file directly onto a slide?
5. True or false: Slideshows that are exported to YouTube from Aperture are uploaded directly to the website.
6. What are two of the possible ways to adjust the duration of slides within a slideshow that advances each slide automatically?
7. How do you record slide timings manually while rehearsing your slideshow?

Answers

1. Slideshow presets are a perfect solution if you want to quickly create a slideshow that you don't need to save or export for later use, or when you want to manually change slides; for instance, when using slides as talking points during a presentation.
2. The Classic theme and the Ken Burns theme have the most options. They are the only two themes that allow you to modify transitions.
3. The Default Settings are global settings that affect every slide in the slideshow. Selected Slides settings affect only the slides that are selected in the Browser.
4. Dragging an audio file to a slide in the Browser adds a secondary audio track. Dragging an audio file to the gray area of the Browser adds it as the main audio track.
5. False. Slideshow movie files exported from Aperture are placed in the Aperture Slideshows folder, in the Pictures folder. The files are not uploaded automatically. You must upload the movie files using QuickTime or directly to the YouTube website.
6. In the Slideshow Editor, set the desired duration in the "Play slide for" field. The results differ depending on whether you are in the Default Settings or Selected Slides view. Default Settings changes the duration of all slides within the slideshow, whereas Selected Slides affects only the currently selected slides. Another way to adjust the duration of slides is to fit them to an audio track using the Action pop-up menu.
7. The Slide Duration button, which looks like a stopwatch, records your pressing of the return key to advance to the next slide while rehearsing the slideshow playback.

12

Lesson Files APTS Aperture3 Library

Time This lesson takes approximately 60 minutes to complete.

Goals Post photos to Facebook and Flickr
Build and customize a web journal to showcase photos
Publish a web journal
Using Photo Stream

Lesson 12

Presenting Your Photos on the Web

Among the most popular ways to share photos is to post them on the web. From personal web galleries to social networking sites, it's easy to see why sharing your photos online is so popular.

First and foremost, you're publishing to the broadest possible worldwide audience. Second, if you work with clients, they don't need to schedule a studio visit or request work samples. And let's not forget the immediacy of web-based presentation, in terms of how conveniently the images can be viewed and how quickly you can get feedback from professionals and fans.

In this lesson, we'll touch upon the many ways you can use Aperture to share your photos online using sharing sites such as Facebook and Flickr, and you'll build a customized web journal in which you can combine your images with your words.

Posting to Facebook and Flickr

The ability to share images to Facebook and Flickr is built into Aperture. The Share button in the toolbar makes it easy to log in to the service you want and post images.

> **NOTE ▶** You must have an Internet connection and accounts for Facebook and Flickr to perform the next exercises.

Posting to Facebook

Facebook is very good at helping users broadly share their everyday photos. Although not geared toward professional photographers or photo hobbyists, Facebook users upload on average 250 million photos daily, making it the most popular photo sharing site worldwide.

1 In the Library inspector, select the NW Africa Five Star Images album.

2 Command-click the first three images in the Browser to select the images you will upload.

3 In the toolbar, click the Share button and choose Facebook from the menu. The Facebook login dialog appears.

If this is the first time that you have clicked the Share button and chosen Facebook as an option in the toolbar, the Facebook login dialog will appear. Enter your Facebook account name and password and click Login. This information allows Aperture to access your Facebook account. It does not give Aperture access to any personal data.

After connecting to your Facebook account, Aperture asks in which Facebook album to store the images and whether the photos are freely viewable by everyone or a limited number of people.

4 Select an existing album or choose to create a new album for the images being uploaded. Also, select the privacy level for the images from the Photos Viewable By pop-up menu.

5 Click Publish.

After you click Publish, a Web section is created in the Library inspector. Selecting your Facebook account in the Web section reveals The NW Africa Five Star Images album in the Viewer.

TIP > You can delete an entire album from Facebook from within Aperture by selecting the Facebook album and then choosing File > Delete Album. A warning will alert you that the album's images and associated comments will be removed from your Facebook account.

From within Aperture, you can change the Facebook album images, and open the Facebook webpage in a browser.

6 Right-click your Facebook account in the Web section of the Library inspector, and choose Visit Albums.

Safari launches and goes to your Facebook Albums page if you are logged in to your Facebook Account. You can add images to your Facebook Albums within Aperture which will then update the online Facebook albums.

7 Back in Aperture's Library inspector, select the NW Africa Five Star Images project.

8 Select the image **Senegal 2006-11-03 at 15-41-51**.

9 In the toolbar, choose Share > Facebook.

Since you previously logged in to your Facebook account, Aperture jumps to the album and privacy dialog.

10 Select the NW Africa Five Star Images album from the Album pop-up menu. Click Publish.

Aperture synchronizes the Facebook album with the update album in Aperture. You can see the changes online in your Facebook account after the synchronization completes.

11 Switch to Safari by clicking its icon in the Dock.

12 As you should still be on your Facebook album page, click the Safari Refresh button to update the Album webpage.

After the refresh, notice that the NW Africa Five Star Images album now indicates an additional photo. In just a couple of clicks, you can easily push your images to your Facebook account.

13 Log out of your Facebook account in Safari, if desired, and then quit Safari.

Facebook is primarily a social network that offers a great way to share photos with friends and family. For professionals, it can also help you attract prospective clients.

Posting to Flickr

Yahoo-owned website, Flickr is the second largest photo sharing site in the world. You might be more interested in posting to Flickr because it attracts a more photo-educated user base that can post helpful comments and critiques to your photos.

1 In the Library inspector, select the NW Africa Five Star Images album.

2 Command-click the first three images in the Browser to select the images you will upload.

3 In the toolbar, choose Share > Flickr.

If you've never clicked the Flickr button, the Setup dialog will appear. Clicking the Setup button will open Safari to a Yahoo login window where you can enter your Yahoo account name and password. After you enter your account information and log in to Flickr, you must then click the "OK, I'll Authorize it" button to allow Aperture access to your Flickr account. This does not give Aperture access to any personal data.

TIP ▶ To remove a Flickr or Facebook account from Aperture, select the Flickr or Facebook account in the Library inspector. Right-click the account and select Delete Account. This does not remove the images from those sites. It just removes the login status for Aperture on this Mac.

4 After authorizing the Aperture Uploader in Safari, return to Aperture.

A publish dialog lets you specify the Flickr album, privacy, and size settings for the images you are uploading.

5 Leave these settings as is for this upload and click Publish.

When you click Publish, a Web section is created in the Library inspector if it did not already exist. The Flickr account is shown in this Web section. When you select your Flickr account, the NW Africa Five Star Images album will appear in the Viewer. After the album is uploaded, a Publish icon appears to the right of the album's name in the Library inspector.

TIP ▶ You can delete an entire Flickr album from within Aperture by choosing File > Delete Flickr Album. All the images will be removed from your Flickr webpage.

From within Aperture, you can delete an image from the Flickr album. This same process can be used to delete images from a Facebook album.

6 With the Flickr account chosen in the Library inspector, select the NW Africa Five Star Images album from the Viewer.

7 Select the **Senegal 2006-11-03 at 07-30-35** image and press the Delete key.

A warning appears stating that the image and associated comments will be taken offline immediately. The original image and any versions within Aperture projects will not be deleted.

8 Click Delete to confirm.

TIP ▸ You can upload additional images to the same Flickr album by adding the images to the Flickr album in the Aperture Library inspector. Once the Flickr album includes the content you want, click the Publish button next to the album name in the Flickr section of the Library inspector.

9 In the Flickr Section of the Library inspector, click the Publish button to update the album on Flickr.

10 Right-click the Flickr account in the Library inspector and choose Visit Sets to see your Flickr webpages.

Keywords are posted as tags in Flickr, and all the EXIF data for each photo is also posted. If the "Include location information for published photos" checkbox is selected in the Advanced section of Preferences, GPS data will appear in Flickr.

Creating a Web Journal

If you want more control over how your photo galleries display, you can create web journals and webpages within Aperture.

When you need to create webpages that combine text and photos, the web journal is your most flexible option. For example, you could add several images to a page from a particular shoot, then add text to describe the shoot and put the images in a context. To create a web journal, you can first select the photos, or create an empty web journal and add images as you build pages.

> **NOTE ▶** The webpage album and Smart Web Page Album are similar to a web journal album, but provide fewer options and do not allow you to place text alongside images.

Let's first select images from the NW Africa Five Star Images album and then start building a web journal.

1 In the NW Africa Five Star Images album, press Command-A to select all the images.

2 In the toolbar, choose New > Web Journal.

The Web Journal dialog appears with a few setup options. The Untitled Web Journal has its name highlighted for renaming, and you'll find a list of themes or layout styles that you can apply.

3 Name the new web journal *Don Holtz Portfolio*. Make sure the "Add selected items to new web journal" checkbox is selected.

4 Select the Art Collection theme, and click Choose Theme. The Webpage Editor appears with the images you selected displayed in the Browser.

The images do not need to be selected before you create the web journal, and you can add images to a web journal at any time.

5 In the Library inspector, select the People of NW Africa project.

The four-star images would be perfect to include in your web journal. Using the Filter HUD, you'll easily be able to find and add them.

6 Press V until only the Browser is displayed, and then click the Filter HUD button.

7 From the Filter HUD Rating pop-up menu, choose "is" and then drag the slide to the
right until four stars are displayed.

Only the four-star images are shown in the Browser. You'll add these images to the
web journal.

8 Press Command-A to select the images in the Browser, and drag them to the Don
Holtz Portfolio web journal in the Library inspector.

NOTE ▶ This is the same method you use to add images to a web page. The images
included in a Smart Web Page are updated based only on the Query HUD setting.

Now that your web journal layout is set and all your images are gathered in the Browser,
it's time to add images to pages.

Adding Images to a Web Journal

You can use a few different methods to add photos to web journal pages in combination
with a few controls that make it easier to find the photos you want to add.

1 In the Library inspector, select the Don Holtz Portfolio web journal. In the Browser,
select the four images shown below and drag them to the web journal page in the Viewer.

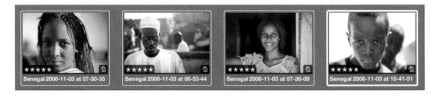

The four images are added to the page, and red usage indicators displaying the number 1 are added to the Browser thumbnails. This red badge indicates the number of times the image has been used in the web journal.

TIP ▶ You can remove an image from a web journal page by positioning the pointer over the image and clicking the minus sign that appears over the thumbnail.

It will be easier to see the unused images by filtering the Browser to display only images that have not yet been placed in the web journal.

2 Click the Show Unplaced Images button to show only those images that you have not used.

Some of the remaining images in the Browser are stacks. Because only the stack picks can be added to the web journal, you'll collapse the stacks to make it easier to see only the stack picks.

3 Choose Stacks > Close All Stacks.

You are now ready to add all of the images that are currently shown in the Browser to your web journal.

TIP ▶ If you want to add images from the stack other than the pick image, you can extract the other images from the stack and add them to the web journal.

Creating and Populating Pages Automatically

Instead of creating new pages and dragging images onto each one, you can have Aperture automatically create and populate pages based on a metadata category such as date, keyword, or rating.

1 From the Page Action pop-up menu in the tool strip, choose New Page for Each Day.

All the displayed photos in the Browser are added to new pages based on the dates the photos were taken. You can rearrange the pages in the Page pane into any viewing order for your website.

2 In the Pages pane, select the bottom-most page.

3 From the Page Action pop-up menu, choose Move Current Page Up.

The selected page is now moved up in the list to the second page of the website, rather than the third page.

NOTE ▸ You can add and delete pages by clicking the Add (+) or Remove (−) buttons located in the tool strip.

Once images are added to pages, you can customize your web journal to best showcase your work.

Changing and Modifying Web Journal Themes

Without understanding the code behind the web journal, you can change themes, customize the image layout, and add blocks of text to your pages.

Changing a Web Journal Theme

You can change a theme at any time and all your images and text will reflow to fit within the new theme.

1 Click the Theme button.

2 From the Theme list, choose Picture.

3 Click Choose Theme.

NOTE ▶ This is the same process you would use to change a webpage theme.

This theme uses a header image. It would be nice to add a header image on the first page, and not on the following two webpages.

4 Click the Show All Images button to view all the images in the Browser.

5 Drag **Mauritania 2006-11-06 at 07-42-27** into the gray header drop zone on the web journal page.

NOTE ▶ Not all themes place an image in the header.

6 Move your pointer over the image in the header to display the Image Scale HUD.

7 Drag the Image Scale slider to the right, until only the eyes of the woman are displayed in the header drop zone.

8 To better frame the eyes, drag the image in the header box to pan it.

TIP ▶ To replace an image in the header, drag the new image on top of the current header drop zone image.

9 In the Pages pane, select the second page in the list.

10 From the Page Template pop-up menu, choose "Header with Text" to remove the header from this page.

11 In the Pages pane, select the third page in the list. From the Page Template pop-up menu, choose "Header with Text."

This image box is removed from the Template page and replaced with text only.

This is shaping up to be a nice-looking, cohesive series of pages. You'll change a bit more on the images before you begin to enter the text of your web journal.

Modifying a Web Journal Layout

With a new theme selected, let's reorder images on the main page and lay out the columns of images in a neater arrangement.

You can change the order of images on a page by dragging them to new locations.

1 Select the topmost page in the page list.

2 Drag to the left the image of the woman smiling in the doorway until the green insert line appears at the far left of the screen.

3 When the green insert line is located to the left of the first image in the row, release the image.

You can also control the size of the thumbnail images and how many rows and columns are used in the web journal to display the thumbnails.

4 In the tool strip Columns field, click the left arrow to change the number of columns from 4 to 2.

The number of columns decreases to two for all pages, but you'll need to scale the images to better fill the page.

5 Change the Width value to 320 to enlarge the images.

> **TIP** ▶ In the "Fit images within" pop-up menu, you can choose whether portrait or landscape images are spaced apart according to their longest or shortest edges.

As you add more images to a page and mix portrait orientations with landscapes, it becomes even more important to control the layout.

Displaying Metadata in a Web Journal

Depending on the audience for your web journal, it can be critical at times to display the images' EXIF and IPTC metadata.

The same metadata views you used in Lesson 2 can be chosen to display valuable information under the thumbnail images on the web journal.

1 From the Metadata Views pop-up menu, choose Name & Caption.

The name and caption for every photo on all the pages is now displayed; on photos without captions, only the name is displayed.

By default, the web journal is designed to show an enlarged detail view of an image when anyone clicks the image thumbnail on the main pages. You can preview how these enlarged image pages will appear from within the Webpage Editor, and you can assign a different metadata view for the detail page.

2 In the web journal page, move the pointer over the first image of the woman smiling in the doorway.

3 Click the Detail button to view the enlarged image webpage.

4 From the Metadata Views pop-up menu, choose EXIF Info.

5 Scroll down to see the very detailed EXIF information now displayed on the image.

6 Click the word *Index* to return to the main webpage.

After exploring this functionality, you might want to create a specific metadata view that you can recall for all your web journals; but for now, you'll leave the metadata as is and explore other types of text you can add to pages.

Adding Text to a Web Journal

In a web journal, text is used not only for technical information about the images, but also for weaving a story around your album, giving insightful commentary about each shot, each page, or about you.

1 On the first web journal page, triple-click the placeholder text "Your site heading" and type *Don Holtz Portfolio*.

2 Scroll to the bottom of the page and triple-click to select the text block that contains the text "© Your document copyright here." Enter © *Don Holtz*.

TIP ▶ Aperture can fill in the copyright text automatically if you enter it in the Web Copyright field of the Aperture Preferences Export tab.

Let's add some text about the photographer on the first page of the journal.

3 Click the Add Text Block button to add a text block to the page. Scroll to the bottom of the page to see the block.

4 Enter the following text into the block:

From Iceland to Taiwan to the Sahara Desert, Don Holtz's assignments have taken him around the globe. His clients and projects have included National Geographic, Traveler Magazine, and Sports Illustrated.

With the text entered, you'll now move it above the images so it sits in the middle of your webpage.

5 Click the handle at the top of the text box and drag it above the images on the web journal page.

6 When you see the green insert line displayed above the top row of images, release the image.

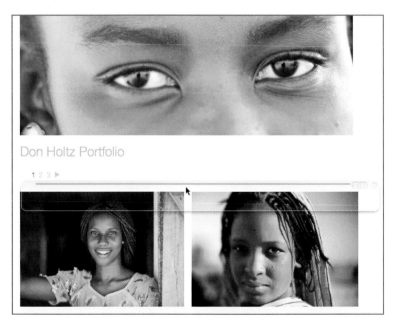

In just a few minutes, you've created a wonderful web journal that presents the images in an elegant theme with detailed information about each image. You can now think about where you want to host this creation.

Publishing a Web Journal

When your web journal is completed, you can export the pages for uploading to the server of your choice.

1 Click the Export Web Pages button. A sheet opens so you can specify where to write the files. The Export As text is taken from your album's name.

> **NOTE** ▶ When creating webpages, keep in mind that many servers don't allow spaces in filenames.

You can control the quality of the thumbnail and detail images that are published. You could select the quality level from a pop-up menu, but you could also edit the presets' quality settings, much like you did for previews in Lesson 3.

2 From the Thumbnail Image Preset pop-up menu, choose Web Thumbnails – JPEG – Medium Quality.

3 From the Detail Image Preset pop-up menu, choose Web Detail – JPEG – Best Quality.

4 Specify the desktop as the destination, and click Export. Aperture exports the web journal to a folder on your desktop.

TIP ▸ If you want to check the progress of the export operation, choose Window > Show Activity.

5 When the export is complete, hide Aperture by pressing Command-H. Now let's view the site locally.

6 On the desktop, double-click the Don Holtz Portfolio folder.

7 Double-click **index.html** to view the website in Safari.

8 When you finish viewing the pages, quit Safari.

9 In the OS X Dock, click the Aperture icon to return to Aperture.

TIP ▸ You can copy the exported folder to a website using an FTP program. You can also compress the folder to a ZIP archive and email it.

You have now seen some of the webpage creation and photo sharing capabilities of Aperture. These are by no means the only methods for sharing photos on the web. You can easily export versions of your photos and share them on any web service that suits your needs. In the next lesson, you'll learn how to export versions and originals, as well as print photos and books.

Using Photo Stream

More than likely, you have at least one Mac or Windows-based PC plus an iOS device or two...or four. Aperture allows you to use iCloud's Photo Stream service to easily push new images to all of your iCloud-connected devices. The devices receive your recent photos automatically. Of course, you may tell any of the devices to not automatically download new images, but when enabled, Photo Stream and iCloud keep all of your libraries in sync, automatically.

NOTE ▸ To start utilizing Photo Stream, you must have an iCloud account. For help setting up iCloud, refer to http://support.apple.com/kb/PH2605.

Within Aperture, you enable Photo Stream in Preferences. The Photo Stream Preferences also allows you to control the automated import and upload options of Aperture.

1 In the menu bar, choose Aperture > Preferences.

2 In the Preferences window, select the Photo Stream tab.

3 Select the My Photo Stream checkbox to activate the service.

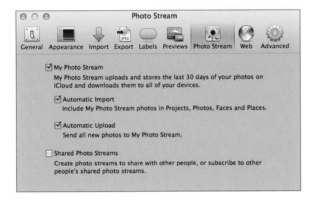

TIP ▸ If you have not set up iCloud on this computer, you will be prompted to sign in to your iCloud account before continuing. If you do not have an account, click Cancel.

The Automatic Import and Automatic Upload options enable themselves with Photo Stream activation. So now when you snap a photo on a device connected to the same iCloud Photo Stream account, Aperture will automatically download that photo to your active library. And any photos you import into Aperture are automatically uploaded to your Photo Stream in iCloud.

You can disable the two automatic options and still share photos among Aperture, iCloud, and other devices on the same iCloud account. This manual control is handy when working with lots of images, especially RAW files that might overwhelm another connected device. Let's look at how to manually upload to Photo Stream.

4 In the Library inspector, select the People of NW Africa project, and then choose three images from within the project.

5 From the toolbar, choose Share > Photo Stream.

The selected photos are uploaded to your Photo Stream account. A status appears next to Photo Stream listed in the Library inspector under Recent.

6 To see the images stored in your Photo Stream, select Photo Stream in the Library inspector.

The three photos you uploaded appear in the Browser. If there were additional images on Photo Stream to download, you would simply drag the images from Photo Stream to the desired project.

TIP You may delete an image from Photo Stream by right-clicking the image and choosing Delete from Photo Stream option.

Lesson Review

1. Of the photo sharing web services built into the Aperture toolbar (Facebook and Flickr), which service allows you to control who can view your photos?
2. How do you first assign a theme to a web journal?
3. How can you place a short descriptive sentence under each photo?
4. What publishing options are available for web journals?
5. How do you enable Photo Stream for Aperture?

Answers

1. Both Facebook and Flickr allow you to set who can view your photos.

2. Choose New > Web Journal to display the Web Journal dialog with a few setup options, including a list of themes that you can apply.

3. First, write a descriptive sentence for each image in the Caption metadata field. Then in the Webpage Editor, select a metadata view that contains the Caption field.

4. You can export the pages for loading to a server of your choice.

5. First you need to sign in or create a free iCloud account. Go to System Preferences to sign in to iCloud. In Aperture, choose Aperture > Preferences and then select the Photo Stream tab. Select the Enable Photo Stream checkbox.

13

Lesson Files APTS Aperture3 Library

Time This lesson takes approximately 60 minutes to complete.

Goals Compose, proof, and purchase a finished book

Prepare and order printed images

Export originals and versions

Lesson 13
Delivering Final Images as Books, Prints, and Files

You would have no reason to build your Aperture library and refine images if you couldn't get them out of your library. While sharing online is convenient, and slideshows can make people sit up and take notice, photos transform into a precious keepsake when contained in a beautiful book or framed portrait.

In this lesson, you'll learn how to get master images and your carefully adjusted versions out of Aperture, along with all the metadata you've assigned. You'll also create elegantly designed books and high-quality prints from the wedding photos you've worked with in previous lessons.

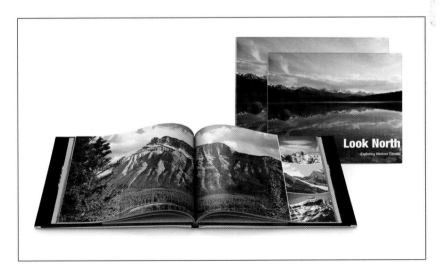

Creating a Book Layout

In this exercise, you'll look at the depth and flexibility of book creation in Aperture. You can quickly put selected photos into any number of professionally designed book themes. The book can be printed using an Apple print service or converted to a PDF for use by another print service.

Exploring Book Themes

To begin creating a book, let's take a few minutes to become familiar with the themes that Aperture offers.

1 In the Catherine Hall Studios project, select all the images. Then from the toolbar, choose New > Book.

> **TIP** You don't have to select a project to create a book; you can create a book that doesn't exist in any project by selecting Library Albums in the Library inspector and then choosing New > Book.

The Theme selection sheet appears with a number of thematic designs for your book. Different themes provide different default layouts. However, you can modify the layouts yourself or even design a new theme from scratch.

By default, the sheet shows you the themes available for Extra-large books, as indicated in the Book Type pop-up menu.

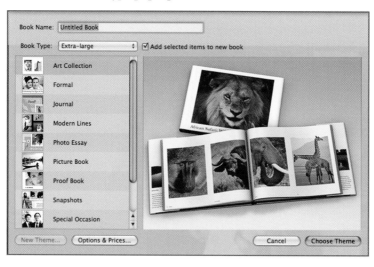

2 In the left pane, click a theme other than the one you've currently selected. Each time you click a theme, the right pane displays a preview of a book using that theme.

NOTE ▸ To determine printing costs, click the Options & Prices button to view the latest pricing from Apple.com. Book printing services are available from Apple in the US, Canada, Japan, and select countries in Europe.

3 Click the Book Type pop-up menu and choose Medium. The right pane changes to show you a softcover book preview.

NOTE ▸ The Extra-large book type is available only in hardcover editions. The Medium and Small book types are available only in softcover. The Large book type is available in both editions.

Notice that some themes provide alternative versions—such as the Stock Book themes—in both black and white versions.

4 Click the Book Type pop-up menu and choose Small. The Small book uses a single theme, as shown in the sheet's left pane.

5 From the Book Type pop-up menu, choose Custom.

The left pane is now empty, and the New Theme button at the bottom of the sheet is available. The Options & Prices button is now dimmed because custom books cannot be printed by Apple, although you can print them yourself.

6 Click the New Theme button.

A New Custom Book dialog appears. You can use this dialog to create a new book theme, give the theme a name, and specify the theme's book dimensions and general layout characteristics. If you click OK in the dialog, the new theme you've specified will appear in the list of custom book themes in the sheet. But you aren't going to do that right now.

7 In the New Custom Book dialog, click Cancel, and then from the Book Type pop-up menu, choose Extra-large. The list of themes reappears in the sheet's left pane.

For the wedding album, let's try something less traditional.

8 Select the Photo Essay theme.

> **TIP** ▶ Although the names of the books suggest the layout's use, the customization options allow you to modify a book theme to suit many situations.

9 In the Book Name field, type *Cathy and Ron's Wedding,* and click Choose Theme. Aperture creates a new book under the currently selected project.

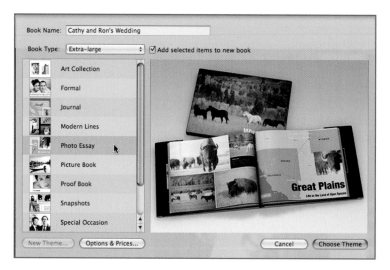

Just as when you created a web journal, the Browser is available for selecting images, and the Viewer shows the current page or page spread you're editing. The Pages panel shows thumbnails of all of the pages in your book for easy navigation.

A book album starts out with no pictures on its pages. You're about to address that.

Changing Master Pages

You may have noticed that the number of pictures in the Browser (58) appears just above the Browser. Now look just below the Viewer—it displays the number of pages in the book (20), as well as the type of book.

Although the book has 20 pages, plus a cover, in the Pages pane to the left of the Viewer you can see that the number of photo boxes in the layout is considerably more than 20. Several of the pages have two or more photo boxes.

This seems like too many small images for a wedding book. You'll want to change some of the pages to contain a single image.

1 In the Pages pane, click page 4 in the layout.

2 Click the down arrow in the gray box to the left of the selected page. A menu appears showing the available master pages for the current theme.

Notice that several of the master pages in the Set Master Page menu have a checkmark beside them. The checkmark indicates master pages that are currently included in the book's layout.

3 From the Set Master Page menu, scroll down to choose "2-Up w/Text Opt. A."

You can change several pages at once to speed up the process.

4 In the Pages pane, click page 5 in the layout, then scroll down and Shift-click page 7.

5 Click the Set Master Page pop-up menu at the bottom of the Pages pane and choose "1-Up Full Bleed." The selected pages now use the 1-Up Full Bleed master page, and fewer pictures will be required to fill the book.

Adding Pictures to Pages

To add images to your book, drag them from the Browser onto any photo box. Let's start adding images to the beginning of your book.

In the Pages pane, the first image is the cover image, and the second image is the small inset on the inside cover flap, so let's first select pictures to fit those two places.

1 In the Pages pane, click the book's front cover.

2 In the Browser, find the picture of the rings, **01_0093_AT_058**, and drag it into the empty photo box in the Viewer.

3 Select the next page in the Pages pane, the inside flap.

4 In the Browser, select **08_0207_HJ_114**. Drag it into the Viewer and drop it on the small, empty photo box on the inside flap.

Although dragging images to pages in a book seems easy, it can also become time consuming considering the number of images and the number of photo boxes you may use. You can use another method to place pictures onto the pages. Aperture can automatically flow the images onto pages, filling in the empty photo boxes. You'll use that approach in the next exercise.

Autoflowing Pictures to Pages

The Autoflow feature can very quickly fill the photo boxes of your book with all the images from the Browser, or just those images you select.

If you select specific images, Autoflow places them in the order you *click* them, rather than the order they appear in the Browser.

1 Command-click eight images in this order: **03_0079_HBD56CB0**, **04_0102_HJ_061-5**, **09_0221_HJ_122**, **10_0236_HJ_131**, **13_0300_HJ-162**, **17_0311_HJ_163**, **16_0328_AT_154**, and **19_0374_HJ_187**.

2 From the Book Action pop-up menu (to the right of the Set Master Page pop-up menu), choose Autoflow Selected Images.

NOTE ▸ You can tell how many times an image appears in a book by looking in the Browser. Every picture placed in a book has a red badge in the upper-right corner containing a number that indicates how many times the image appears in the book. You may need to click in the Browser to see the badges appear.

The first nine pages of the book are now filled with pictures in the order in which they were selected in the Browser. To fill in the remaining pages, you'll autoflow the unused images.

3 From the Book Action pop-up menu, choose Autoflow Unplaced Images.

The remaining images are placed in the book.

All these images have caused your book to grow from the 20-page default minimum to 26 pages. Although you can have up to 99 pages in a book, you'll reduce this page count by changing some of the layout and deleting some unnecessary pictures.

Deleting and Rearranging Pages

Autoflow is a great feature to start with, but in most cases not every picture gets placed exactly where you want it. Also, because you autoflowed all the pictures into the book, it has grown beyond your desired page count. Let's delete a few pages and move a few pages

around within the book, so the book opens with a pictorial sequence that more closely matches the chronological order of the wedding day.

1 In the Pages pane, click page 14, and then Shift-click page 15. The images on these pages show details of the wedding ceremony, which belong closer to the front of the book.

2 Drag the pages up until your pointer is just to the left of page 4 and release the button.

As you drag, a green line appears to the left of each page that the pointer passes over to show you where the pages would appear if you dropped them at that location. When you drop the pages, the other pages in the book move to accommodate the new placement.

3 To see a two-page spread in the Viewer, in the tool strip, click the Show Full Spreads button.

Because these are wedding ceremony pictures, the couple probably wants them to be a highlight of the book. Let's change the layout to better focus on a few of the ceremony images.

4 From the Set Master Page pop-up menu, choose "2-Up w/Text Opt. A." The selected pages now use the "2-Up w/Text Opt. A" master page and focus on only four images of the ceremony.

Let's get our book back down to the minimum 20-page length by deleting the last six pages. Although you may want to keep some pictures on those pages, you'll add them again later.

5 In the Pages pane, select page 21 and Shift-click page 26.

6 Click the Remove Pages (–) button. A warning dialog will appear reminding you about the 20-page minimum. Because you have 20 pages, click Delete.

You've now completed a simple pictorial wedding narrative for the book's cover and opening pages. Next, you'll modify a few of the pictures on the pages.

Customizing Pictures and Page Layouts

Each book theme includes a set of master page layouts that you can apply to any page in the book. However, you aren't limited to those master pages for your layouts. You can add picture and text boxes to any page and change their sizes and appearances.

Framing Images in a Photo Box

With the basic book structure in place, it's time to focus attention on the pictures on the pages. Some are not cropped quite correctly, but you can fix those.

1 In the Pages pane, select page 9.

2 In the Viewer, click the picture of the bride and the bridesmaid.

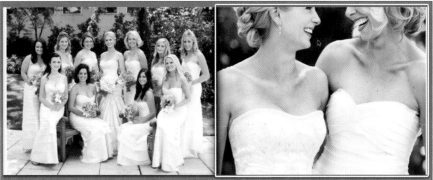

This is a portrait image, which is scaled to fill the entire page. It would be nicer to see the entire image, even if that means areas of the page are left empty.

3 Control-click (or right-click) the picture and choose Photo Box Alignment > Scale To Fit Centered from the shortcut menu.

The portrait image is scaled so that the entire image can be viewed on the page. The white background page is revealed to fill in the sides. But that's a lot of white space!

To better fit within the book's theme and present a more formal look, you'll change the background to black.

4 From the Background pop-up menu, choose Black. The image now is framed with black columns instead of white.

The next page is unique. It's a beautiful two-page spread, but the heads of many in the wedding party are cut off. The crease of the book also comes uncomfortably close to the groom's face.

5 In the Pages pane, select page 10, and double-click the image in the Viewer to open the Image Scale HUD.

6 In the Viewer, place the pointer over the image, then drag down to reposition the image so that the tops of heads are no longer cropped off the page.

7 To correct the crease, drag the Image Scale slide slightly to the right to increase the size of the image on the page.

8 In the Viewer, place the pointer over the image, then drag to reposition the page's crease between the bride and groom.

9 Continue to reposition the image until you are happy with the framing.

When you are done adjusting the crop, you'll have a nicely framed image that spans two pages.

TIP▶ When you work on a book, the Browser can display all the available images or only those that haven't been placed. You can switch between these two modes by clicking the Show All Images and Show Unplaced Images buttons that appear beside the search field.

Correcting the image framing in photo boxes is a common adjustment. One of the less common customization options for books takes advantage of the Places feature in Aperture.

Customizing Maps

Some themes integrate maps into your book. This is useful to show readers a trip itinerary or where an event took place. If the project or images already have location data, the maps will automatically be laid out correctly. If you haven't assigned a location for the project or photos using the Places feature, you can still build a map page within a book.

The Photo Essay theme you selected at the beginning of this lesson includes a map. In fact, any theme designed with maps will automatically place a map page in the book.

1 In the Pages pane, select page 15.

This is the map page added for you when you selected the theme. You'll need to format the map to show the location of the wedding; but the theme also placed a photo insert over the map, which should be removed.

2 Select the photo on the map page and press Delete.

The image was removed, but an empty photo box remains on the page. To remove a photo box, you need to change the page mode from content editing to layout editing. The Edit Content button allows you to modify the images that are placed in the book, whereas the Edit Layout button allows you to change the layout of the page.

3 At the top of the Viewer, click the Edit Layout button.

Notice that the photo box now has a different selection outline. When you click the Edit Layout button, photo boxes can be scaled and repositioned on the page. In this case, you'll just delete the photo box so you can begin designing the map.

4 With the photo box selected, press Delete to remove it.

5 Double-click the map to open the Map Options HUD.

If the Places feature has been used on these images or in the project, the map would already be formatted correctly. Since that's not the case here, you'll enter the Sonoma, California location of the wedding. Let's start by adding a title for the map.

6 In the Title field, enter *Sonoma, California*. The map title is added in the lower left of the map.

7 Click the Add Places button to add a location to your map.

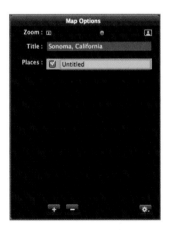

8 Double-click the Untitled location added to the Places list.

9 Type *The Fairmont Sonoma*.

10 From the Google Results, select The Fairmont Sonoma. The map centers on Northern California, and a place marker with text is added to the map to identify The Fairmont's location.

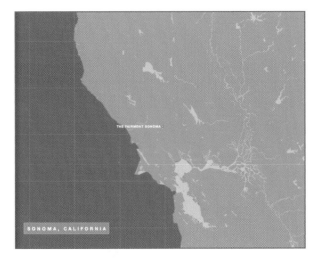

11 Drag the Zoom slider all the way to the right to zoom in close to the place marker.

Maps graphically display the setting of your book. You can add additional places to the map list if you are detailing an itinerary. You can even apply travel lines between place markers. Since this wedding took place in a single location, this was an easy map to create.

Changing Images in a Photo Box

When you autoflow photos into a book, you will probably want to swap some images for other images. Quickly go through a few of the pages and check to see if you need to replace any of the images.

1 In the Pages pane, select page 17. This is a beautiful layout with a full page shot of the couple on page 17. There is no need to change this, so in the Pages pane, select page 19.

2 There are too many images on page 19, so in the Pages pane, select page 19. Then, from the Set Master Page pop-up menu, choose "2-Up w/Text Opt.A."

Page 18 repeats the couple from the previous page. You'll need to replace this image. Because the other three images across this spread show the reception hall, you'll replace the couple with an unused reception hall shot.

3 In the tool strip, click the Show Unplaced Images button. The Browser now displays 22 photos, none of which are used in the book as of yet.

4 In the Browser, scroll the window to locate **60_1082_HJ_599**, the wedding cake, and drag it onto page 18 to replace the duplicate image of the couple.

The majority of the book is looking great, but it lacks a special ending. That's what you'll create to finish the book.

Arranging New Photo Boxes

Because you removed a few pages, some unused wedding images remain in the Browser. Some of them are fairly significant to the event. You'll create a special ending to the book using a customized ending page.

1 Scroll down in the Pages pane so you can view and select page 20.

The last photo in the browser is a good image to end the book. It shows the couple at the end of the reception, hugging and smiling for the camera. But you also have that nice nighttime image of the mission already on the last page of the book. Since this is the last page of the book, you'll create a customized layout that uses both images.

Using the edit layout mode, you can add a picture box, size it, and place it on the page using the nighttime mission image as a background.

2 At the top of the Viewer, click the Edit Layout button, if necessary.

3 From the Add Box pop-up menu, choose Add Photo Box. An empty photo box appears on the page ready to be filled and resized.

NOTE ▶ The Edit Layout button must be chosen to enable the Add Box button.

4 In the Browser, drag the last image of the smiling couple, **80_1346_HJ_762**, into the gray photo box.

The box and photo sizes don't match, but in edit layout mode, you can resize and reposition photos boxes.

5 In the Viewer, click the picture of the couple to display crop handles around the image.

6 Drag up on the top-center crop handle until you reach the top of the page. More of the image is now revealed because you expanded the photo box. Let's correct the bottom part of the photo box.

7 Drag down on the bottom-center crop handle until you reach the bottom of the page. The entire photo is now revealed.

Since this is the classic bride and groom photo, and it is the end of your book, you'll create a border to frame the image.

8 Below the Pages pane, from the Book Action pop-up menu, choose Show Layout Options.

The Layout Options inspector appears at the top of the Pages pane. The inspector controls show the dimensions and position of the object that is currently selected in the Book Layout Editor. You'll use these controls to place a black border around the picture.

9 In the Layout Options inspector, increase the Thickness to 0.25.

The picture now has a black border, but it's difficult to see against the dark photo background. Next, you'll create two more copies of the empty box.

10 In the Viewer, select the background nighttime image.

11 From the Set Photo Filter pop-up menu, choose Wash – Light.

A light white overlay provides a more subtle background and causes the border and photo of the couple to stand out.

That really puts the final touch to the book. At this point, you would change the place-holder text into true poetry; but who knows when the muse will inspire you, so let's move on to something a bit more technical: ordering and printing books.

Ordering Books

Aperture, like iPhoto, provides access to the Apple professional book-printing service. In the next exercise, you'll set up an Apple account and place a book order.

> **NOTE ▶** If you don't actually want to set up the account and buy a book, you can just follow along with the steps in this exercise.

1 In the top right of the Viewer, click Buy Book. Aperture quickly checks through the book and, if it finds any problems, such as empty text fields, it displays an alert.

2 If a warning alert appears, and you wish to proceed, click Continue.

Aperture checks your Internet connection and then, if you've established an Apple account, asks you to allow access to your stored account information so that it can connect to the print service using that information. In this case, you would click Allow.

If you've never established an Apple account on this computer, a book ordering sheet appears with a Sign In area to enter your Apple ID and password. You can also click the Create Account button at the bottom of the screen to create a new account.

The following steps assume you have an Apple ID already. If you don't, details on creating one appear at appleid.apple.com.

3 Enter your Apple ID and password, and then click Sign In.

When you finish, the book ordering sheet will include a Preview Book button along with a Continue button at the bottom of the screen. Clicking Preview Book will create the book in PDF form and open Preview for you to view it.

TIP It's always a good idea to preview your book before you buy or print it.

4 Click Continue to go to the final ordering page.

By default, the book will be shipped to the address associated with your Apple account, but you can add additional shipping addresses.

5 From the Ship Via pop-up menu, choose a shipping method. The cost of your order shown in the sheet is adjusted to accommodate the shipping method you've chosen.

6 If you actually want to buy the book, click Place Order; otherwise, click Cancel.

If you choose to buy the book, Aperture uploads all of the necessary images and text needed to send the book to the print service. Depending on the size of your book, the number of images, and the speed of your Internet connection, this process could take some time.

After you are done, relax and take a break. In a few days, your book will be on its way.

Delivering Printed Images

The images in your Aperture library can be distributed in a wide variety of ways; yet despite all the uses to which you can put your images, and all the places you can display them, demand for the venerable, familiar color print lives on. Aperture provides ample support for this most basic and enduring of image output formats.

In this exercise, you'll proof your images on the screen to prepare them for printing, and you'll set up a printing preset that is customized for your printer and paper.

Proofing Onscreen

With all of the differences between your Mac's screen and your printer—color gamut, resolution, and underlying imaging technology—WYSIWYG (What You See Is What You Get) is more of an unattainable ideal than an actuality, even when using a finely cali-

brated monitor. The Aperture onscreen proofing features, however, can get you as close to WYSIWYG as is possible given those unavoidable technological constraints.

1 In the Library inspector, select the Catherine Hall Studios project.

2 In the search field pop-up menu, choose five stars.

3 Select the last image in the Browser, **80_1346_HJ_762**, to see it in the Viewer.

4 Press V so you are looking at the Viewer only.

The image provides a good mix of bright and dark areas, including areas of fine detail and large swaths of gently-graded color—a good image to test proofing and printing.

5 Choose View > Proofing Profile.

The Proofing Profile submenu includes a large selection of output profiles. You can use these profiles to get a reasonably accurate preview of how your selected image will look when output to a particular printing device. Let's see what the image looks like on your printer.

6 From the Proofing Profile submenu, choose a profile that matches your printer. If you don't see an appropriate profile listed, choose Generic CMYK Profile.

The image changes subtly to match the profile.

7 Press Shift-Option-P a few times to switch between the normal screen display and the proofing profile display. You can see the color differences that the proofing profile imposes, especially in the skin tones and the red spotlight in the background.

Now that you've seen what the image will look like when you print it, it's time to set up a printing preset.

Each print size has its own rectangular shape, known as the *aspect ratio*. For example, an 8x10 print is proportionately taller and narrower than a 4x6 print. To make your image fit these different print shapes, photo labs usually enlarge the image slightly and crop out what doesn't fit. For the best results, you should crop your images to the same aspect ratio as the print size you are ordering.

Printing with Presets

When you print an image in Aperture, you have a variety of controls and options that you can use to fine-tune the printed output. Although you could set these controls each and every time you print, you'll probably want to use the same settings more than once. That's where printing presets come in.

> **NOTE** ▸ If you don't have an appropriate color printer installed on your Mac, you can still follow the steps to understand how printing presets work.

1 Press V to return to a Split View in the main window layout.

2 Select **80_1346_HJ_762**, and then Command-click **24_0487_AT_224**.

3 Choose File > Print Images, or press Command-P to display the Aperture Print window. The Standard preset is selected in the window's left panel.

4 In the lower left of the Print window, from the Action pop-up menu, choose Duplicate Preset and name it *5x7 my printer*. You'll use this preset to save the settings in the Print window's center panel.

5 From the Printer pop-up menu, choose your printer, or leave it set to the default if your printer is not connected.

6 From the Color Profile pop-up menu, choose a profile appropriate for your printer, or choose Generic CMYK Profile if no appropriate printer profile is available.

The preview image changes slightly, displayed with the color range associated with the chosen profile.

7 From the Paper Size pop-up menu, choose A4; and from the Image Size pop-up menu, choose 5x7. The image scales down on the previewed page.

8 Double-click in the Photos Per Page field, and type *2*.

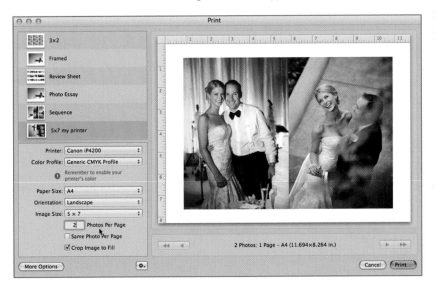

The preview window now shows how the two images will look when printed on paper of the chosen size. There is no need to go further for basic printing, but Aperture does offer more options for controlling the appearance of your prints.

NOTE ▶ Aperture automatically sends 16-bit color image data to your printer if the printer supports it. 16-bit color provides a wider color gamut than 8-bit color image data, and it produces smoother color transitions and less color clipping in the printed output.

Using Expanded Printing Options

Next, using the expanded options in the Print window, you'll make some additional adjustments to improve the output image quality.

1 At the bottom of the Print window, click the More Options button.

The first additional control offers finer controls for the rows and columns. You'll use Column Spacing to place some separation between the two images on the page.

2 Drag in the Column Spacing slider to increase the column spacing to 0.2 in.

To print from the RGB screen image to paper (which uses a CMYK color space), a color space conversion is required. The conversion may require approximations to preserve the image's most important color qualities. Knowing how these approximations work can help you control how the photo may change while maintaining the intended look or mood.

3 Scroll down in the Options window to view the Rendering section.

Perceptual and relative colorimetric rendering are technical color space conversion processes. Relative colorimetric rendering maps as precisely as possible all the colors the printer can print. That's nice, but the downside is that the printer is limited, and what used to be a continuous gradient of blues in the sky may be reduced to a more limited set of blues, introducing banding (or quantizing) artifacts. Perceptual rendering will adjust colors to keep the smoothest transitions between the shades. Great, no banding, but—wait for it—the downside is that colors can sometimes appear slightly different than the original image.

4 Set Render Intent to Perceptual.

5 Make sure the Black Point Compensation checkbox is selected. This option modifies the output slightly so that details in the darkest part of the image aren't completely lost when you print.

There are also a number of image adjustments here, identical to the adjustments found in the Adjustments inspector. If you know your printer prints slightly darker or less sharply, you can make adjustments here without creating a new version in the library.

TIP ▶ When you adjust the sharpening controls, you can click the Show Loupe button to closely examine the edges in the preview image.

6 From the Action pop-up menu at the bottom of the Print window, choose Save Preset. The adjustments you've made in the Print window are saved in the preset so you can use them again on other print jobs.

7 Load the appropriate size and quality of paper into your printer to match the profile you've selected, and then click Print, or click Cancel if you don't want to print right now.

TIP ▶ If you decide not to print at this time, you can click Preview to see what the output will look like, and you can save the preview PDF that Aperture generates so you can print it later.

If you don't own a high-quality printer, you can use Apple print services by choosing File > Order Prints. Either way, using printing presets makes it much easier for you to produce uniformly high-quality prints, time after time.

NOTE ▶ Remember that due to the differences in color methods between the computer screen and ink on paper, what you see on your screen will never match exactly your printer output. You may want to run several color tests to gain an understanding of the differences.

Delivering Digital Images

Long ago in the analog world, a professional photographer would often contract to deliver carefully-prepared, selected prints to a client. As you've seen, you can still deliver prints of your Aperture images from the same Apple printing service that provides the printed books.

In the digital world, however, you'll more likely deliver raw master photographs, or corrected and enhanced versions. Aperture provides extensive output options that you can use to deliver the necessary materials—even if the recipient is yourself.

Exporting Originals

Handing a client copies of referenced originals from an Aperture project is not particularly difficult. Because the raw images are not stored within the Aperture library, you can simply copy the images from wherever you've stashed them and submit them. To deliver managed originals, however, you must create copies by exporting them from the library.

Even if you're working from referenced originals, you still might want to use the Aperture export capabilities. They not only provide you with exact copies to deliver, but offer you versatile sorting and renaming features that you can use to prepare a tidy delivery package. As an added bonus, the original can include any IPTC metadata you've prepared.

> **NOTE ▶** Exported originals are visually identical copies of the images that you originally imported into Aperture, which means they contain none of the changes you may have made using Aperture image manipulation tools.

1 In the Library inspector, click the Catherine Hall Studios project, and then choose View > Browser. The five-star images from that project appear ready for delivery.

2 Press Command-A to select all the images, and then choose File > Export > Originals, or press Command-Shift-S. An export originals sheet appears that you'll use to set up the export.

3 In the sheet, navigate to the desktop, and then click New Folder.

4 Name the folder *Originals with custom name*, and click Create.

The sheet now displays the empty plain originals folder.

5 In the sheet, from the Subfolder Format pop-up menu, choose Project Name.

6 From the Name Format pop-up menu, choose Custom Name Date and Time, and then in the sheet's Custom Name field, type *Wedding*.

> **TIP** You can make your own custom folder name and filename presets to suit your exporting needs. Choose Aperture > Presets > Folder Naming to see a window in which you can assemble the naming and sorting elements you want to use for folders, and choose Aperture > Presets > File Naming to create your custom file-naming presets.

7 From the Metadata pop-up menu, choose Include IPTC. All the IPTC metadata, including keywords, captions, and ratings, will be embedded in the exported original file.

> **TIP** You can also write IPTC metadata into the original images by choosing Metadata > Write IPTC Metadata to Originals.

8 Click Export Originals.

> **TIP** For time-consuming exports, you can select "Show alert when finished" in the export sheet to have Aperture display an alert window when the export is done.

The export begins. The sheet closes and you can continue working while the export proceeds. This export comprises only a few images and takes just a few seconds. After the process is complete, original files are renamed "Wedding" followed by the date and time each image was taken.

Aperture also allows you to export your versions using high-quality presets for 16-bit TIFF, PNG, and Photoshop formats. The export process is the same with only one or two fewer options than when exporting originals. In the end, you can use these high-quality version exports to deliver images for almost any purpose.

You've now completed all 13 in-depth lessons that took you from import, organizing, and rating to editing, sharing, and printing. Nonetheless, there is still more to be learned about Aperture, some of which is included in the two appendices. But it's time to start using your own images in an Aperture library, applying what you've learned, and rediscovering your photos with new enthusiasm.

Lesson Review

1. Describe two ways autoflow works to place images on pages.
2. Can keywords be embedded into a original image?
3. How can you tell how many times an image appears in a book?
4. True or false: An exported original contains all the edits and adjustments you've made to an image in Aperture.

Answers

1. The Autoflow feature can very quickly place all the images, or just the images you select, from the Browser into the empty photo boxes of your book.
2. Yes, any IPTC metadata you've prepared in Aperture can be written into the originals you deliver by choosing Metadata > Include IPTC in the Export window. You can also write IPTC metadata into the original images by choosing Metadata > Write IPTC Metadata to Originals.

3. In the Browser you'll see that every picture placed in a book has a red badge in the upper right containing a number to indicate how many times the image appears in the book.

4. False. Exported originals are virtually identical copies of the images you originally imported into Aperture, which means that they contain none of the changes you may have made using the various image manipulation tools.

Cameo: Ron Brinkmann

Refining Excellence

THEY SAY A GOOD ARTIST knows when to put down the brush. Ron Brinkmann's spellbinding travel photography serves as conclusive proof. While

his sense of adventure gets him the shot, it's Brinkmann's subtler, more cautious moves that define him as a skilled editor.

Brinkmann's past pursuits run the gamut from supervising visual effects work on feature films to technology director for Amazon and Apple, and he is a regular co-host on the This Week in Photography podcast.

What is your camera of choice, and your preferred subject matter?

I'm using an older Canon 40D as my "big camera," a Panasonic LX3 as my point-and-shoot, and the iPhone as my "with me all the time" camera. Most of my photography is done while traveling, and I'm trying to capture the place I'm visiting with landscapes, candids, occasionally wildlife, and the random unique local detail.

Do you adjust most of your images, or only selects?

Generally just the selects, although sometimes I'll need to play with adjustments on several images to get a better feel for which ones are worthy of being considered final selects.

What basic adjustments do you make to your selects?

I tend to shoot things slightly overexposed. So if I got the shot exactly the way I wanted it in-camera, I use Aperture's Brightness adjustment to darken the image slightly and give it more punch.

If I didn't get it right (or if it was a scene with a wide dynamic range), I'll play with Exposure and Highlight Recovery first. Since I shoot a lot outdoors, it's common for me to simultaneously fight both hot highlights (specifically, blown-out skies) and deep shadows. So I'll often go back and forth with these tools, along with the Highlights and Shadows adjustments, to pull everything into the right visual range.

Once I'm sure I've got an image that works from that perspective, I might play with Definition, use the Color tool to tweak the hue or add a bit of saturation, and do a final pass of sharpening. All of these I try to keep pretty subtle.

Beyond these basic adjustments, how much retouching do you do?

A lot more, now that Aperture 3 supports brushing in localized adjustments! I do some brush-based work on about half of my selects, and crop 90 percent of them to get a pleasing composition.

Are there times when you use JPEG instead of RAW?

I shoot RAW as much as possible. Now that Aperture supports the RAW format for my LX3 point-and-shoot, I'll even shoot RAW with that. Aperture makes the RAW workflow so lightweight, it doesn't add perceptible post-processing time.

What's the most common image adjustment mistake you see people make?

I see a lot of abuse of saturation and sharpening. It's always tempting to go a little too far. Take a final look at everything a day later and make sure you didn't overdo things.

Sage advice from a practitioner of nuance. With a powerful palette at his fingertips, this disciplined artist knows when to say when. Learn more about Ron at his website: www.digitalcomposting.com.

Appendix **A**

Setting Up Your
Work Environment

Your work area affects how you judge your images, and your eyes are both your best friends and your worst enemies when it comes to evaluating images. Take some time to evaluate your working environment. Look at everything from your Mac display to the paint on your walls. The information in this appendix is by no means a step-by-step setup process; but if you are familiar with OS X, it will give you information to better configure your Mac for evaluating photographs.

Adjusting Your System Preferences

The Mac default desktop background and interface colors are very pleasing to the eye. However, when you're making critical color judgments and image corrections, it pays to be bland. Here are some general tips on setting OS X System Preferences to neutralize your workspace.

In System Preferences, in the Displays setting, select the native resolution of your LCD display. Native resolution information can be found in the display manufacturer's documentation.

> **NOTE** ▸ If you're using an older CRT display, verify that the Colors pop-up menu is set to Millions.

Next, to limit the influence the Mac interface has on your color judgment, open Desktop & Screen Saver preferences. In the Desktop view, choose the solid dark gray color square as your desktop color. Then, in the General preferences, choose Graphite from both the Appearance and Highlight Color pop-up menus.

If you've been using the OS X default setup, you should now notice that your close, minimize, and maximize buttons are gray instead of red, yellow, and green.

Yes, it is a dark cave, but one that is conducive to evaluating photos.

Calibrating Your Display

One of the most important aspects of photo management is achieving predictable color between your Mac screen and your printing or sharing output. You can do so by calibrating color across the multiple devices you use in your photography. OS X uses a built-in color management technology called ColorSync, which applies industry-standard ICC profiles to help you calibrate color and create your color management workflow. To implement a professional color management workflow, all of the devices in your photography loop should have profiles that are created using calibration instruments such as colorimeters and spectrophotometers.

Using Multiple Displays on a Mac

For the ultimate image editing and onscreen proofing experience, use a system with multiple displays, allowing you to create a desktop that spans two screens. Aperture improves on this simple extended desktop capability by letting you specify how the second screen is used. For example, your primary display could show the Aperture interface, while your secondary display shows a full-screen view of the currently selected image.

> **NOTE ▸** Even if you're not currently using multiple displays, keep reading. You may find yourself working on a two-screen system someday, and knowing how to harness both screens will boost your productivity.

Connecting Two Displays to Your Mac

The hardware requirements for hooking up a second display vary by system. For example, connecting a second display to a MacBook Pro is relatively easy. Generally the steps are:

1 Turn off the computer.

2 Connect a display cable from the second display to an available display port on the Mac. Make sure the cables are firmly connected.

3 Turn on the displays, if necessary. (Apple Thunderbolt displays will power on automatically.)

4 Start the Mac.

> **MORE INFO ▸** The Apple support website has additional information on connecting multiple displays.

Configuring OS X for Multiple Displays

When your computer is properly connected to two displays, you can configure them for maximum performance. By adjusting System Preferences, you can configure the displays to show a continuous desktop across both screens. This mode is called extended desktop mode and is ideal for working in Aperture.

> **NOTE ▸** When two displays are connected, Aperture controls the second display, so you must remain in the extended desktop mode. If you switch your displays to mirroring mode, Aperture may not work properly.

In the Displays setting of System Preferences, the Arrangement button allows you to adjust the displays so that their physical placement matches the way your Mac sees them. You can drag blue rectangles to match the positions of the displays on your desk, and drag a white rectangle to move the menu bar to the display you choose.

Configuring Aperture for Multiple Displays

With the displays attached, you're ready to configure Aperture for multiscreen viewing. Aperture considers the display with the menu bar to be the *main viewer*. The other display is the *secondary viewer*. By default, the main viewer displays the Aperture application and the secondary viewer displays images.

You can specify the function of the secondary viewer by choosing a setting from the View > Secondary Viewer submenu.

> **NOTE** ▶ If you do not have two displays connected, the main and secondary viewer submenus will not be active.

You have five choices for configuring your secondary viewer: Mirror, Alternate, Span, Black, and Off.

When set to Mirror, the second display shows an exact mirror of the Viewer on the main display. The difference is that the secondary display shows the selection fullscreen, with no interface elements.

When set to Alternate, the secondary viewer shows only the currently selected image, or the primary image when multiple images are selected.

If you choose Span from the Secondary Viewer submenu, then when multiple images are selected some of them will move to the second display, while the rest of the images in the selection remain on the main display. Span mode spreads the selection across both displays, so your images can be viewed at a larger size. How Aperture chooses to distribute them will depend on the size of your Viewer and the size of your displays.

If you want to eliminate the second display, choose Black from the Viewer Mode pop-up menu. The exception here is when in the Browser view. The selected Browser image appears fullscreen on the secondary display.

If you want to use your second display for something other than Aperture, you can choose Off from the Viewer Mode submenu. This reveals your Mac desktop and frees the display to show the Finder or another application.

Using Tethered Shooting

Aperture allows you to shoot tethered, meaning that images are captured directly to your computer as you shoot.

Your camera is connected to the computer using a USB or FireWire cable. After you select a project for the images, choose File > Tether > Start Session. You then use the Aperture Tether HUD to control your camera and take photos as you work.

Not all cameras support tethered shooting, and those that do may need to be set up in specific ways to enable this functionality. For a list of cameras that Aperture supports for tethered shooting, go to http://support.apple.com/kb/HT4176.

Consult your camera's documentation for specifics on settings. Different cameras from the same manufacturer may vary in regard to each of the following points:

► Some cameras must be set to a specific communication protocol to allow tethered shooting. Set your camera to use PTP mode unless otherwise specified.

► Some cameras support both remote computer control and camera control of the shutter when shooting tethered, others may only support one or the other.

► Some cameras require a media card to be inserted for tethering.

► Cameras that use the Mass Storage mode are not supported.

It's a good idea to avoid putting your computer to sleep while shooting tethered in Aperture or Image Capture. If the computer does go to sleep during a tethered session, your camera may no longer be detected, and it may be necessary to quit and reopen Aperture, unplug the camera, and reconnect it.

Expanding Aperture Functionality

When you begin using Aperture, its hundreds of features and functions can be overwhelming. As you continue building your library, you may require additional features and functions. With that in mind, Aperture can expand its feature set in two ways: by integrating plug-ins from other companies, and by applying Automator and AppleScript, easy-to-learn Apple scripting languages.

Adding Plug-ins

Plug-ins are small applications that run inside a larger host application such as Aperture. Aperture includes a flexible plug-in architecture that can integrate a wide variety of third-party plug-in types:

▶ Image editing plug-ins—You can extend the adjustments in Aperture; and add specialized tools for noise reduction, selective adjustments, lens correction, and much more.

▶ Export plug-ins—Although Aperture 3 includes direct sharing to Facebook, Flickr, and iCloud Photo Stream, over two dozen export plug-ins are available to expand your export options. Using these export plug-ins you can share your photos to SmugMug or Picasa web albums, as well as upload to remote FTP backup servers or generate a Flash-based web gallery.

▶ Photo book plug-ins—The books you create in Aperture are easy to order through Apple Print Services. By adding photo book plug-ins, you can also use Aperture to create and order photo albums from some of the finest bookmakers in the world.

▶ Extras—This catch-all category includes such additions as third-party web themes that add a variety of creative design options when presenting your photos on the web.

Additional information about Aperture plug-ins can be found at www.apple.com/aperture/resources.

If you are a developer interested in creating plug-ins for Aperture, the free Imaging Plug-in Software Development Kit (SDK) for Aperture is available through the Apple Developer Connection (ADC) at http://developer.apple.com/mac/library/navigation/index.html.

Applying Automator and Applescript

Automator is an application included with OS X that easily automates complex tasks. Automator performs *actions,* or individual commands, such as Choose Projects or Set IPTC Tags. You can link several individual actions to create a fully-formed workflow. A workflow automates multiple tasks that you would normally perform manually.

For example, you might use Automator in conjunction with Aperture to do the following:

▶ Create a *drop folder* that automatically assigns specific keywords, flags, ratings, or IPTC metadata to any images you drop into it.

▶ Create an application that automatically exports all of the images from a selected project, compresses them into a ZIP archive, and uploads them to an FTP server.

▶ Automatically send an SMS text message from Aperture when an import process is complete.

Automator also lets you automate processes that span multiple applications such as Mail, Photoshop, and others.

Using Prebuilt Workflows

You can download a number of prebuilt workflows from the Apple Automator website, including some fantastic Automator actions that let you easily perform complex operations with a single click.

Go to the Aperture Resources website (www.apple.com/aperture/resources/plugins. html#automation) to access the following workflows:

▶ Aperture In-Design Integration

▶ Aperture Caption Palette

▶ Publish for Approval

▶ Aperture PDF workflows

▶ Aperture Hot Folder

▶ Scan and Import Mail image attachments

▶ Aperture and Keynote Integration

All of these workflows are small, free, and ready to download.

Learning to Use Automator for Aperture

If you want to create custom workflows and automate some of the activities you perform over and over, download the Aperture 3 AppleScript Reference at http://images.apple.com/aperture/resources/pdf/Aperture_3_AppleScript_Reference.pdf.

This is a complete, 36-page guide to using AppleScript with Aperture. This PDF document describes classes, commands, and other AppleScript-specific features found in the Aperture 3 AppleScript dictionary.

Index

Apple Certification
Fuel your mind.
Reach your potential.

Differentiate yourself and gain recognition for your expertise by earning Apple Certified Pro status to validate your Aperture 3 skills.

How to Earn Apple Certified Pro Status

As a special offer to owners of Aperture 3, you are eligible to take the certification exam online for $75.00 USD. Normally you must pay to take the exam at an Apple Authorized Training Center (AATC). To take the exam, please follow these steps:

1 Visit http://training.apple.com/certification/onlinecert for system requirements.

2 Log on to ibt.prometric.com/apple, click Secure Sign-In (uses SSL encryption) and enter your Prometric Prime ID. If you don't have an ID, click First-Time Registration to create one.

3 Click Continue to verify your information.

4 In the Candidate Menu page, click Change Domain on the left and set the Domain to IT&ProApps. (If you don't see this option, skip to the next step.)

5 Click Take Test.

6 Enter APT3EUPP in the Private Tests box and click Submit. The code is case sensitive and only valid for one use.

7 Click Take This Test.

8 Read and Agree/Accept the Certification Program Agreement.

9 Click Continue to skip the voucher and enter your credit card information to pay the $75 USD fee.

10 Click Begin Test at the bottom of the page.

11 When you finish, click End Test. If you do not pass, retake instructions are included in the results email, so do not discard this email. Retakes are also $75.

Reasons to Become an Apple Certified Pro

- **Raise your earning potential.** Studies show that certified professionals can earn more than their non-certified peers.

- **Distinguish yourself from others in your industry.** Proven mastery of an application helps you stand out from the crowd.

- **Publicize your Apple Certifications.** Each certification provides a logo to display on business cards, resumes and websites. In addition, you can publish your certifications on the Apple Certified Professionals Registry to connect with schools, clients and employers.

Training Options

Apple's comprehensive curriculum addresses your needs, whether you're an IT or creative professional, educator, or service technician. Hands-on training is available through a worldwide network of Apple Authorized Training Centers (AATCs) or in a self-paced format through the Apple Training Series and Apple Pro Training Series. Learn more about Apple's curriculum and find an AATC near you at training.apple.com.